The Art of William Heath Robinson

Geoffrey Beare

Above: West House, Pinner with the
proposed Museum extension

Previous page: 'To Hampstead', an
illustration for *My Line of Life*, London:
Blackie & Son, 1938 [76].

Published on the occasion of the exhibition
Heath Robinson
5 November 2003 – 18 January 2004
Dulwich Picture Gallery
Gallery Road, London SE21 7AD

Designed by Anne Odling-Smee and Geoffrey Beare
Photography of William Heath Robinson Trust works by
Matthew Hollow
Production co-ordinated by Uwe Kraus
Printed in Germany
ISBN 1898519 23 4

British Library Cataloguing-in-Publication Data:
A catalogue record is available from the British Library

Exhibition sponsored by

HARVEY & WHEELER
E™1855

Exhibition supported by
Elizabeth Cayzer Charitable Trust
Friends of Dulwich Picture Gallery

Foreword

This book is published to coincide with an exhibition of the work of William Heath Robinson which opens at Dulwich Picture Gallery and tours to the Holburne Museum, Bath, the Walker Art Gallery, Liverpool and the Laing Art Gallery, Newcastle upon Tyne. This unique opportunity to see the range, humour and artistry of 'the Gadget King' (who is of course so much more than that) is a collaboration between the William Heath Robinson Trust and Dulwich Picture Gallery. The exhibition has depended upon the combined forces of Peter Higginson and his colleagues at the Trust and Ian Dejardin, the Curator at Dulwich, and his team. However the prime mover in the entire project, both as scholar and tireless champion of the Heath Robinson cause, was Geoffrey Beare. We are all extremely grateful to Geoffrey for suggesting the project in the first place and for carrying it through with impeccable selection, and a brilliantly written and designed catalogue.

On behalf of the Gallery I would like also to thank the sponsors who have made this exhibition possible, in particular the Elizabeth Cayzer Charitable Trust, the Friends of Dulwich Picture Gallery, and Harvey and Wheeler Estate Agents.

This publication also accompanies the launch of the William Heath Robinson Appeal whose mission is to create a permanent home for the William Heath Robinson Collection, a holding of some 500 original illustrations and artefacts, of international significance and huge popular appeal, which are now rarely seen by the public. West House in the Memorial Park, Pinner, Middlesex is the chosen site for this Gallery, in acknowledgement of the fact that William Heath Robinson did much of his best work while living in Pinner.

West House is the last surviving house in Pinner still standing in its own grounds. Set on a rise in the beautiful Memorial Park, it looks across to the 14th century church on the opposite ridge at the top of Pinner's medieval High Street. The house was once the home of the grandson of Lord Nelson and Emma Hamilton and was purchased, with its grounds, by the people of Pinner as a memorial to those who fell in the two World Wars.

The West House & Heath Robinson Museum Trust has commissioned the architects Richard Griffiths and Ptolemy Dean to design a Gallery extension to West House (illustrated opposite). Their ambition to make these plans a reality is shared by the Council of the London Borough of Harrow, the William Heath Robinson Trust and the Pinner Association (who are the beneficiaries of the original gift). The Trust needs to raise £3 million for this purpose. If you wish to find out more about this important venture please contact Martin Verden, Chairman of the Appeal Committee, on 0208 866 0111.

To find out just how rewarding and popular such a Gallery would be you need only turn the pages of this catalogue.

Desmond Shawe-Taylor
Director, Dulwich Picture Gallery

The Art of William Heath Robinson

Introduction

At the end of his life William Heath Robinson was famous as 'The Gadget King' and it is for his humorous drawings and contraptions that he is still most widely known. However in the first quarter of the 20th century he was ranked with Arthur Rackham and Edmund Dulac as one of England's foremost illustrators, capable of a wider range of subject matter than either of them. His success, both as illustrator and humorist, resulted from his formidable skills as a draughtsman and watercolourist.

Early life

William Heath Robinson was born in Islington, North London, on the 31 May 1872. He had two older brothers and was to have two sisters and a younger brother. The names William Heath were those of his maternal grandfather, but his talents as an illustrator must have come from his father's family who, for two generations, had been artists and craftsmen. His paternal grandfather had trained as a bookbinder in Newcastle upon Tyne and had worked for Thomas Bewick among others before travelling south to London where he gave up bookbinding in favour of wood engraving, working for such artists as John Gilbert, George Du Maurier and Fred Walker. William's father, Thomas, started his working life as a watch maker before moving on first to wood engraving and then to illustration, spending his later years as news illustrator for the *Penny Illustrated Paper*.

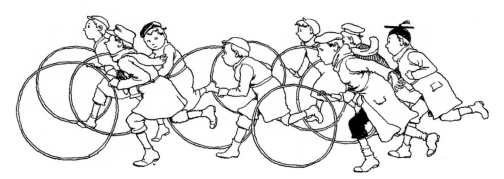

In his autobiography, William describes his early years at some length and the picture he paints is of a happy and relaxed childhood in which the companionship of his older brothers Tom and Charles was an important element.[1] Among other things he tells how, on a Sunday, the children would keenly watch the progress of their father's drawing for the next issue of the *Penny Illustrated*

My Grandfather Robinson engraving, an illustration for *My Line of Life*. London: Blackie & Son, 1938 [69].

Above: The Schoolmaster, an illustration for *My Line of Life*, London: Blackie & Son, 1938 [72].

Left: The Hoop Club, an illustration for *My Line of Life*, London: Blackie & Son, 1938 [71].

Opposite: Frontispiece for *Bill the Minder*, London: Constable & Co., 1912 [23].

1. *My Line of Life* by W Heath Robinson, London, Blackie & Son Ltd, 1938.

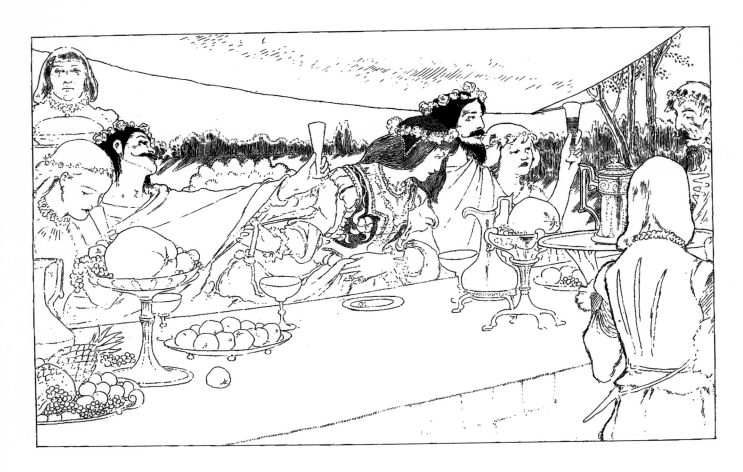

Above: 'They All Gazed at Him, and Admired at the Sight', an illustration for *Don Quixote*, Bliss, Sands & Co, 1897 [1].

Opposite: '…and the wind blew keen and cutting into the wanderer's face', an illustration for *Danish Fairy Tales and Legends*, Bliss, Sands & Co., 1897.

Paper, or 'Pip' as it was known, and it was at such times that the brothers received their first informal drawing lessons. He also describes how much of his amusement as a child came from the books that he and his brothers read. Many of these were bought from second-hand booksellers of Holywell Street where he would have become familiar with the steel engraved illustrations of H K Browne and George Cruikshank as well as the woodcuts of the Sixties school.

Heath Robinson's formal training as an artist began at a small art school in North London and was continued at the Royal Academy Schools. He complained that at both an inordinate amount of time was spent in drawing from the antique, which perhaps accounts for the fact that in his early work many of the faces display the long straight nose and short upper lip so often seen in classical sculpture. Whilst this training was not particularly inspiring, he received a sound technical grounding.

On leaving art school his first inclination was towards landscape painting and it remained his first love throughout his life, but economic realities soon forced him to turn to a more readily saleable art form. In a chapter of his autobiography entitled 'Bread and Butter' he tells how he was of necessity, but not unwillingly, drawn into the field of book illustration and how he started work in a small room off his father's studio. His brothers Tom and Charles had already embarked on careers in the same field and so it was natural that he should have followed them. At the end of 1895 Charles had just designed and illustrated a delightful edition of R L Stevenson's *A Child's Garden of Verse* for John Lane, which was very well received and was to be reprinted innumerable times through the years. He had also been accorded the honour of being discovered by *The Studio* magazine, which had published an article devoted to his work, comparing him to such fashionable artists as Aubrey Beardsley and Charles Ricketts. He was therefore a young man in demand with publishers and must have had a strong influence as his younger brother started his career.

First steps: *Little Folks* and Bliss, Sands & Co

William got off to a slower start than Charles and his first attempts to obtain commissions from London publishers met with little success. He got praise for his portfolio of drawings, but no firm offers of work until Cassell & Co. asked him to make two drawings for *Little Folks* magazine in 1896. The first of these, 'The Fairy Pedlar', confirms the influence of his brother Charles. The second is an illustration for the nursery rhyme 'Bo Peep' and in it he made good use of the single block of colour that was available to illustrators in *Little Folks* at that time.

Further magazine work came from Isbister & Co. who commissioned over fifty line drawings and a full-page half-tone illustration to accompany a serial in *The Sunday Magazine*. This magazine had been a regular patron of the Sixties illustrators such as Du Maurier and these rather uninspired drawings are very much in that style. Isbister also asked for three drawings to illustrate a children's story by W H Hudson that was to appear in the same magazine and these alone give some hint of what was to follow.[2] He also made three rather clumsy drawings for a new magazine called *Golden Sunbeams* to which his brother Charles was the main contributor of illustrations. These were published in 1897, but may have been drawn earlier, since one of the Charles Robinson drawings is dated 1894.

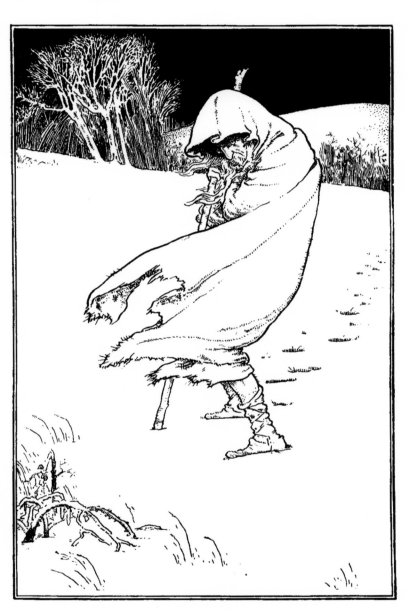

In 1897 the young artist must have been greatly encouraged by a commission from Bliss, Sands & Co. to illustrate three books, even though two of the three were to be part of a series of standard works that bore the legend 'The Cheapest Books in the World'. These were *The Pilgrim's Progress* and *Don Quixote*. The drawings for these books are immature and many of them show a lack of confidence, but already some of the qualities of his later work can be discerned. These include the use of novel viewpoints, often taking the reader very close to the scene that is depicted, and the use of strongly drawn foreground figures against a lightly sketched background to give depth to the illustrations. Occasionally, telling use is made of a small area of solid black in what is otherwise a purely line drawing, a device that was to be characteristic of the work of his brothers Charles and Tom. All of these qualities can be seen in the illustration from *Don Quixote* reproduced above. The placing of the main figure, Don Quixote, at the extreme edge of the composition is a bold move, as is the positioning of the serving boy in the foreground with his back to the viewer. One gets the impression of an artist still feeling his way with his medium, but brimming over with original ideas.

The third book that Heath Robinson illustrated for Bliss, Sands & Co. in 1897 was *Danish Fairy Tales and Legends*, a collection of forty-five stories from Hans Andersen's *Eventyr* translated from the Danish by Mrs Howitt. This volume was less austere in appearance than the other two, being bound in morocco-grained cloth decorated with illustrations from the book blocked in gilt on the front and spine. The top edge was gilded and the quality of the paper slightly better, the whole being aimed at the lucrative school prize market. The

2. It should be noted that in his autobiography Heath Robinson confused *The Sunday Magazine* with *Good Words* for which he never worked, an error perpetuated by later biographers.

7

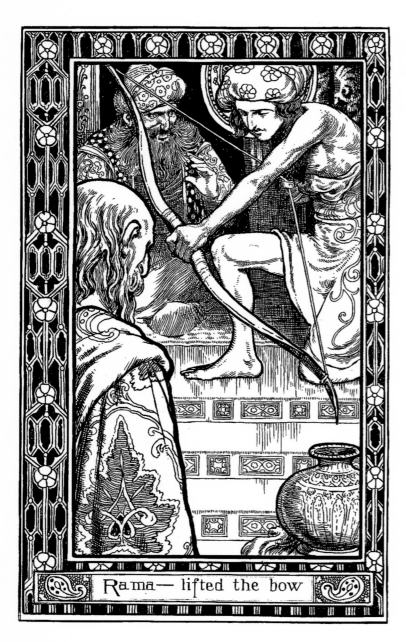

Rama— lifted the bow

'Rama lifted the bow', an illustration for *Rama and the Monkeys* by Geraldine Hodgson, J M Dent & Co., 1903 [11].

Opposite: 'She took off her red shoes, her most treasured possessions, and threw them in the river', an illustration for *Fairy tales from Hans Christian Andersen*, J M Dent & Co., 1899 [2].

3. Quoted in Langston Day, *The Life and Art of W Heath Robinson*, London: Herbert Joseph Limited, 1947, p. 87.

drawings show greater confidence and a firmer line, and the last in the book is particularly striking, with the curving form of the windblown wanderer, reminiscent of Laurence Housman's wood engravings, set against the solid black sky which fills the top of the picture.

Heath Robinson went on to illustrate other books for this publisher, who by 1898 had dropped Mr Bliss to become merely Sands & Co. One of these was an edition of *Lamb's Tales from Shakespeare*, which was issued in a uniform format with the Andersen stories. The drawings are a little more confident than those for the previous three books, and are signed for the first time. However, they represent only a small step towards the wonderful images that he was to make for the 1899 *Andersen* or for *Poe's Poems* in 1900. There are some good things here, especially the illustrations to 'A Midsummer Night's Dream' and 'The Tempest' but also much that is undistinguished. They give little indication of the fine illustrations that he was to produce in later years to Shakespeare's plays.

Indian tales

Amongst Heath Robinson's early books three collections of Indian folk tales stand out as particularly successful. The first of these was *The Giant Crab*, a collection of Indian folk tales retold by W H D Rouse. This was published by David Nutt and was issued in time to appear in his Christmas list for 1897. The book presented a subject that allowed the artist to give free rein to his imagination and he was no longer constrained to a series of full-page plates, the whole book being printed on good quality paper. As a result he produced a highly original set of drawings, which display an increased self-confidence and freedom of interpretation as well as, on occasions, a great sense of fun and mischief. The obvious sympathy between artist and subject is matched by the way the best of the drawings intertwine with the text. In two of the drawings he makes use of the circular frame that was to reappear in many of his books over the years, whilst in the cover design one can see the first influence of the art nouveau style that was becoming fashionable. It is therefore not surprising that two years later he was asked to provide a similar set of drawings for a second collection of Indian tales by Rouse called *The Talking Thrush*, this time published by Dent.

Dent also asked him to illustrate *Rama and the Monkeys*, another book of Indian folk tales, this time adapted by Geraldine Hodgson from *The Ramayana*. The book, which had a chromolithographed frontispiece and title page and six line drawings, was published as one of the 'Temple Classics for Young People.' Heath Robinson's eldest brother Tom was the most frequently used illustrator for the series, which also included *Perrault's Fairy Tales* illustrated by Charles and the first version of *Gulliver's Travels* to be illustrated by Arthur Rackham. All of these books are difficult to find and *Rama and the Monkeys* is one of the scarcest titles, but it is well worth searching for. The drawings show a freshness of approach in their composition and are well suited to the text. In the picture of Rama lifting the mystical bow of Janaka, Heath Robinson shows his skill in

capturing a dramatic moment in the narrative and peopling it with distinct, identifiable characters. We see for the first time the pleasure he takes in drawing richly decorated fabrics and interiors, something he continued throughout his career. Again, the imaginative choice of viewpoint and the heavy outlining of the foreground figure give depth to the drawing and emphasise the drama of the scene. In another of the drawings in the book, a portrait of Hanuman, the monkey king, is given a decorative treatment, with the backlit figure of the leader of the monkeys seated on the edge of a pool that reflects his image. A slender tree rises on either side of the figure and each is balanced by a water lily floating on the pool.

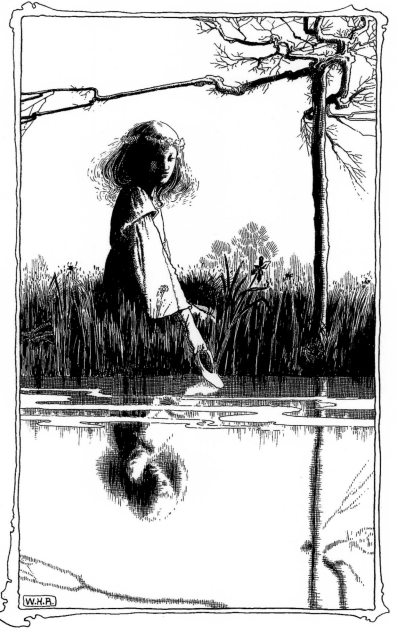

Finding a style – Andersen, Poe's Poems and Don Quixote

In September 1899 Dent published an edition of *Andersen's Fairy Tales* using a new translation of the stories by Mrs E Lucas, for which they commissioned drawings from all three Robinson brothers. Frank Swinnerton, who worked in Dent's outer office at the time, remembered their visits. He wrote:

> They used to swing into the Dent shop at 29–30 Bedford St like the three musketeers. My memory is of Tom, rather small and sedate, first; Will, very thin and taller than the others, in an overcoat which was so closely buttoned that he looked thinner than ever, in the middle; and Charles, always freer and more jaunty in his movements than the others, last. They would stand talking with me while they waited until Mr Dent could see them, and then they filed upstairs. What happened then I don't know; but soon afterwards they would come clattering down again like schoolboys, always very much amused at what had happened above.[3]

The new edition of *Andersen* was issued in an extremely attractive pictorial binding designed by Charles. Each of the brothers contributed between thirty and forty drawings and the high spots are William's although he was the youngest of the three. His use of predominantly dark illustrations for this book may have been inspired by H K Browne's dark plates for Dickens and Ainsworth with which he must have been familiar, and the substantial reduction of these drawings on the printed page gives to some of them a texture similar to steel engraving. The delicacy of composition and the brilliant use of shadow and reflection perfectly capture the poignancy of the moment when Karen casts her treasured red shoes into the river. Whatever the source of the experiment, it led to a number of highly original and appropriate drawings that emphasise the sombre side of Andersen's writing. Particularly attractive are the *art nouveau* frames to the drawings, many including vignettes that serve as pendants to the main illustration. Unfortunately, the high standard achieved in most of them was not maintained throughout. The introductory drawing to 'The Snow Queen' is hideous, making the queen look like some ageing fertility goddess.

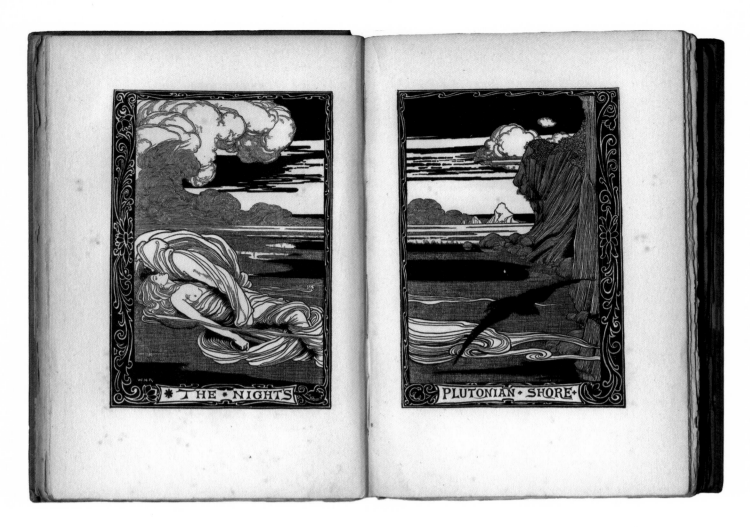

Double-page illustration for *The Poems of Edgar Allen Poe*, George Bell & Co., 1900.

The book was obviously a great success and by 1939 had been reprinted fourteen times. Dent also made use of some of the illustrations in other editions of *Andersen's Fairy Tales* that they published. These included a pocket edition in their 'Temple Classics for Young People' series in 1901, Dent's *Andersen in German* in 1902 and the Everyman edition, which was first published in 1906, and which was to remain in print until 1960.

At about the same time Heath Robinson was one of the artists asked to make a number of drawings for a new edition of *The Arabian Nights* to be published in weekly parts by Archibald Constable. He used the commission as an opportunity to experiment with a number of shapes and styles of drawing, experimenting with novel viewpoints and decorative effects.

Towards the end of 1899, Heath Robinson submitted to George Bell & Sons some specimen drawings he had prepared for an illustrated edition of Lord Byron's epic poem *Childe Harold*. Although impressed by the drawings, the publishers did not think the text a suitable one and asked him to suggest a similar but smaller work. He wrote in reply:

> … may I suggest an Ingoldsby Legends. I think my style would suit this and I should delight in illustrating it. Don Quixote too I should very much like to illustrate. I do not remember to have seen an illustrated edition of Poe's Poems, this particularly would give me immense scope.[4]

It is indicative of both his powers of self criticism and his increased self confidence that he should want to illustrate *Don Quixote* again only three years after the publication of the Bliss, Sands edition. However, it was his suggestion of Poe's poems that appealed to Bell, who had recently started to publish illustrated volumes of poetry in 'The Endymion Series'. On 2 January 1900 Heath

4. Letter from W Heath Robinson to Edward Bell dated 17 November 1899, Reading University Library 348/171.

Robinson visited Edward Bell and agreed to do seventy drawings to illustrate *The Poems of Edgar Allen Poe* for £50, an auspicious start to the new century. In October, a thousand copies of the book were published at 6s each, and there was a limited edition of 75 copies printed on Japanese vellum at a guinea. Sales of the book were initially depressed by the death of Queen Victoria on 22 January 1901, but in September there was a second printing.

When the book was first published a reviewer in *The Studio* magazine wrote:

> Mr Heath Robinson's numerous decorations and illustrations display much charm and delicacy of execution, and they proclaim him a most worthy disciple of the modern school of penmen.[5]

This modern school had grown up when the newly developed zinc line block replaced wood engraving as the primary means of reproducing black and white illustrations. For the first time an artist could draw a picture on paper or board and know that his image would be exactly reproduced on the printed page. Furthermore, he could have his drawing reduced onto the block, making the printed image finer than the original. The limitation of the technique was that it could print only in black and white, with no intermediate tones, and it was this limitation that was exploited by the new school. They absorbed the lessons of simplification and stylisation embodied in the Japanese prints that had recently started to be published in Europe, and following the lead of artists such as Beardsley and Whistler established a new style of decorative illustration.

Earlier volumes in 'The Endymion Series' had been illustrated by Byam Shaw, R Anning Bell and A Garth Jones, and Heath Robinson said that he was gratified to be invited to join such a select company. Other artists of the new school whose influence he acknowledged included S H Sime, Walter Crane and his brother Charles. Another influence was the *art nouveau* style, which had begun in Scotland and by the turn of the century had spread through book illustration, painting and domestic and commercial design, both in England and on the Continent. This had been reflected in a few of Heath Robinson's earlier drawings for books such as *The Arabian Nights*, but in the Poe drawings he embraces the style completely, not just as a follower of fashion, but adapting its sinuous outlines and rich textures to achieve a fine balance between illustration and decoration. In this book his experiments in composition and in the balancing of solid areas of black and white come to fruition. In drawings such as those to 'The Bells' or 'The Night's Plutonian Shore' he had added to Beardsley's decorative values of line and contrast a feeling of rhythmical movement and grace.

Soon after the publication of *The Poems of Edgar Allen Poe,* Heath Robinson suggested to Edward Bell that he should illustrate a volume of Dante's poetry to be published in the same series, and in January 1901 he wrote:

> I have been reading the edition of Dante you lent me and needless to say feel all the more desirous of illustrating it. I learnt a lot in illustrating Poe's Poems and feel that now I could do much better work of this kind. I think too that this work would lend itself more easily to decorative line drawing.[6]

Sadly, Bell felt that the Dante would be too great an undertaking although whether for artist or publisher is not clear. Perhaps the poor sales of the Poe poems at the time of Victoria's death weighed too heavily in the balance. Whatever the reason, the loss is ours, and the lessons that Heath Robinson had learnt in illustrating Poe were not to be fully realized for another twelve years.

5. *The Studio*, December 1900, vol. XXI, p. 209.

6. Letter from W Heath Robinson to [Edward] Bell dated 7 January 1901, Reading University Library 315/188.

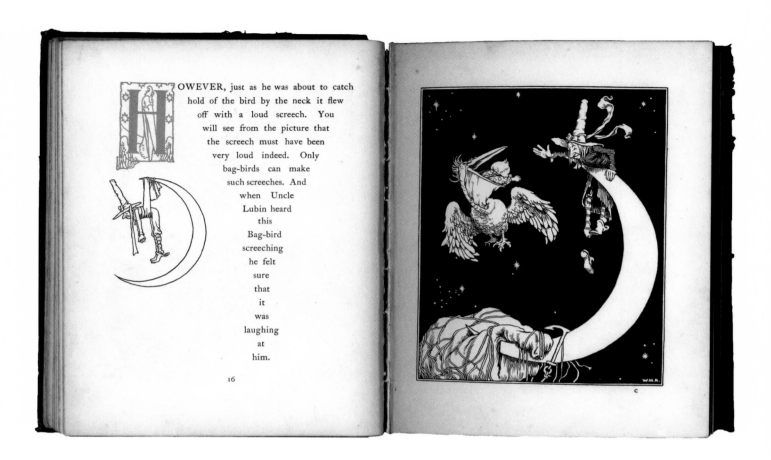

HOWEVER, just as he was about to catch hold of the bird by the neck it flew off with a loud screech. You will see from the picture that the screech must have been very loud indeed. Only bag-birds can make such screeches. And when Uncle Lubin heard this Bag-bird screeching he felt sure that it was laughing at him.

16

Above: A double-page spread from *The Adventures of Uncle Lubin*, Grant Richards, 1902.

Below: My little daemon', an illustration for *My Line of Life*, London: Blackie & Son, 1938 [77].

7. Quoted in Langston Day, *The Life and Art of W Heath Robinson*, London: Herbert Joseph 1947, p. 102

Grant Richards – *Uncle Lubin*

If he had lost one publisher he soon found another who was to be very important to him over the next three years. This was that ebullient Edwardian character Grant Richards, who in 1902 published two books that were innovations for Heath Robinson; his first book illustrated in colour and the first book that he both wrote and illustrated. The former was a rather uninteresting reprint of *The Surprising Adventures of Baron Munchausen* with four poorly reproduced coloured plates. The latter was *The Adventures of Uncle Lubin*, that 'rare good thing' for children as H G Wells called it in one of his novels.[7] The story is episodic in form, telling the tale of Uncle Lubin as he attempts to retrieve his nephew, Baby Peter, from the clutches of the wicked bag bird.

This strange little man with his tall hat and long coat had briefly appeared in *The Talking Thrush* in 1899 and there was a sequence of four pictures in *The Royal Magazine* May 1901, showing him sitting on a riverbank with two babies, but at this stage his name was 'Hodge'. These first sightings gave no real impression of the marvellous book that Grant Richards was to publish for Christmas 1902. In a series of exquisite drawings a whole cast of eccentric characters was presented to the reader in a volume that, in every detail, had been carefully planned by the author.

The first edition of *Uncle Lubin* was completely designed by Heath Robinson from covers, through pictorial endpapers, to the setting of the pages of text. Each of these starts with a large pictorial capital printed in red, with the words winding down past a related line drawing until by the bottom of the page they have in many cases diminished to a single column. Opposite each page of text is a full-page line drawing, and these are full of invention. They are carefully executed without a wasted stroke of the pen. The figure of Uncle Lubin is expressively drawn and one can share his feeling of helplessness as the bag bird flies away with baby Peter, his sadness as he awakes from his dream, or his sheer embarrassment at being embraced by a grateful Rajah.

One of the most imaginative of the adventures is titled 'The Mer-boy'. Lubin, having decided to search for little Peter in the depths of the sea, builds himself a submarine. During his searches he comes across a shoal of little mer-children. A mer-boy tells Lubin of the school that he and his brothers had until recently attended. Their education had terminated when a large fish had eaten their teacher. A delightful touch is the way that the mer-children's hair floats upwards in the currents.

In *Uncle Lubin*, one can detect a number of ideas that were later to be developed either by himself or by others. Uncle Lubin's dream introduces an image of a fairy world that was to be the starting point for a number of the pictures in *A Midsummer Night's Dream*, whilst the giant that Vammadopper met was the first in a series of giants and ogres. Both the airship and submarine are met with time and again as the subjects of cartoons during the First World War and after. It seems likely that Uncle Lubin's escape from the flood, using his upturned umbrella as a boat, inspired the similar escape of Pooh bear many years later in the story of *Winnie the Pooh*. The book was dedicated to his young niece Edith Mary Robinson, known to the family as Bay, who was the first child of his brother Charles.

In his autobiography Heath Robinson refers to Lubin as his 'strange little genius' that tempted him along a path that ran quite independently of his more serious work. On the dustwrapper of that book he shows himself on the end of a piece of knotted string being led by the strange little man in the tall hat. But it was not only his direction in art that was changed by *Uncle Lubin*, for indirectly it provided the financial support that enabled Heath Robinson to marry. A Canadian named Chas Ed Potter on reading the book decided that this was the artist to illustrate some advertisements that he was writing for the Lamson Paragon Supply Co. Ltd, a task for which Heath Robinson was paid in cash as each drawing was delivered. So, although *Uncle Lubin* was not a best seller, it was the means of gaining at least a degree of security for the young artist who was married to Josephine Latey, daughter of the editor of *The Penny Illustrated Paper*, in 1903.

In 1903 Heath Robinson continued to work for Grant Richards, writing and illustrating *The Child's Arabian Nights*. This is a much less attractive book than *Uncle Lubin* and was obviously aimed at very young children. It has twelve full-page chromolithographed coloured plates and a number of line drawings, all in a simple and somewhat bold style. The most attractive feature of the book is its front cover showing an old bearded arab's head surrounded by those of children, all wearing brightly coloured turbans.

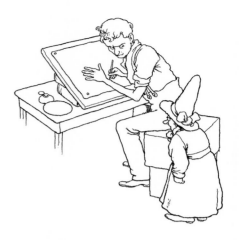

Above: 'Haunted by a strange little genius', an illustration for *My Line of Life*, London: Blackie & Son, 1938 [78].

Below: 'My good genius introduced me to new friends', an illustration for *My Line of Life*, London: Blackie & Son, 1938 [79].

13

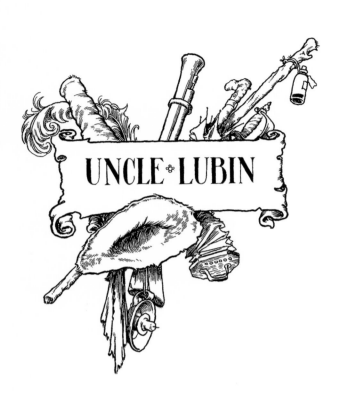

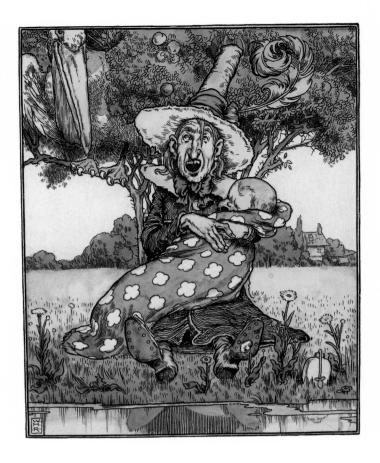

Illustrations to *The Adventures of Uncle Lubin*, London: Grant Richards, 1902.

Above: Half-title design [3].

Opposite top: *The First Adventure – Introduction*, three pen and ink drawings coloured for exhibition after publication [4].

Opposite below: *The Fourth Adventure – The Candle and the Iceberg*, three pen and ink drawings coloured for exhibition after publication [6].

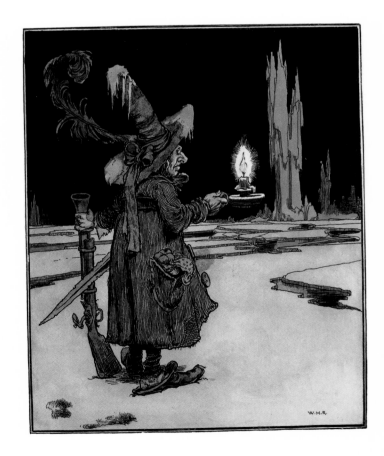

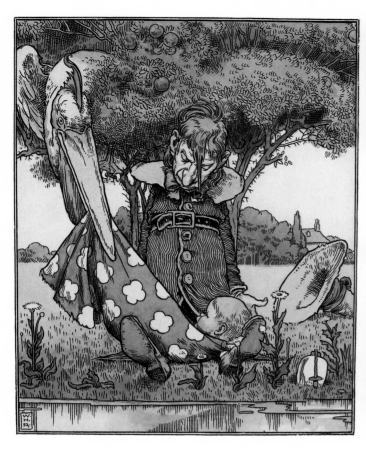
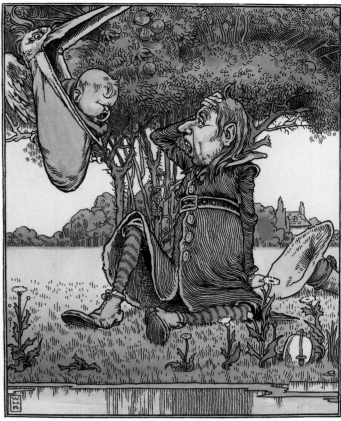
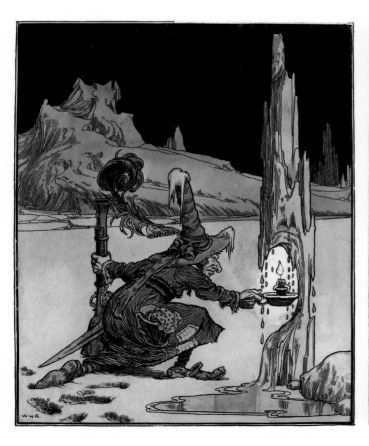
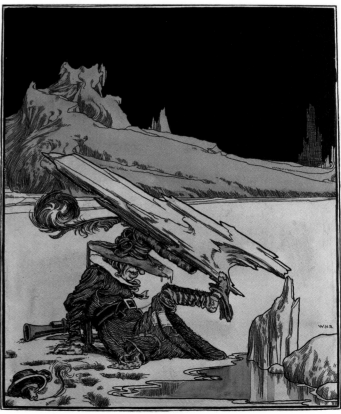

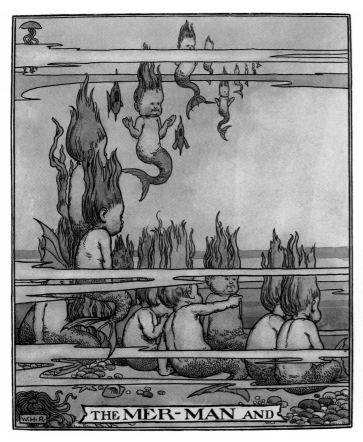

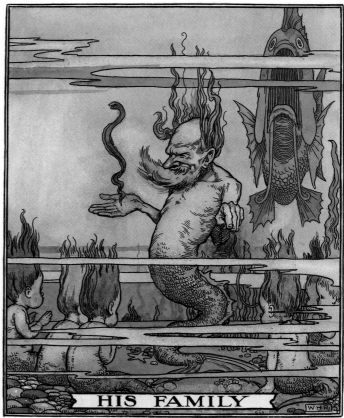

Illustrations for *The Adventures of Uncle Lubin*, London: Grant Richards, 1902.

Above and above right: *The Sixth Adventure – The Merman and his Family*, three illustrations in pen and ink, two subsequently coloured for exhibition [7&8].

Opposite, above far right: *Eleventh Adventure – The Rajah*, pen and ink, coloured for exhibition after publication [10].

Right and opposite below: *Eighth Adventure – The Shower*, three drawings in pen and ink [9].

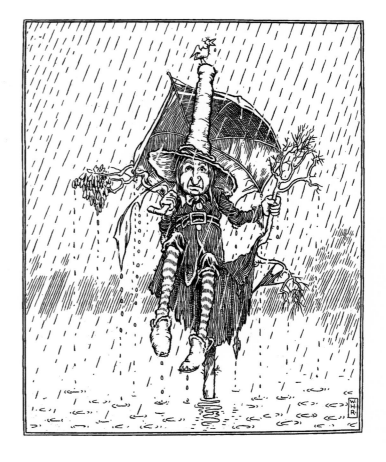

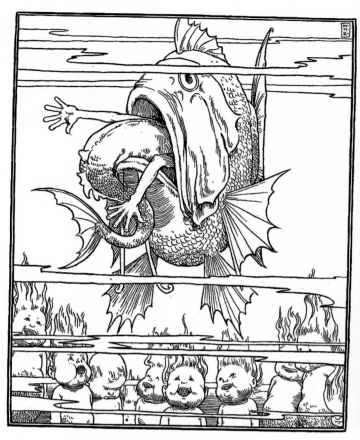

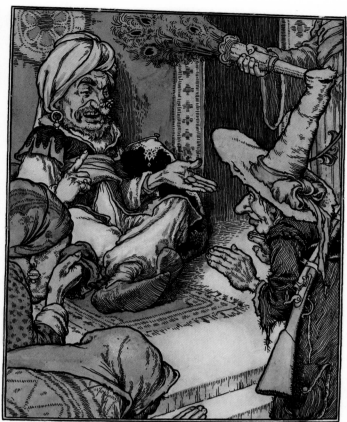

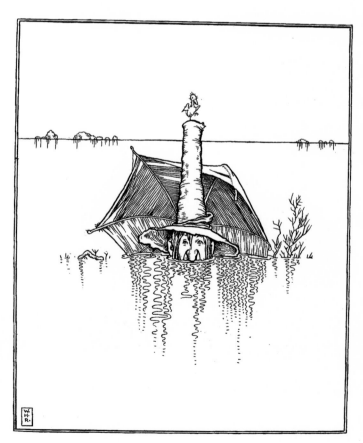

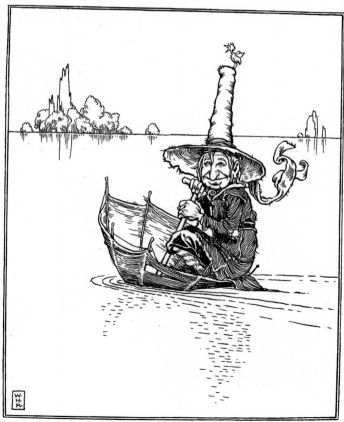

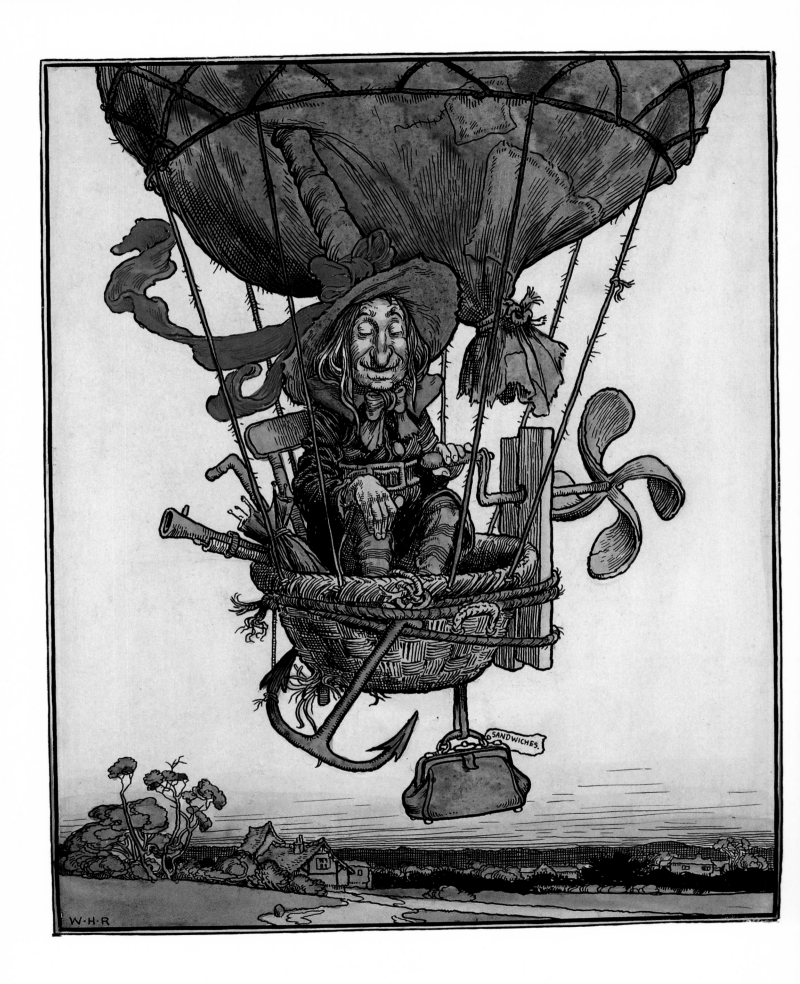

Advertising 1: Lamson Paragon

Heath Robinson's introduction to the world of advertising occurred in 1903, when he received a letter from an American. After reading *The Adventures of Uncle Lubin*, Chas Ed Potter had determined that its creator was the ideal artist to illustrate some advertisements that he had been writing for the Lamson Paragon Supply Company. He invited Heath Robinson to meet him in Tranter's Hotel, near St Paul's Cathedral, to discuss the project. Having heard many tales of American confidence tricksters coming to England and taking advantage of the unwary and innocent, Heath Robinson was suspicious, but agreed to make some drawings as long as he received payment in cash for each one when it was delivered. Every two or three days for the next few weeks he called at the hotel to deliver his drawings, for which he was paid in gold sovereigns, and to plan the next set. These transactions not only laid the basis of a friendship that endured throughout his life, but, as has been mentioned, also provided the financial security that allowed him to marry. Writing to Potter a year later, he said that:

> I am quite an old married man now it seems, at least I am quite used to this state, and took to it quite naturally. I had hoped to introduce you to my wife had you come over this time, but still we hope there may be an opportunity someday. She well remembers your visit to this country and the sudden access of wealth your being in London meant for us, and just at the right moment too.[8]

When Potter joined Lamson Paragon early in 1903, its activities included the manufacture of check books, which enabled traders to keep detailed records of their transactions, 'Plic Books' (which would give a carbon duplicate from a pen and ink written original) and paper bags. Advertising drawings were required not only to promote these products in various trade journals and within the various products themselves, but also for use as 'stock blocks' for client's advertisements on paper bags or on the backs of receipts.

Chas Ed Potter's stay in London was a short one, since by April 1903 he was in Toronto, where he was to continue his advertising activities for many years. Meanwhile, in England, the first of the drawings that he had commissioned from Heath Robinson for Lamson Paragon appeared in *The Grocer* on 25 April 1903 and showed a man about to cut off the ear of a shopkeeper. This headed a half page advertisement for Paragon Check Books, and the copy began:

> Are you satisfied with your sales system? If you are, don't waste time reading further. We want the ear of the progressive shopkeeper – the one who is not satisfied.

Similar drawings were used in advertisements for Paragon Check Books for the next seven weeks, and the sequence was then repeated. This initial campaign must have been deemed a success, since a further eighteen drawings appeared in weekly Lamson Paragon advertisements in *The Grocer* between 12 September 1903 and 23 January 1904, and these were reused until 1 April 1904.

Potter's successor at Lamson Paragon was another American, John Meath Evans, with whom Heath Robinson continued to work for about five years. They developed a close working relationship, meeting once a week to hand over completed work and to discuss ideas for future advertisements. The intensity of these meetings was recorded in a drawing that the artist made in a copy of his autobiography that he presented to Evans many years later.

Opposite: *Second Adventure – The Airship.* An illustration for *The Adventures of Uncle Lubin,* London: Grant Richards, 1902, pen and ink, coloured for exhibition after publication [5].

Below: Heath Robinson's first advertising drawing for Lamson Paragon.

8. Letter from W Heath Robinson to Chas Ed Potter, private collection.

Above: Tailpieces from *The Works of Rabelais*, London: Grant Richards, 1904 [16, 17].

Opposite: Studies of heads for Rabelais, published in the *Strand Magazine*, July 1908, p. 42 [14].

9. *W Heath Robinson* by A E Johnson, Adam and Charles Black London 1913 in the 'Brush, Pen and Pencil' series.

Rabelais

Heath Robinson's great strength throughout his career was the extent to which he could adapt his style of drawing to the task in hand, whilst retaining enough of his personality in the work to make it unmistakably his own. For *The Works of Rabelais* he adopted a broad, flowing style of drawing that was much freer than the precise, tightly controlled line that he had used for the Poe poems or *Uncle Lubin*. It would have been easy for him to have drawn on Beardsley's decadent figures or on Doré's cold and remote images of *Paradise Lost* for this book, but he avoided such easy options and immersed himself in the more basic and unsophisticated world of Rabelais. The reader is transported to a bleak landscape peopled by grotesque peasants and priests whose lives are dominated by fear and superstition and who can find relief only in drunkenness and debauchery. If he looked for inspiration outside the text it was to Breughel's paintings, Da Vinci's studies and perhaps to the carvings in the choir stalls, gargoyles and corbels of our early churches and cathedrals. The characters in 'Ring, Draw, Reach, Fill and Mixe' are first cousins to Breughel's Flemish peasants with their coarse features, over large hands, and open mouths. The link with Da Vinci can be seen most clearly in the drawings of individual characters and in the sheet of studies of grotesque heads, which is a triumph of both imagination and technique. Even more successful than the depictions of people are the images of hell and damnation. The reader is not allowed to remain an aloof and disinterested observer but is drawn into the shrieking, biting, clawing mass of nightmare figures. Teeth bite into flesh and one can almost smell the brimstone as the satanic hoard draw their victim into '… sulphur, fire and bottomless pits.' These are not the comfortable goblins of Victorian fairy stories, but the creatures born of fear and superstition that one can see in early English church architecture and illuminated manuscripts. However, the mood of the book is far from sombre, for the visions of the pit and the gibbet are counterbalanced by a leavening element of robust good humour running through both Rabelais' text and Heath Robinson's drawings, which drawings must have influenced illustrators who followed. Many of them bring to mind the work of Mervyn Peake forty years later.

The Works of Rabelais, which was published in two large volumes containing a hundred full-page illustrations and well over a hundred smaller drawings and vignettes, was his largest and most ambitious project to date. The project was almost certainly suggested to the publisher by Heath Robinson, and the text is the sort of loosely linked episodic narrative that appealed to him so much. The costs involved in printing this extravagant edition of Rabelais' works contributed to the failure of the publishing house of Grant Richards, which was announced in November 1904. After protracted negotiations the stocks and copyrights were sold to Alexander Moring Ltd of the De La More press, enabling a dividend of two shillings in the pound to be paid to creditors, one of whom was Heath Robinson. He thus received little financial reward for all the work he had done for this publisher. Under the circumstances the book was not a great success when first published, but was reprinted in reduced formats many times in later years. A E Johnson, who was to become Heath Robinson's agent, writing in 1913, seemed to prefer the more convenient format of the reduced edition published by Alexander Moring that year, but the price of convenience was too high.[9] The fine gravure frontispieces of the first edition are replaced by poor half tone plates, a number of the smaller drawings and vignettes are omitted, and both the pictorial endpapers and the binding design are also lost.

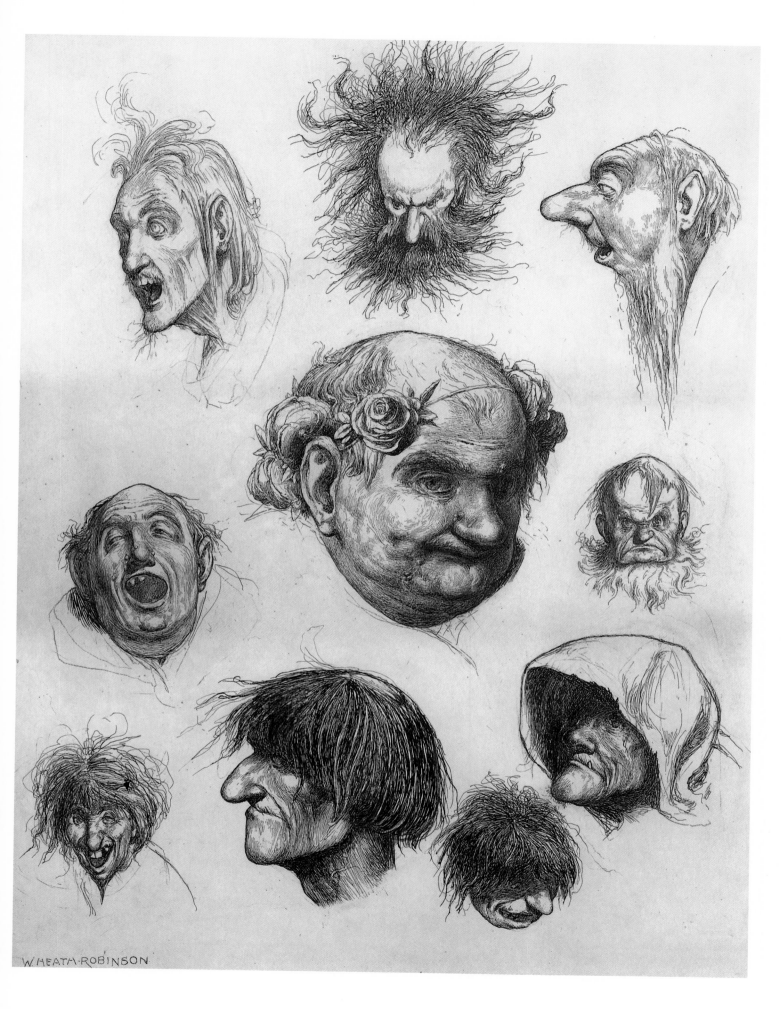

W·HEATH·ROBINSON

21

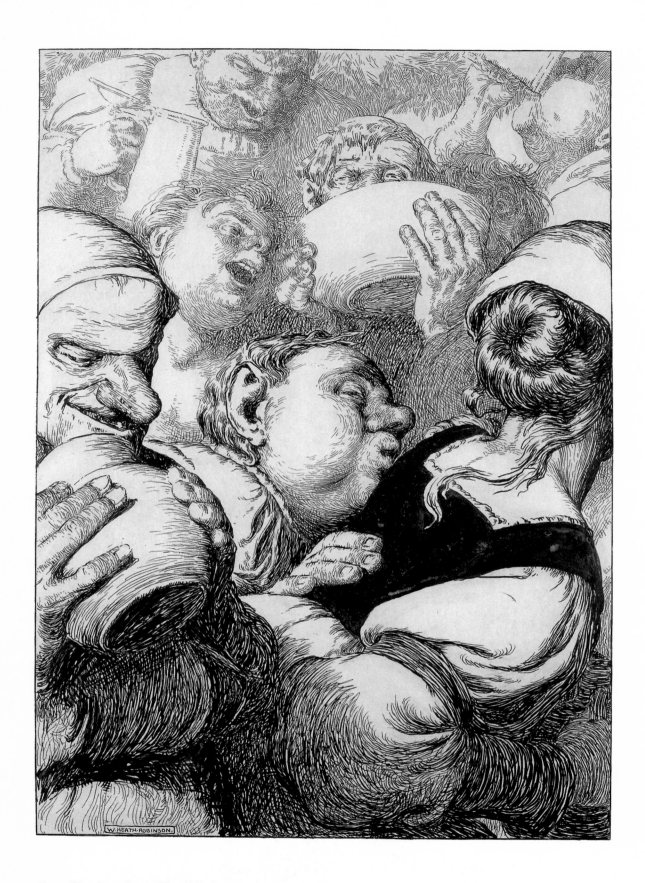

Above: 'Ring, Draw, Reach, Fill and Mixe',
an illustration for *The Works of Rabelais*,
London: Grant Richards, 1904 [13].

Opposite: 'May you fall into Sulphur, Fire
and Bottomlesse Pits', an illustration for *The
Works of Rabelais*, London: Grant Richards,
1904 [12].

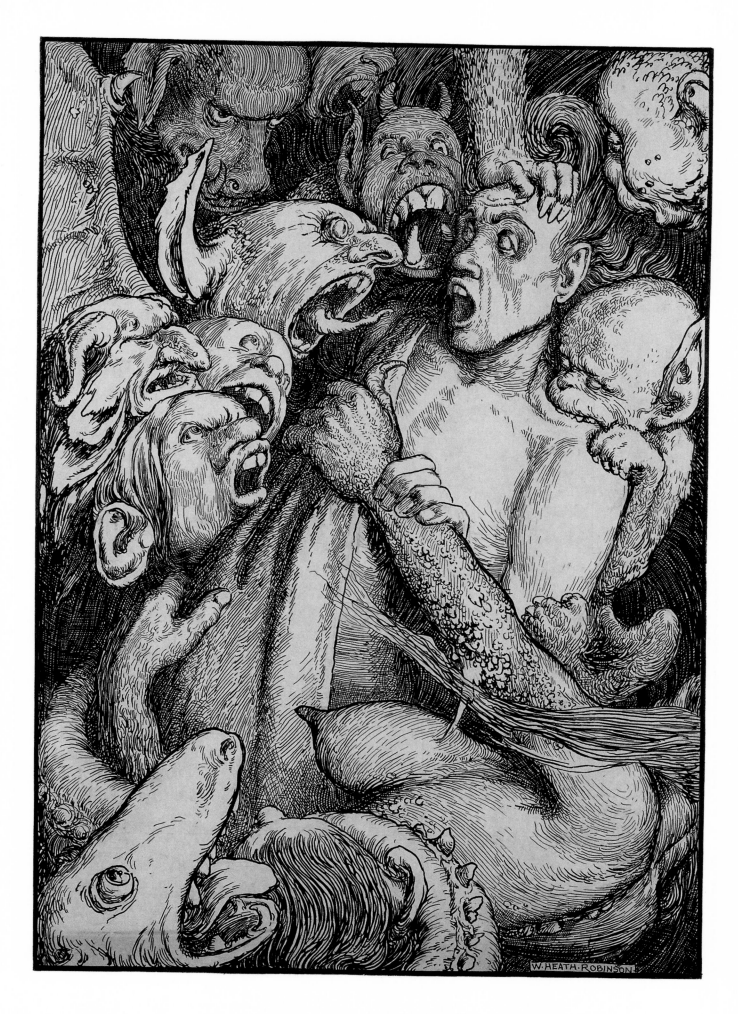

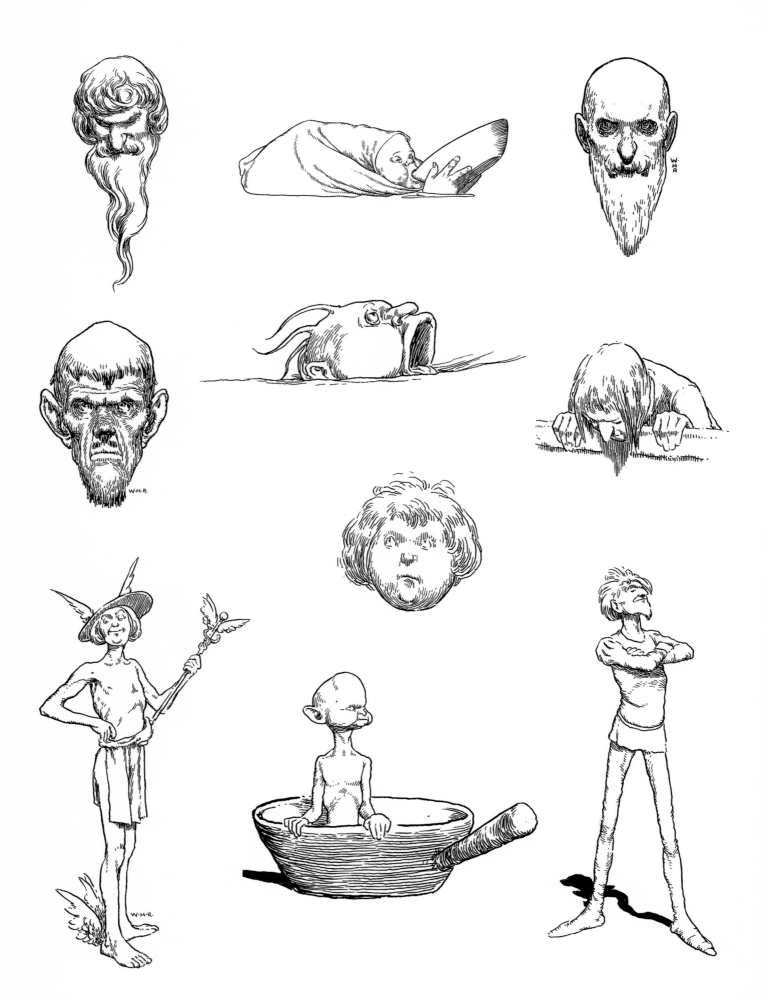

Making them laugh: early work for *Tatler* and *Sketch*

It must have come as a great shock to the young artist to find that with Grant Richards' bankruptcy he had lost his main patron together with any hope of payment for the majority of his recently completed work. He started to look for new sources of income, and especially for commissions that would yield immediate payment. His best prospect lay with the quality weekly magazines, such as *The Sketch, The Bystander, The Tatler* and *The Illustrated Sporting and Dramatic News,* which featured a number of full-page humorous drawings in each issue. Once again the artist showed his versatility, and drawing on his experience of *Uncle Lubin* and other children's books he prepared a series of large, finished black and white pictures suitable for half-tone reproduction. In an interview published in the *Strand Magazine* in 1908 he said that:

> Gradually I found that what was primarily meant to interest the children interested their elders a good deal more. If a sketch of mine was very extravagant the youngsters turned from it in incredulity, but I observed that the boredom of the child was directly in inverse ratio to the delights of his parent.[11]

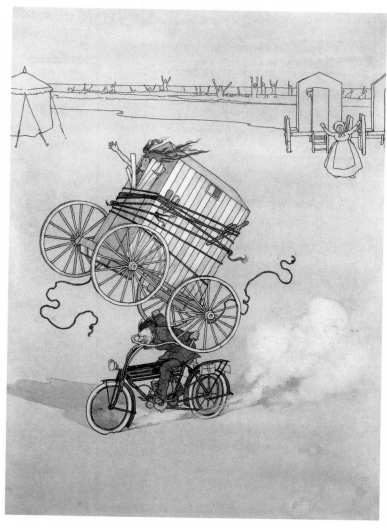

These new pictures set out to satirise the late Victorian and Edwardian taste for allegorical paintings depicting such abstract concepts as 'Hope' or 'Love'. He did not find them easy to sell. In his autobiography he recalls that one editor, having looked through his portfolio remarked: 'If this work is humorous, your serious work must be very serious indeed.'[10] He persuaded *The Tatler* to accept some of them and between March 1905 and February 1906 they published a total of eighteen drawings. It was, however, an uneasy relationship, and Heath Robinson's memories of these early pictures were that:

> The late Clement Shorter, at that time editor of The Tatler … was always a little doubtful about them. He eventually gave up publishing them altogether.[12]

Above: 'Daring abduction of a society beauty at Westgate-on-Sea', a rough sketch for a version of a drawing published in *The Sketch*, 24 July 1912 [85].

Opposite: Head and Tail Pieces for *The Works of Rabelais*, London: Grant Richards, 1904 [15, 18].

Before founding *The Tatler* in 1900, Shorter had been the first editor of its rival, *The Sketch*. This magazine advertised itself as 'pre-eminent for its illustrations of the theatre, to say nothing of society, sport and art.' In 1906 the editor was Bruce Ingram, who encouraged many of the most talented young humorous artists by publishing their work. Amongst those whose early reputations were established in the pages of *The Sketch* were H M Bateman, Lawson Wood and G E Studdy.

In March 1906 *The Sketch* published a Heath Robinson cartoon entitled 'Trapping Whelks on the Shores of the Caspian Sea'. This was the first of a series of eleven cartoons with the collective title 'The Gentle Art of Catching Things' which established Heath Robinson as one of the leading comic artists of the day. Between 1906 and 1914 *The Sketch* published over 200 of his humorous compositions. He preferred to work in a series format, producing up to a dozen pictures with a common theme. This gave him a chance to explore all the ramifications and applications of a single idea, and such series make up the majority of the early *Sketch* cartoons.

10. *My Line of Life* by W Heath Robinson. Blackie & Son, London, 1938.

11. 'Mr W Heath Robinson and His Work'. Anon. *Strand Magazine*, July 1903, vol. 36. pp. 41–9.

12. Ibid.

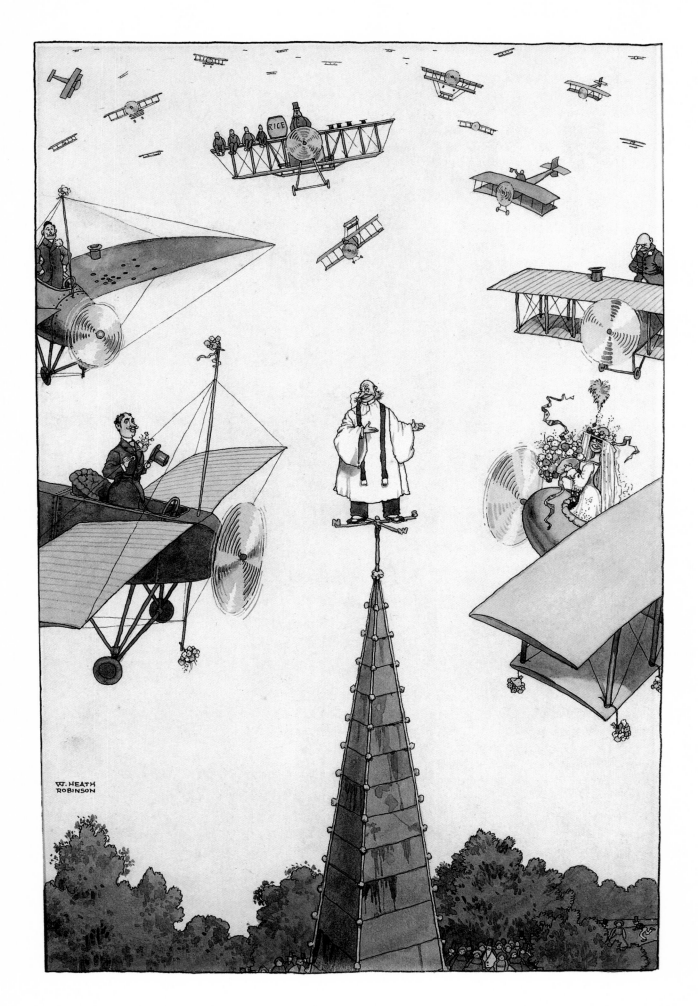

Although it was in the pages of *The Sketch* that Heath Robinson established his reputation as a comic artist, other magazines were quick to recognise his talent. In December 1907 Marion Hepworth Dixon wrote in *The Ladies' Realm:*

> Mr W Heath Robinson is an artist at once so thorough, so conscientious and so original that he can be compared for the moment only with himself. A quaint exaggeration may be said to be the source of his humour, a humour that, unlike that of most of his contemporaries, needs little illumination or explanation in the way of accompanying text.[13]

Later in the same article she draws the reader's attention to the 'really poetic' landscapes in many of his comic pictures. It is ironic that it should have been in his humorous pictures that Heath Robinson found his first real opportunity to display his talents as a landscape artist, for in many of them the most absurd activities take place in beautifully realised settings. He seems to have been fascinated by the light reflected on water, and his favourite backgrounds are the flat wet countryside of East Anglia, the seaside or the sea itself, each of which he captures in a combination of pen, pencil and watercolour.

In August 1908 *The London Magazine* presented a series of cartoons entitled 'How to Agricult' which were accompanied by a short article on Heath Robinson's art. The anonymous writer agreed with Miss Dixon, stating that:

> ... it may sometimes be overlooked, in the laughter provoked by the solemn plausibility of the fantastic embroideries upon simple facts which he delights to weave, that Mr Robinson in his drawings never fails to grasp to the utmost the possibilities of his subject for artistic treatment. As readiness and fecundity of invention is the principal feature, in a 'literary' sense, of the artist's mind, so a strong sense of decoration is the salient feature of his pictorial art.[14]

By 1912 Heath Robinson was widely known for his contraptions, and *The Illustrated London News* reviewing his new children's book, *Bill the Minder,* introduced him as:

> ... the fantastic limner of the dust-heap, the lumber room, the battered tin can, the strange bird and the stranger inhuman being, which contribute the material of his queer makeshift mechanical devices.[15]

The essence of Heath Robinson's humour lies not in his strange machinery, but in his observation of ordinary people, especially those who take themselves very seriously and have no sense of humour. The contraptions were just one way of illustrating the absurd lengths to which they would go to achieve the most trivial of ends. He set out to deflate the pompous or the pretentious by exaggerating their folly to the point of absurdity, and it was not only individuals that were the butt of his humour, for he was equally likely to apply his pen to organizations and institutions, the laws of physics or the workings of fate.

In many ways Heath Robinson's humour is seen at its best in the drawings he made before the First World War. At that time he was approaching his peak as a serious illustrator and this is reflected in the high technical quality of the pictures. He was also free of the constraints imposed by the expectations of art editors who were later to develop a very precise notion of what a Heath Robinson cartoon should look like, and so we see a number of bold experiments in both subject matter and treatment. In some of the pictures there is wild surrealism combined with a streak of the macabre that was later subdued, either by the artist himself, or by editors unwilling to take risks with the sensibilities of their readers.

Opposite: The First Aero Wedding, published in *Flying Magazine,* 30 May 1917 [86].

13. 'The Delicacy of Humour' by M H Dixon, *The Ladies' Realm*, December 1907, vol. 23, pp. 231–8.

14. 'A Maker of Absurdities', Anon, *London Magazine*, August 1908, vol. 20, p. 626.

15. 'Christmas Leaves from the Publishers', Anon. *Illustrated London News*, 7 December 1912, p. 852.

The first gift books – Shakespeare and Kipling

From 1905, Heath Robinson successfully combined his new career as a comic artist with that of a serious illustrator. He was an early recruit to the ranks of those artists commissioned to produce coloured illustrations for the sumptuous gift books that were so popular from that time until the First World War. Hodder and Stoughton chose him to illustrate *Twelfth Night*, which was published with forty coloured plates for Christmas 1908. The watercolours for the book were exhibited at the Brook Street gallery and the show was acclaimed a 'triumphant success'. *The Westminster Gazette* said that:

> Mr Robinson has got far away from tradition. He owes nothing to his contemporaries, either of the pencil, or of the stage. He has treated the subject with the splendid originality of an artist with high imaginative powers and no mean gift of technical expression. His colour is refined and delicate, his draughtsmanship excellent, and his characterisation sufficiently good. The play might give large opportunity for farce bordering even on caricature: but Mr Robinson – in spite of his revealed predilections for the grotesque – has this time held his hand. With notable self-restraint, he never passes the borders of pure comedy ... Mr Robinson must be accepted henceforth as a watercolour painter of high rank, with a very valuable and refreshing gift of originality and poetry.[16]

In his illustrations to *Twelfth Night* Heath Robinson set out to convey the atmosphere of the play, rather than to provide a literal record of its action. The illustrations do not take their subjects evenly from the text, but concentrate on those passages that appealed to him, and in particular on the songs, which provide more than a quarter of the subjects. Although free from the limitation of a stage setting, many of the illustrations retain a theatrical atmosphere, adopting high viewpoints that give one the feeling of looking down from the upper circle in an old fashioned theatre. As in the *Sketch* cartoons, he experiments with the effects of light filtering through trees, reflected from fountains or puddles and diffused by early morning mist. Tones vary from the warmth of a Turner sunset to the cold of a moonlit night, and the effects of light playing on the facades of renaissance buildings or on richly decorated marble pavements are handled with great confidence and skill. In the final sequence of plates in the book, which illustrate the song 'The rain it raineth every day ...' the clown Feste inhabits the same flat and muddy East Anglian landscape that had appeared in some of the drawings for *The Sketch*.

These illustrations presented a considerably greater challenge to the printer than Rackham's tinted drawings. A surviving group of printer's proofs for this book, extensively annotated by the artist, show the great pains that Heath Robinson took to ensure good reproduction of his watercolours. His comments range from 'very good indeed' and 'passed subject to alterations' (generally requiring modification to highlights), to, on the worst of the plates:

> The blue in background is too strong, particularly behind man drinking who is lost too much in the shadow. The lighter parts of tapestry are too light and blue. The man on extreme left has an unpleasant patch of dark brown on his forehead. Compare generally with original. W H R [17]

These proofs also confirm that whilst the majority of the illustrations were printed in three colours, those requiring the greatest depth of tone used the four-colour process.

At the same time as the watercolours for the book were exhibited at The Brook Street Gallery, Arthur Rackham's illustrations for *A Midsummer Night's Dream* could be seen at the Leicester Galleries and Paul Woodroffe's to *The Tempest* at the Baillie Gallery. Dulac's illustrations to *The Tempest* were shown at The Leicester Galleries the following month. The portfolio of coloured plates issued with *The Bookman* Christmas number that year contained three from Heath Robinson's *Twelfth Night* and three from Dulac's *The Tempest*.

16. *Westminster Gazette*, 31 October, 1908, p. 15.

17. Sotheby's sale Thursday 20 June 1985, lot 414.

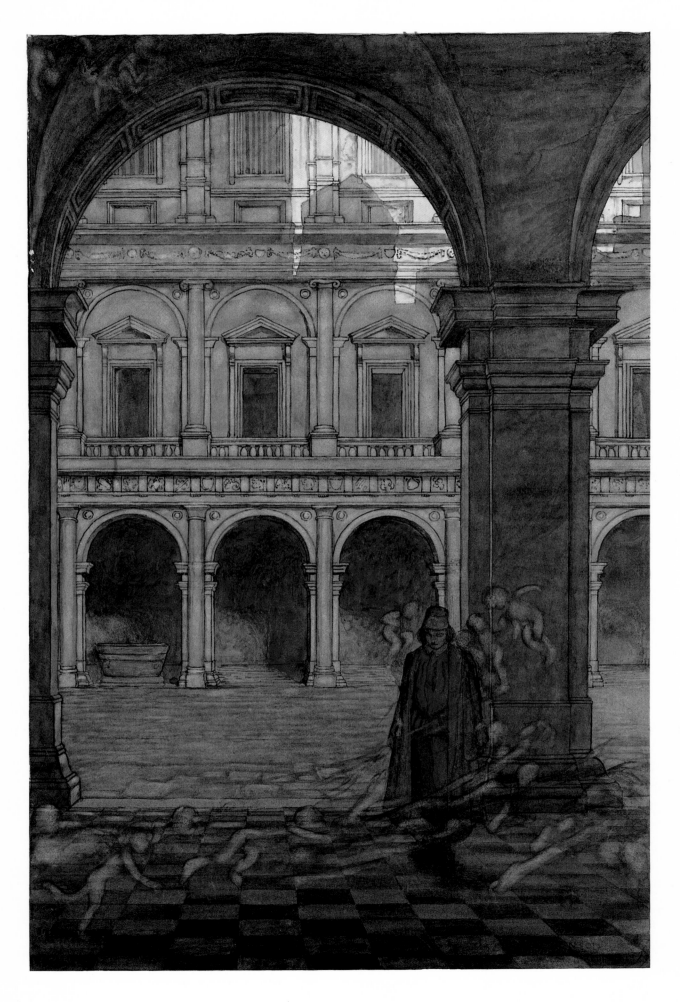

The success *of Twelfth Night* brought an immediate request for another book from Hodder & Stoughton. The text chosen this time was a poem from Kipling's collection *The Seven Seas*. Its title was *A Song of the English* and in the original edition, it spanned just seventeen pages. In these short verses, Heath Robinson had to find subjects for thirty watercolours and more than twice that number of line drawings. He started by visiting the author at his Sussex home, and later commented on Kipling's sympathetic understanding of his role in the project. The pictures were exhibited at the Baillie Galleries in October 1909 to coincide with the publication of the book. The reviewer in *The Studio* magazine praised the line drawings, but thought the coloured illustrations less successful. He concluded by saying that although Heath Robinson was:

> … always an artist of much imagination and invention, perhaps allegory of this kind has not afforded him the happiest opportunity for his lively and resourceful art.[18]

However, two months later another critic reviewing the book for the same magazine wrote:

> Mr Heath Robinson has, by sheer merit, gained for himself a prominent position amongst English illustrators of the day, and he has in this branch of art produced nothing finer than the series of coloured and pen-and-ink drawings for Kipling's Song of the English.[19]

The subject gave him an opportunity to develop his skills in a range of landscapes and seascapes as well as a variety of historical and allegorical subjects. 'The Coastwise Lights of England' shows his skill as a watercolorist, with its lowering sky reflected in the wet sand and the rusting structure evoking Kipling's lines:

> Our brows are bound with spindrift and the weed is on our knees;
> Our loins are battered 'neath us by the swinging, smoking seas.

The following section, 'The Song of the Dead' recounts the price that England has had to pay for her mastery of the seas. In his illustration, the rolling surf, yellow sand and bright tropical light summon a vision of sailors drowned on far distant shores, paying 'the price of admiralty'.

The line drawings were executed with the same strong, flowing lines that had been developed for *Rabelais*. They certainly, to present day audiences, are more appealing than the watercolours, many of whose symbolist images of colonial capitals no longer inspire a sense of pride. However, the variety of published editions of the book and the span of time over which they were issued testify to its popularity in the years either side of the First World War.

The success of *A Song of the English* resulted in a request from Doubleday, Page & Co. in New York to illustrate an American edition of *The Collected Verse of Rudyard Kipling*.

This time only nine coloured plates and fifteen line drawings were required, and the diversity of the poems must have made it difficult to achieve any consistent atmosphere or common feeling that could unify the pictures. He is at his best with the comic-macabre watercolour to the poem 'Tomlinson' which must have been inspired by S H Sime's drawings of 'Ye Shades' in *Pick-Me-Up* and *The Idler*. Of the remainder, it is the line drawings that are the most successful, especially 'The Fires' and 'The First Chantey', the latter executed in a much more delicate style than any of the drawings in *A Song of the English* and with the fine modelling achieved by a combination of pen and pencil. The book was not published in England, but was available in Canada, and the Canadian National Gallery bought the original watercolour entitled 'The Three Decker'.

Opposite: Duke. 'So full of shapes is fancy', watercolour and body colour, an illustration for *Twelfth Night*, London: Hodder and Stoughton, 1908 [19].

18. *The Studio*, November 1909, vol. 48, p. 146.

19. *The Studio*, January 1910, vol. 48, p. 336.

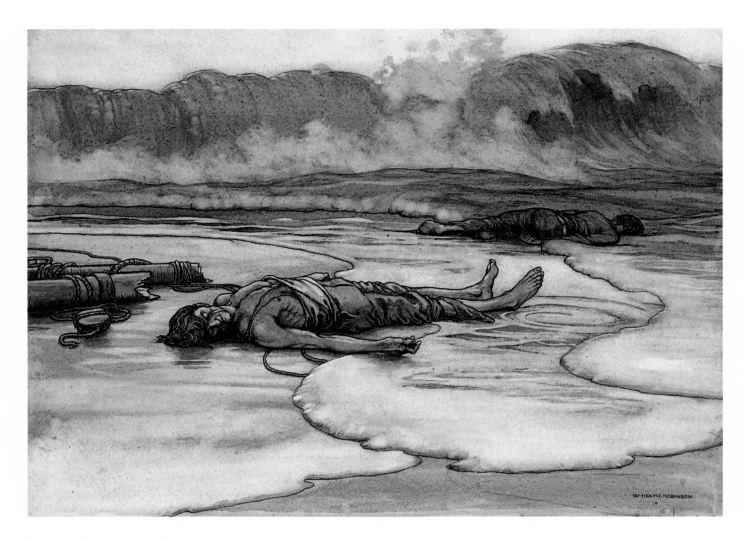

Illustrations for *A Song of the English*
by Rudyard Kipling, London: Hodder &
Stoughton, 1909.

Above: 'There's never an ebb goes seaward
now, but drops our dead on the sand' [22].

Opposite: 'The coast-wise lights of England
give you welcome back again!'[21].

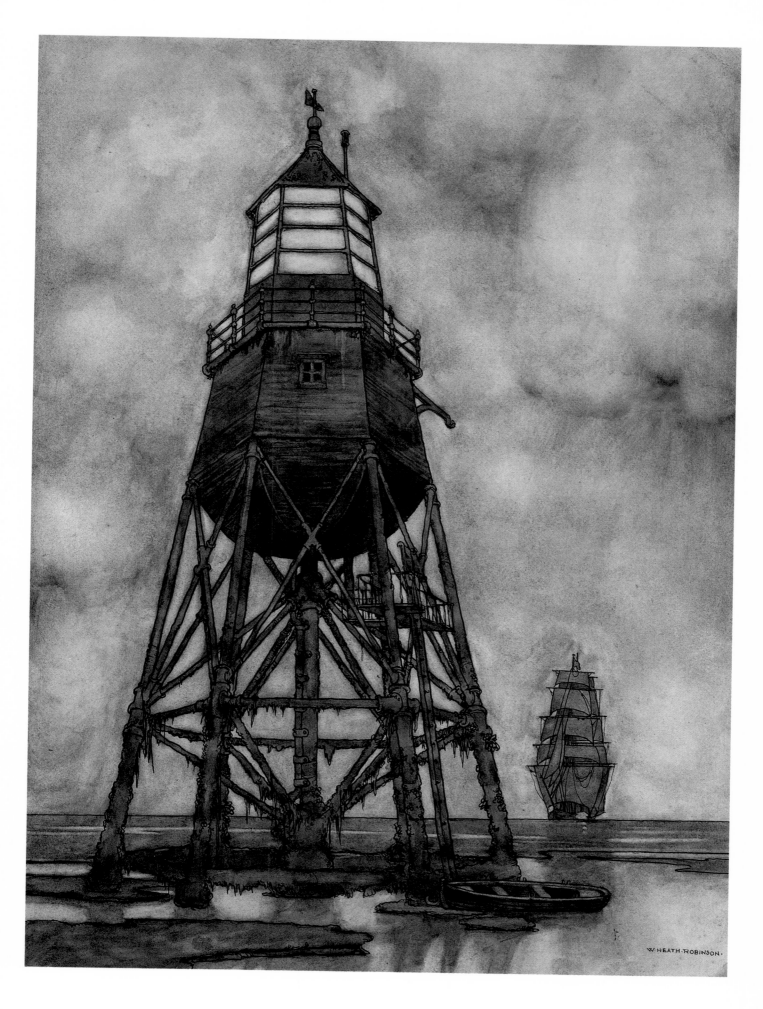

'This boy of mine often sits for me', a photograph published in *The Sketch*, 4 January 1911.

Headpiece for 'The Seige of Troy', *Bill the Minder*, London: Constable & Co., 1912 [31].

Opposite: Headpiece for 'The Ancient Mariner' in *Bill the Minder*, London: Constable & Co., 1912 [25].

20. Introduction to *The Illustrations of W Heath Robinson* by Geoffrey Beare, London: Werner Shaw Ltd, 1983, pp. ix–xi.

21. *The Athenaeum*, 7 December 1912, p. 710.

The book as art – *Bill the Minder, Andersen* and *A Midsummer Night's Dream*

Heath Robinson and Josephine Latey had married in 1903 and their first child, Joan, was born in June the following year. In April 1908 their first son, Oliver, was born and shortly afterwards they moved from their flat in Holloway to a house at Hatch End near the village of Pinner, in what was then rural Middlesex. Two years later they moved to a modern villa in Moss Lane, in Pinner itself, where their second son, Alan, was born in October 1909. Heath Robinson's son, Oliver, has described his father's love of children, and his talent for amusing them with stories of his own invention.[20] In 1910 he started work weaving many of his characters into a picture book for children. By November his ideas were sufficiently advanced to show to publishers, and he signed a contract with Constable for a volume of about sixteen stories. These were to be illustrated with sixteen coloured plates and 120 line drawings. The working title of the book was 'The King of Troy'. He took great pains over both the text and the pictures for the book.

By the time it was completed, the title of the book had been changed to *Bill the Minder*. The story, like *Uncle Lubin,* is a loosely linked episodic narrative whose hero, Bill, is also a child-minder, but there the resemblance ends, for unlike Lubin, Bill is a champion minder. The book describes the adventures of Bill and his charges as they first discover the deposed King of Troy asleep in a haystack, and then journey with him back to his kingdom to help him regain his throne. On their travels they meet such fantastic characters as the Ancient Mariner, the Triplets, the Real Soldier, The Wildman, the Lost Grocer and many others, each of whom tells the sad story of his or her life before joining the party. They eventually reach the city of Troy, lay siege to it and restore the king to his rightful place. The characters are beautifully realised both in text and illustrations, and in this respect the book is a worthy successor to *Uncle Lubin*.

In 1911 when these drawings were being made Heath Robinson was interviewed for *The Sketch* magazine to which he regularly contributed his humorous drawings. One of the photographs accompanying the interview showed him using Oliver, then three years old, as his model, and his own children and those of his brothers must have provided many subjects for the illustrations to *Bill the Minder*. In the interview he said that although

> … I do not use models when I am actually making a drawing… I find them very good when studying. This boy of mine often sits for me.

He also said that if he wanted a particularly eccentric pose he would act as his own model with the aid of a mirror.

Bill the Minder was published by Constable in 1912 in a handsome green cloth binding decorated in gilt and with a four-colour plate inset on the front within a gilt border of rules, scrolls and rose heads. It was well received by the reviewer in *The Athenaeum,* who wrote:

> We harboured the thought that the fine feathers of Bill the Minder might conceal but a poor bird after all, but assuredly a handsome exterior is a fitting – indeed, the only suitable setting – for a richly imaginative and original book which takes a leading place amongst the many which have passed through our hands this season… It would be a delicious book even without its decorations in the way of coloured plates and drawings? – illustrations so apt that it will surprise no-one to find that author and artist are one.[21]

Certainly in *Bill the Minder* there is a consistency in both the quality and style of the illustrations that was absent from the two Kipling volumes. Looking back at this phase of his career in a newspaper interview many years later, Heath Robinson observed:

The trouble about illustrative work is that one is so tempted to choose a part of the text that inspires a good illustration, instead of interpreting the author's central idea. I was never an illustrator in the real sense of the word: I was too independent and wanted to go my own way too much. So when I found out how pleasant it was, in Uncle Lubin, to fit words to the illustrations instead of illustrations to the words, I repeated the experiment on a larger scale.[22]

However, with regard to the text of the book, Heath Robinson was very modest. Writing in 1917 to O M Badcock, with whom he had studied at the Royal Academy Schools, he said that in writing the book he had attempted something beyond his powers. He felt that:

> … it was not a book for children and that they would not understand it, or else be bored terribly. Uncle Lubin in my mind is from this point of view far superior. But then I am only in the same boat as most writers of books for children, who have an eye all the time on the kind Uncle or Aunt who is going to make the purchase and who so often do not understand children.[23]

Perhaps he was right and this is one reason why the book is so much sought after by adult collectors today.

Following the publication *of Bill the Minder,* Constable asked Heath Robinson to illustrate a new edition of *Hans Andersen's Fairy Tales* to be published in a similar format. It was the third time that he had illustrated these stories and he said that this time he tried to bring out their happier aspects.

The coloured plates for the book are among the best that Heath Robinson ever made. In them, he achieved that combination of the familiar and the fantastic that appeals so much to children. This is particularly true of the illustrations in which the tiny, magical figure of Tommelise is seen riding on the back of a swallow or talking to mice that are drawn with great realism. The magical qualities of flying are evoked in the pure fantasy of the colour plates to 'Elfin Mount' and 'The Little Mermaid' with their delicate, ethereal colouring, or in a more believable, but no less dreamlike picture of three children on a swing for 'The Snow Queen'. However the most strangely haunting of the coloured pictures is that to 'The Wild Swans' illustrating the passage in which Elise whispered to the roses in the thick hedge outside her house, 'Who is more beautiful

22. *The Statesman of Calcutta,*
11 September 1938.

23. Manuscript draft in the collection
of the William Heath Robinson Trust.

35

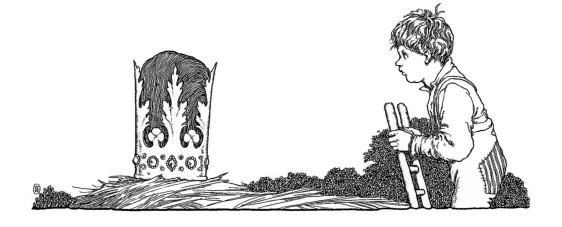

Illustrations for *Bill the Minder*. London: Constable & Co., 1912.

Clockwise from bottom left: 'He climbed the rick' [24]; Headpiece to 'The Real Soldier' [27]; Headpiece to 'The Triplets' [26]; 'Moping about the Common' [28]; 'Kept him out of mischief' [29]; Tailpiece to 'The Camp Followers' [30].

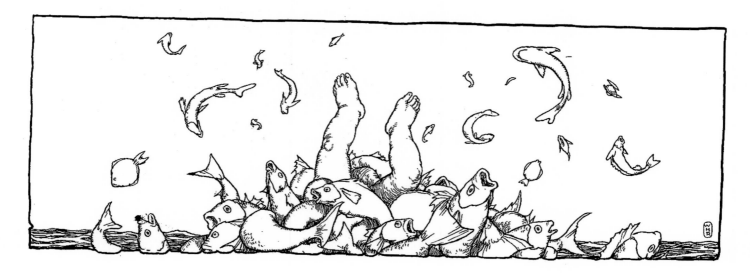

Right: The Little Robber Girl, an illustration for *Andersen's Fairy Tales*, London: Constable & Co., 1913, coloured for exhibition after publication [33].

Opposite: Suddenly a large raven hopped upon the snow in front of her, an illustration for *Andersen's Fairy Tales*, London: Constable & Co., 1913 [32].

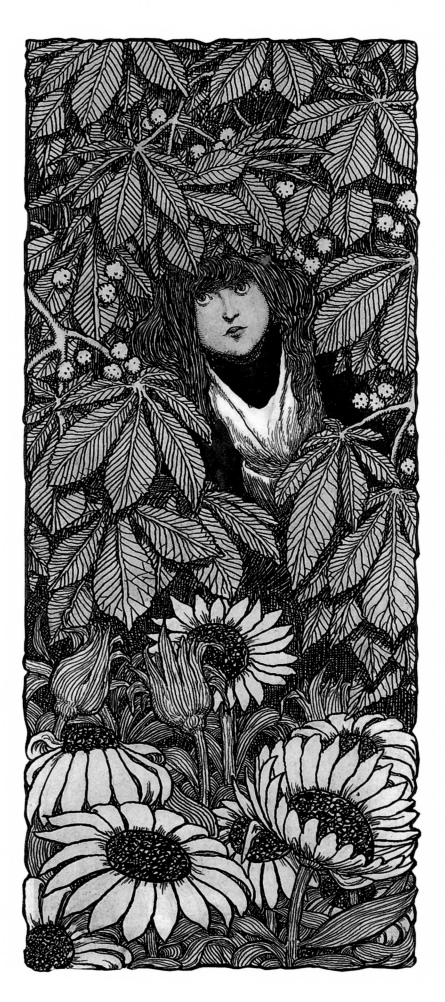

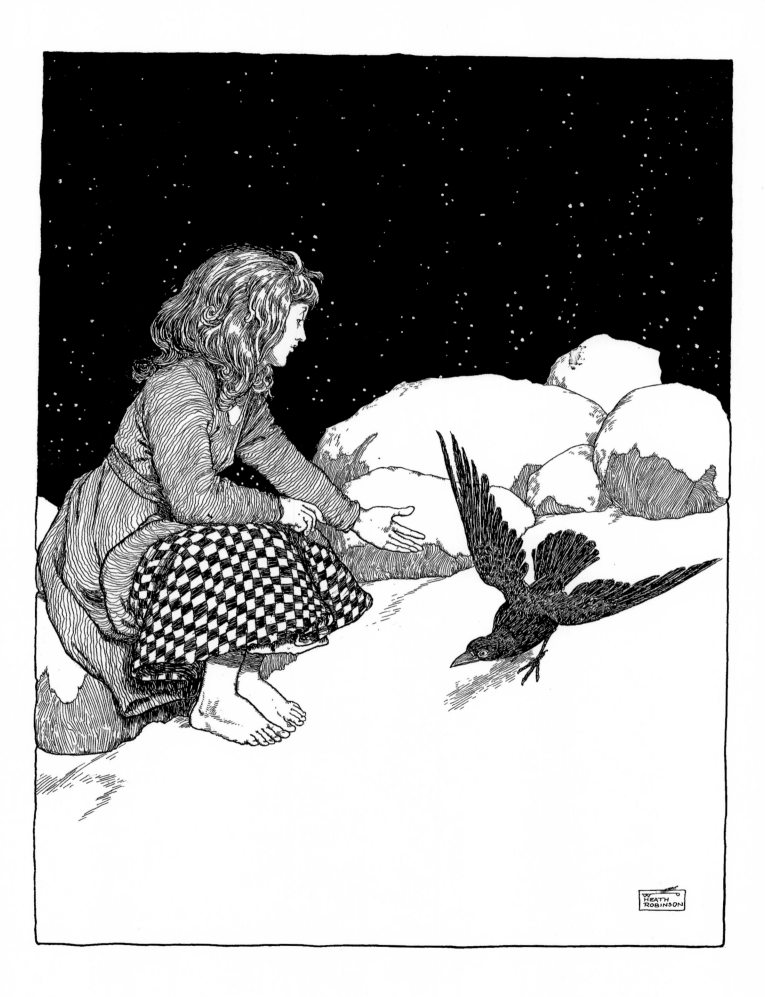

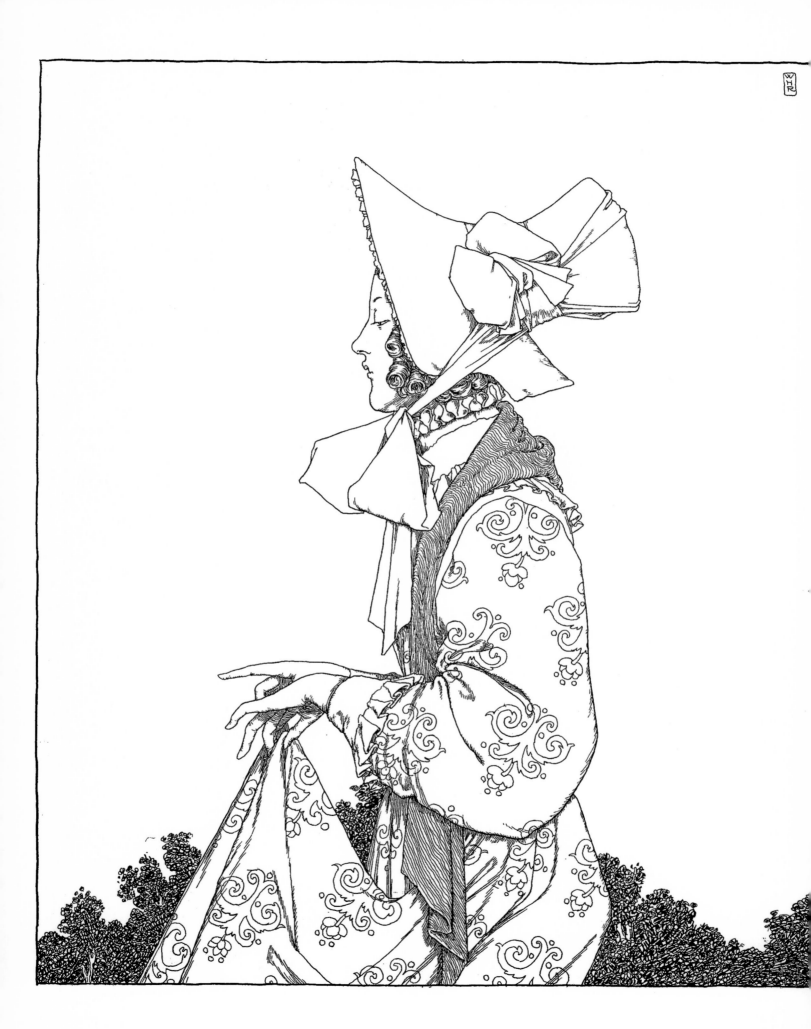

than you?' The roses shake their heads and say 'Elise'. The girl's face has a serene and mystical expression, which contrasts with the severe profile of the peasant's wife sitting in the background reading her hymn book. The whole composition has a mediaeval quality. It is a disturbing picture and the unhappy face of the boy in the bottom corner indicates that he too senses something strange and fey in the air.

The book is one rare occasion on which Heath Robinson's coloured plates are even more successful than his line drawings. The latter are in general less finely drawn than those for *Bill the Minder*. Even so, he had time to try something new and the silhouettes illustrating 'The Marsh King's Daughter' and 'The Emperor's New Clothes' are particularly effective. The decorative element continues in 'The Little Robber Girl', while the drawing of Karen shows a new economy of line. The picture of Gerda with the raven has the black sky of his early decorative drawings, but here incorporated in a more realistic image.

The years from 1910 until the start of the First World War must have been very happy ones for Heath Robinson. He took great pleasure in his garden, and in the society of his neighbours, among whom was the artist Bert Thomas with whom he found much in common and who became a lifelong friend. Among the interests they shared were the countryside, old houses and young children, all of which they had at Hatch End and Pinner. His brother Tom also lived close by and many a pleasant evening must have been spent by the two brothers and their friends in the Queen's Head in Pinner village. This inn with its old oak panels and timbered ceilings was a favourite with them and sported a signboard painted by Tom. They were often joined by friends from London for walks in the surrounding countryside and eventually formed a walking club known as The Frothfinders Federation of which their brother Charles was also an active member.

For his next project, Heath Robinson took the initiative, and submitted some sample drawings to Constable, made up into a dummy book, for an illustrated edition of *A Midsummer Night's Dream*. This met with the publisher's approval, and a contract was signed in April 1913. In his autobiography, he said:

> The old Greek stories of the Wedding of Theseus and Hippolyta; of Pyramus and Thisbe and of life in Ancient Athens as seen through English eyes bewitched me. All of these and their strangely harmonious combination with everything that was lovely, and humorous too, in our English countryside filled me with enchantment. I was ambitious to try to express something of this in my drawings and make them a record of this, the most wonderful moonlight night in fantasy.[24]

He was now forty-one years old and at the height of his powers as an illustrator, and this book was to be his finest achievement. In it he consolidated all that he had learnt during the past eighteen years, in particular the lessons gained in illustrating *The Poems of Edgar Allen Poe*.

As with *Twelfth Night*, Heath Robinson set out to recreate the atmosphere of the play rather than to provide a pictorial record of the action, this time with a subject that gave him greater scope for his imagination. It is the black and white illustrations that dominate the book and they fall into two main groups, the woodland scenes and the drawings of the rustics. In the woodland scenes, Heath Robinson has developed a decorative style of drawing foliage that was first used

Above:'I will move storms, I will condole in some measure', an illustration for *A Midsummer Night's Dream*, London: Constable & Co., 1914.

Opposite: Karen, an illustration for *Andersen's Fairy Tales*, London: Constable & Co, 1913 [34].

24. *My Line of Life*, op. cit.

41

by Beardsley in a number of his drawings for *The Savoy*. Heath Robinson started to refine the technique in the drawings to Poe's poems, whilst his brother Charles had used a similar treatment in one or two of the drawings to Shelley's *A Sensitive Plant* in 1911. In A *Midsummer Night's Dream* the style is refined further and combined with solid black skies and strong foreground patterns of wild flowers or horse chestnut leaves to produce a series of drawings that have great depth and variety of texture. These provide the ideal setting for that 'most wonderful moonlight night in fantasy'.

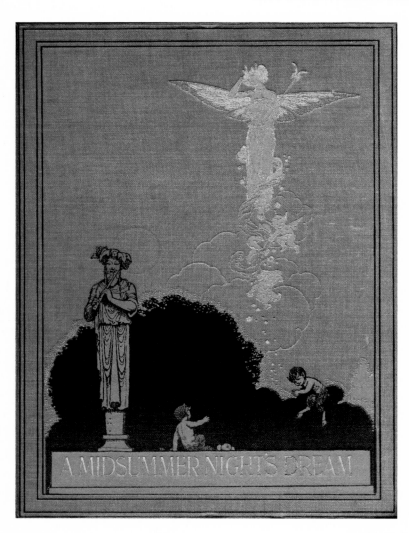

Above: The binding design for the trade edition of *A Midsummer Night's Dream*, London: Constable & Co., 1914.

Opposite: Theseus, 'Now, fair Hippolyta, our nuptial hour draws on apace', an illustration for *A Midsummer Night's Dream*, London: Constable & Co., 1914 [35].

In sharp contrast are the series of pictures of the rustic characters Quince, Snug, Bottom, Flute, Snout and Starveling, who are drawn with great economy of line. There is little or no supporting detail in the background or foreground, in a style that derives from Japanese woodcuts. Each of the characters is a recognisable individual and these drawings perfectly express the gentle rustic humour of Shakespeare's text.

Two other drawings must be mentioned that do not fall into either of the above groups. These are the beautiful illustrations of Titania on the seashore that illustrate the lines 'To dance our ringlets to the whistling wind' and 'Full often hath she gossip'd by my side'. Heath Robinson writing of his first sight of the sea said that he was 'thrilled by the sight of that distant horizon, and the sun shining on a sail far away'. This love of the sea shore remained with him throughout his life and was the setting for some of his best illustrations, such as the drawing to Poe's poem 'Evening Star', and especially these two in *A Midsummer Night's Dream*.

The coloured illustrations are very much an integral part of the book, providing variety of texture and tone, and if anything fulfil a supporting function in the overall scheme. With their subdued colouring and incidental subjects they add to the atmosphere of the book without becoming the focus of attention. The experiments with light that were a feature of the *Twelfth Night* illustrations continue here, as in the delicate frontispiece showing Titania borne by her fairies across the surface of a lake.

The book was first issued in a restrained but luxurious binding of grey cloth blocked with a pictorial design in gold, ochre, mauve, pink and two shades of blue. There was also a limited edition of two hundred and fifty copies on hand-made paper. At the time of first publication it was commonly believed that the First World War would end by Christmas, but as it dragged on over the next four years sales of the book must have been depressed. Heath Robinson considered this book to be his greatest achievement, and when it was published in October 1914, a reviewer described it as:

> The most complete and beautiful specimen before us of an illustrated book as a single work of art.[25]

25. *The Times Literary Supplement*, 10 December 1914.

Illustrations for *A Midsummer Night's Dream*, London: Constable & Co., 1914.

Right: Half Title for Act II [37].

Opposite: Lysander '...and she, sweet lady, dotes, Devoutly dotes, dotes in idolatry, Upon this spotted and inconstant man' [36].

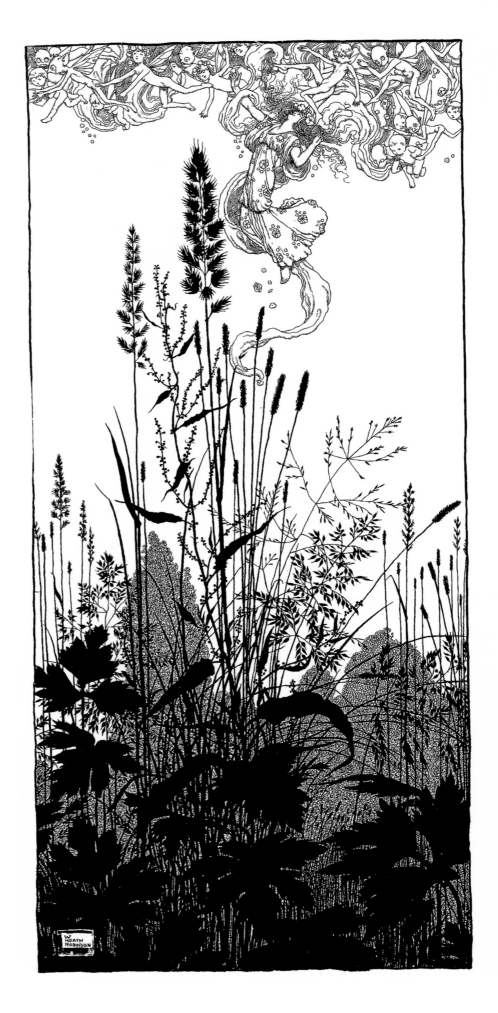

44

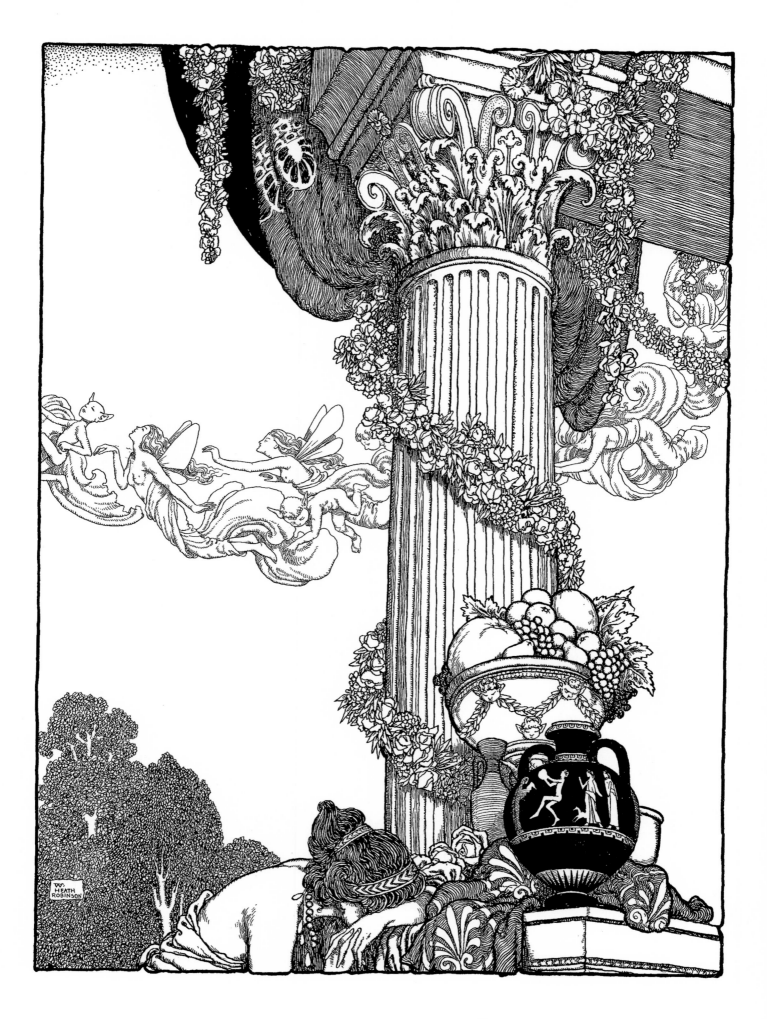

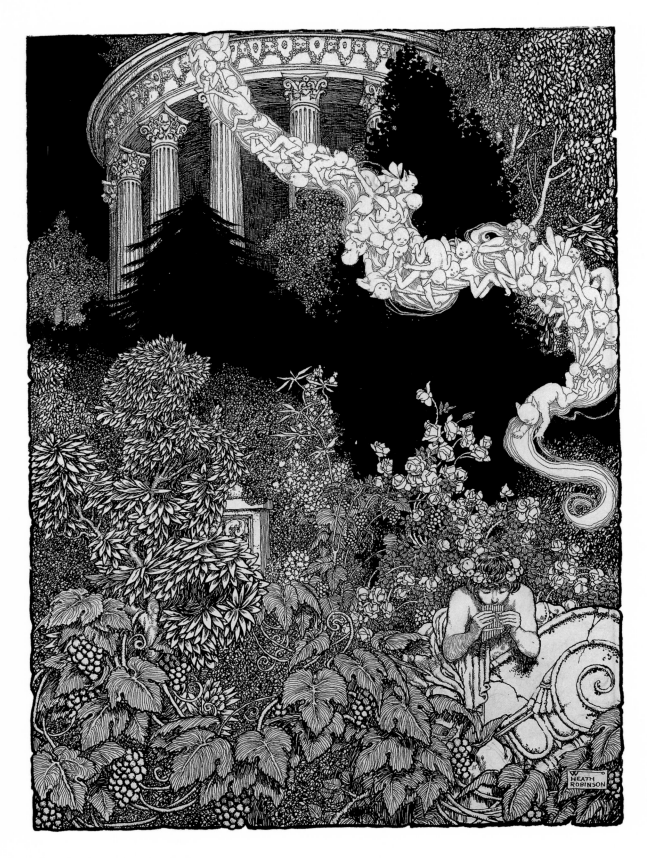

Illustrations for *A Midsummer Night's
Dream*, London: Constable & Co., 1914.

Above: Titania, 'Playing on pipes of corn,
and versing love to amorous Phillida' [38].

Opposite: Demetrius, 'Thou runaway, thou
coward, art thou fled' [39].

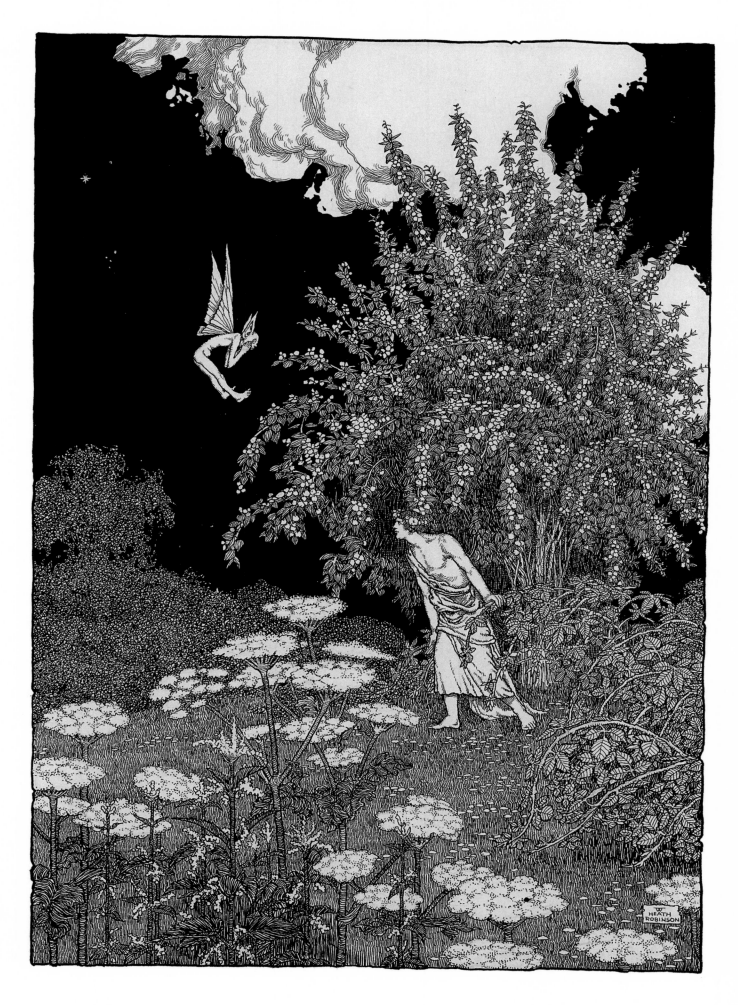

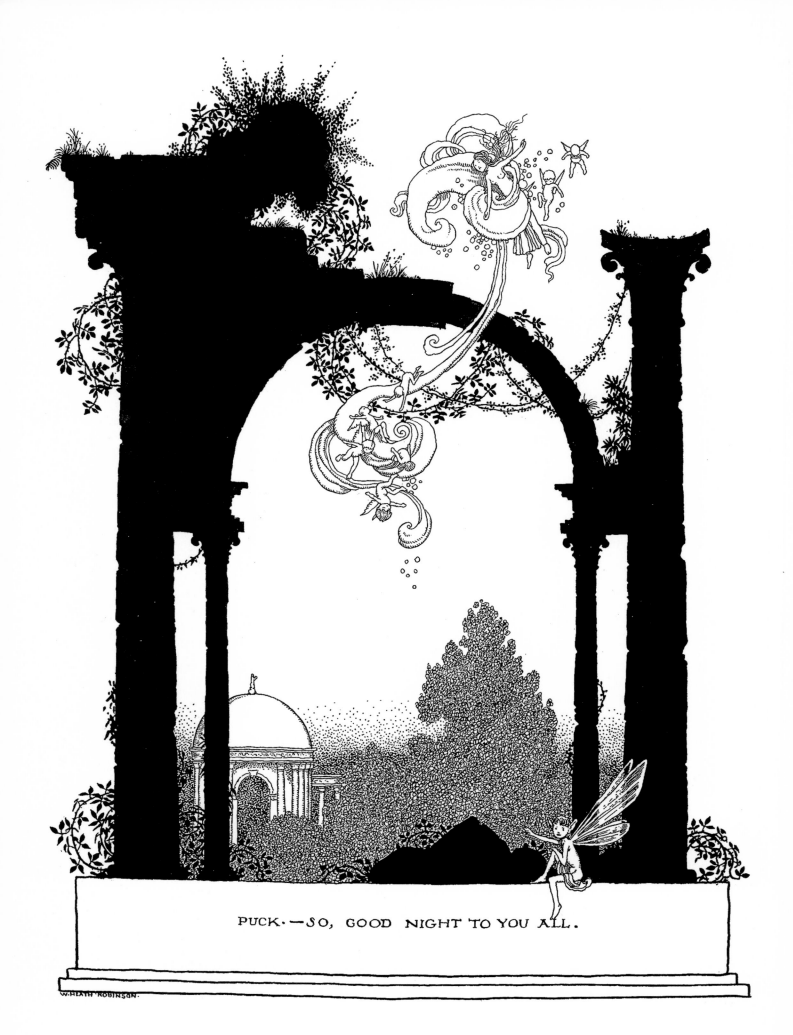

PUCK. — SO, GOOD NIGHT TO YOU ALL.

War service – WWI cartoons and collections

Although Heath Robinson illustrated children's books for Constable after 1914, the onset of the war had spelled the end of the deluxe gift book. He wrote that even in the autumn of 1914:

> Publishers were beginning to restrict their enterprise within narrower channels, and these were all connected with the war. There was now no demand for purely artistic productions, for new editions of Shakespeare or other classics, unless they bore some connections with the all-absorbing topic.[26]

If the onset of war reduced his employment as illustrator, it greatly increased the demand for his comic drawings. As early as 1909 he had drawn a series of cartoons for *The Sketch* called 'Am Tag' prompted by current reports that a German invasion was imminent. The first six drawings showed various ways in which the German army might try to enter Britain covertly, whilst the remainder show how the Territorial Army, by various subterfuges and inventions, would overcome the invading force. Thus, when the war really started in 1914, Heath Robinson had already demonstrated his ability to counter, by the application of gentle satire and absurdity, both the pompous German propaganda and the fear and depression engendered by the horrors of war. What better antidote to the stories of 'baby-eating Huns' than Heath Robinson's drawing of portly Bavarians in bathing costumes and helmets attempting to block the Gulf Stream. Our sappers are shown digging their tunnels not to plant massive bombs under the enemy's trenches, but to steal his supper beer! Battles are fought not with machine guns and grenades, but with such weapons as the button magnet or the 'tachobomb', and with cylinders of laughing gas.

Heath Robinson's wartime cartoons had a wide circulation in the pages of *The Sketch, The Illustrated Sporting and Dramatic News,* the *Strand Magazine, Pearson's Magazine* and *London Opinion* and were extremely popular with both servicemen and civilians. He was inundated with letters suggesting additional subjects for his series of inventions under the heading 'BRITISH PATENT (applied for)', asking for pictures to decorate the walls of the mess or wardroom, or just thanking him for providing some relief from the horrors of the front. One letter was written from 'Observation Post Heath Robinson' that was close to the front line and often strafed by the enemy. The occupants asked for some reading material to relieve the tedium of their off-duty hours spent miles from any organized recreation. Another writer informed Heath Robinson that an aero-engine testing machine at the Royal Aircraft Factory had been named after him. Typical is the following letter, from a member of the British Expeditionary Force dated 6 November 1916:

> Dear Heath Robinson,
> Your 'Some Frightful War Pictures' has just reached our mess within the last few days & you can have no idea how much your illustrations are appreciated out here. All members of this mess have been 'at it' since the very beginning so your sketches in the various magazines etc. have always been a source of great amusement to us.
> It is a general opinion that one of your future inventions will result in the decisive blow for victory, so keep out of the way of 'Zepps' until you have arrived at it. Pending this, would you be good enough to demonstrate to us by means of your wonderful sketches:
> I. 'How to extricate a broken down motor lorry from a ditch or shell hole'
> II. 'A 'quick & easy' method for offloading ammunition from motor lorries at gun pits, under shell fire.' Your ideas would I'm sure be of great service to this branch of the Army & our mess will be everlastingly indebted to you.
> Thanking you in anticipation and trusting to hear, at an early date, that your second volume of 'Frightful' is in the hands of the Printers.
> I remain,
> Yours sincerely,
> T S Jackson, Capt. ASC (MT) 14[27]

Opposite: Puck, 'So, goodnight unto you all', an illustration for *A Midsummer Night's Dream*, London: Constable & Co., 1914 [40].

26. *My Line of Life*, op. cit., p. 146.

27. Letter from Captain T S Jackson to W Heath Robinson, 6 November 191, William Heath Robinson Trust Collection.

Opposite: German breaches of the Hague Convention – Huns using siphons of laughing gas to overcome our troops before an attack in close formation, published in *The Sketch*, vol. 91, p. 139 (August 1915) and in *Some Frightful War Pictures*, plate XXIII [87].

Some Frightful War Pictures was a collection of war cartoons from *The Sketch* and *The Illustrated Sporting and Dramatic News* published by Duckworth in 1915. It was followed a year later by a similar collection called *Hunlikely*. Following the success of these collections Heath Robinson prepared a book of original line drawings called *The Saintly Hun: A Book of German Virtues* for 1917. The book was a masterpiece of understated satire whose tone was summarised in the opening lines of his introduction:

> It cannot fail to be apparent that in the course of the last year or so a certain acerbity has insinuated itself into public utterances in this country having reference to our great Teutonic neighbours. It is in the hope not only of checking this lamentable tendency, but in some degree of mitigating the insidious poison which it disseminated, that I have the temerity to place before the British public, this collection of drawings.

Many of these delightful drawings were produced in a style similar to that used for *Peacock Pie* whilst the remainder are in silhouette. The picture of 'Charity' is typical. The absurdity of the kind-hearted Prussian officer giving his clothing to a Belgian peasant is heightened by the amazement on the face of the peasant and the disdain of the two young children in the background.

Obvious subjects for the 'Heath Robinson' treatment were the early aeroplanes and airships, and in the later years of the war, *Flying* magazine commissioned a series of cartoons. These pictures gave the artist the ideal opportunity to combine his mechanical contraptions with his wartime satires. They also gave him a chance to draw landscape from an elevated viewpoint, showing small figures in foreshortened perspective, looking up in amazement, which he often used to good effect in succeeding years.

In 1918 Heath Robinson made his only journey overseas when he was asked by an American syndicate to make drawings of the US troops in France. He first visited the port of St Nazaire, where the majority of the US force disembarked, and while he was sketching on the quay an over-zealous policeman arrested him as a spy. The incident had a happy conclusion as Heath Robinson related:

> Instead of the fierce officer I expected to behold I was greeted by a most suave gentleman, who was full of profuse apologies, which he delivered with Gallic fervour for all the indignity and inconvenience I had been subjected to. He at once wrote out the permission I had neglected to obtain and I was free.[28]

After three days spent at St Nazaire he went to Paris where he stayed for two weeks. He was taken on some trips by the US forces to their battle front in Old Lorraine, but could not manage to obtain the necessary permits from the French for all of the visits that he had planned. One permit, applied for on the 8 May was not issued until 19 June, three weeks after his return to England. The resulting drawings show the US forces, in their distinctive 'scout' hats, as a highly mechanised force with all manner of gadgets. A number of the pictures were published in *The Sketch* after the armistice under the title of 'War Inventions Not Needed'.

28. *My Line of Life*, op. cit., p154.

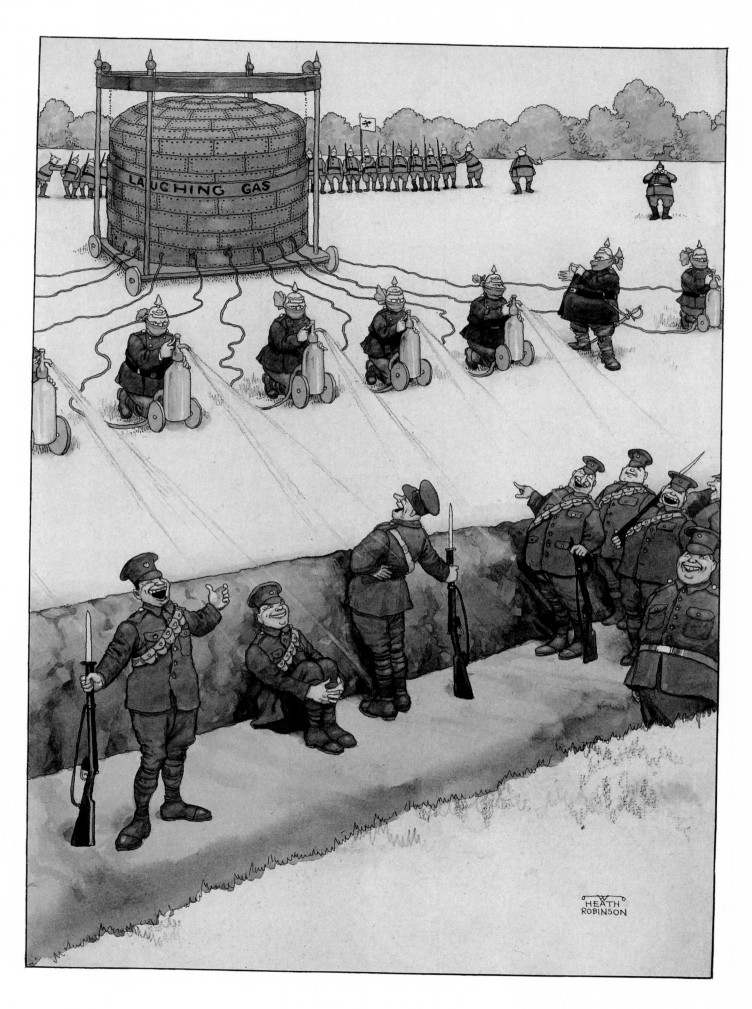

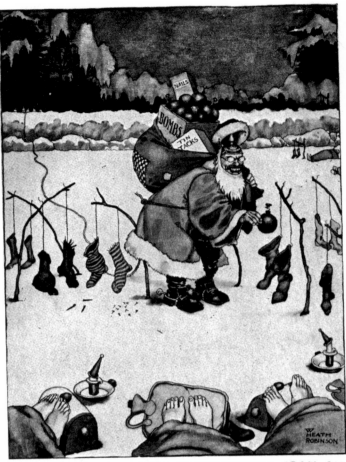

WISHING·YOU·THE·BEST·OF·EVERYTHING·FROM·ALL
RANKS·OF·THE·3?·DIVISION· XMAS 1915

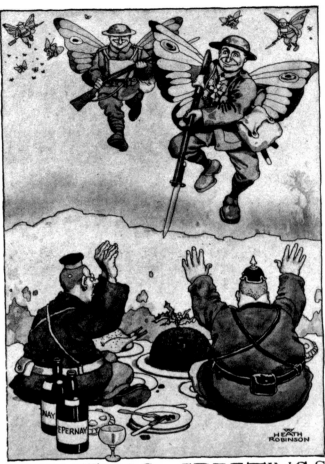

CHRISTMAS GREETINGS
FROM THE 19ᵀ DIVISION

Above: Designs for Christmas cards for the 3rd Division in 1915 and for the 19th Division in 1918.

Opposite: 'On they went', an illustration for *The Water Babies*, London: Constable & Co., 1915 [43].

Divisional Christmas cards

Amongst the requests that Heath Robinson received from soldiers at the front were letters asking him to provide Christmas card designs for particular formations. In 1915 he designed a card for the 3rd Division. This was titled 'The kind of Santa Claus we may expect on Christmas Eve'. It showed a German soldier with a Father Christmas coat draped over his uniform, and an evil grin on his face, dropping bombs into the stockings of sleeping British soldiers. The card was printed in half-tone in postcard format. It proved extremely popular and the 30,000 copies that were printed proved too few to meet the demand for them.

A second card design that he made in 1918, this time for the 19th (Western) Division, was printed by photogravure in the more traditional folded format, but with a small drawing on the front and a larger picture inside. Its design was even more surreal than the first. On the front was a small vignette of a British 'Tommy' with butterfly wings on his back carrying a large Christmas pudding. Inside was a full-page picture showing more British soldiers with butterfly wings descending through the air to surprise a pair of stout German soldiers who are eating their Christmas dinner. The British soldiers are grinning, while the Germans throw up their hands in surrender. The explanation for these bizarre images is that the divisional sign of the 19th Division was a peacock butterfly. Few other artists could have used this fact to such startling effect.

Illustrations for *The Water Babies*,
London: Constable & Co., 1915.

Above: 'There are Land Babies – then
why not Water-Babies?' [41].

Opposite: 'There would be a New
Water-Baby in St Brandan's Isle' [42].

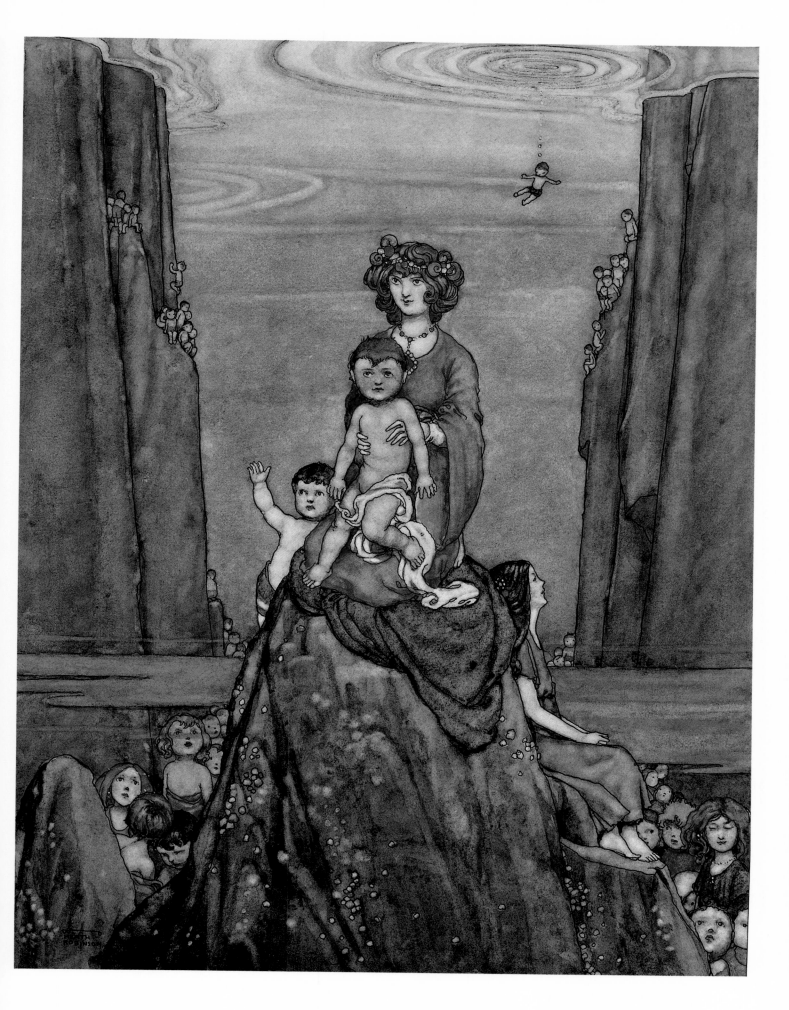

Illustrations for *The Water Babies*,
London: Constable & Co., 1915

Above: When all the world is
young, lad [45].

Opposite: Trudging along with
a bundle on her back [44].

Illustrations for *The Water Babies*,
London: Constable & Co., 1915.

Above: 'The first thing which Tom saw
was the black cedars' [47].

Opposite: 'Thou Little Child' [46].

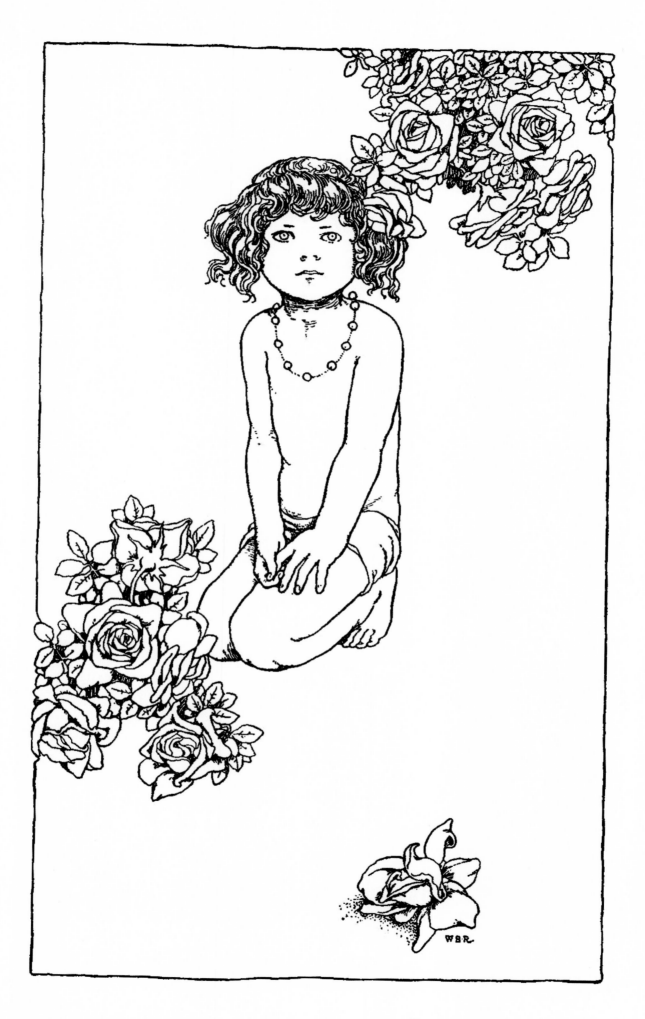

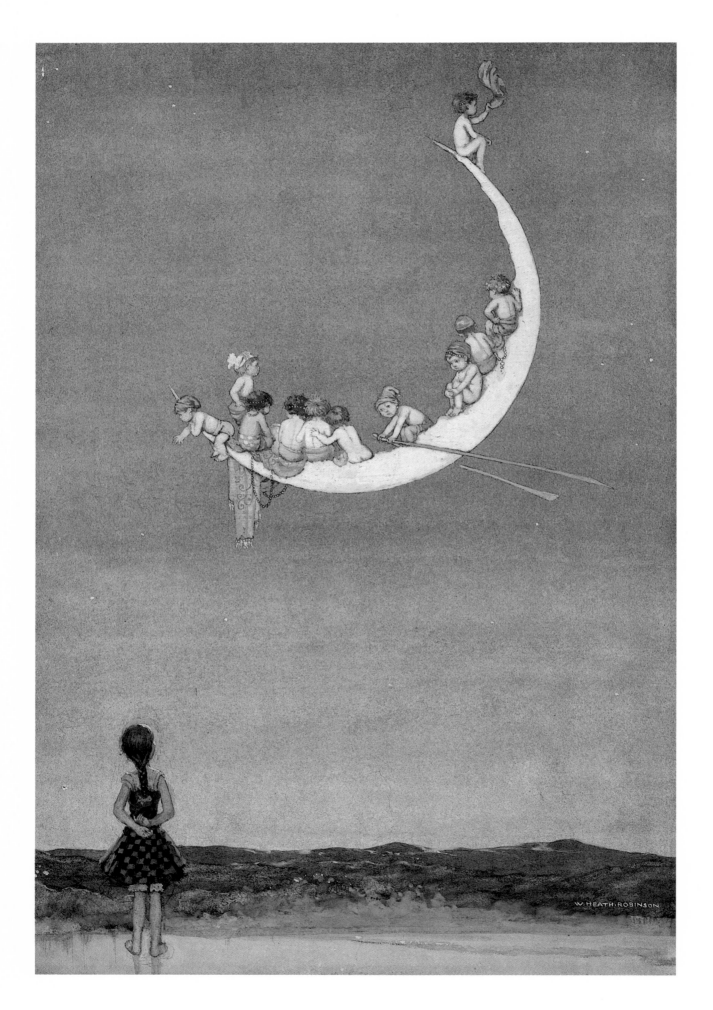

More work for Constable – Water Babies and Peacock Pie

On the same day that Heath Robinson contracted to illustrate *A Midsummer Night's Dream* he also signed a contract to illustrate Charles Kingsley's story of *The Water Babies* for Constable. It was an obvious choice, following on from the illustrations to 'The Little Mermaid' in *Andersen's Fairy Tales*. The girl with her bundle on her back is identifiable with the Gerda from Andersen's story of 'The Snow Queen' and the old dame who takes pity on Tom early in the story is one with Karen's mother in 'The Red Shoes', and he once again makes effective use of silhouettes.

It provided him with an opportunity to portray two of his favourite subjects, children and the sea. These elements had previously been combined in the stories of 'The Wild Swans' and 'The Little Mermaid' in Andersen's tales. There is, however, an element of absurdity in the Kingsley story that was absent from Andersen, and which acts as an antidote to its more mawkishly sentimental episodes. Heath Robinson was the right illustrator to exploit this aspect of the book without dispelling its atmosphere of fantasy and mystery. His skill in deploying areas of solid black and white on a page to provide a satisfying abstract design, at the same time as achieving a moving illustration, is clearly seen. Pictures such as 'The first thing which Tom saw was the black cedars' draw heavily on the decorative tradition of the Japanese that so inspired Heath Robinson's generation of artists.[29] The gentle beauty of drawings such as the one showing Tom being guided through the water by the fairies is juxtaposed with the absurd giant with 'a great pair of spectacles on his nose' or the slapstick comedy of the diving figure in 'The End'.

Commissioned at the same time as *A Midsummer Night's Dream, The Water Babies* was probably intended to be published in a lavish gift book format like *Hans Andersen's Fairy Tales*, but by the time it came to press, war had broken out and it was reduced to a more modest octavo volume.

The format of Heath Robinson's next book for Constable was even more limited by wartime restrictions. This was Walter de la Mare's *Peacock Pie*, which had a single coloured plate for the frontispiece and one black and white illustration to each poem. Because of the poor quality of the available paper, these had to be in line. The limitations of medium inspired him to even greater heights of imagination and inventiveness in this exquisite set of drawings, whilst the abstract nature of some of the poems gave him ample opportunity to exercise his love of decorative design. The style of drawing has developed from *A Midsummer Night's Dream* with a strong emphasis on texture and pattern to produce a series of illustrations that echo the simplicity and rhythm of de la Mare's verse. Variety is achieved by varying the size of the drawings, the density of line and the shape of their outline, and some of those with circular frames, such as 'The Song of Finis' are particularly attractive. The book is in the tradition of illustrated children's poetry books started twenty years earlier by his brother Charles with his designs for *A Child's Garden of Verses* and *Lullaby Land,* and must have influenced those artists who followed such as E H Shepard illustrating *When We Were Very Young* by A A Milne.

There is one wonderful unpublished illustration that might have been made for *Peacock Pie* and included in the book had circumstances allowed. It is called 'The Moon's First Voyage'. Both the jagged new moon and the girl with her single plait appear in the book several times. The babies with their pearls and rich fabrics are similar to those depicted in a picture that was shown at the second exhibition of the Society of Humorous Art at the Goupil Gallery at Christmas 1913. That picture shows an Indian peddler with his wares, a selection of babies, displayed for sale on a tray.

Above: Cake and sack, an illustration for *Peacock Pie* by Walter de la Mare, London: Constable & Co., 1916 [48].

Opposite: The Moon's First Voyage, an unpublished illustration circa 1916 [49].

29. See for example Simon Houfe, *Fin de Siecle*, London: Barrie & Jenkins, 1992, pp. 3–4 *et seq.*

Fairy tales from many lands – work for the *Strand Magazine*

Anyone who, in December 1914, was looking for interesting and varied reading material and had a shilling to spend could hardly do better than to invest in the 'Grand Double Christmas Number' of the *Strand Magazine.* This consisted of two hundred pages of text and pictures as well as eighty pages of advertisements. Inside he would find the latest episode of 'The Valley of Fear' by A Conan Doyle and 'Parted Ways' by P G Wodehouse, the latter illustrated by Alfred Leete. There were other stories by such authors as Edgar Wallace and W W Jacobs and an article explaining how a process block was made, illustrated with photographs of the *Strand's* own equipment. For children there was a story by Norah M Craggs called 'The Death of Rancing Roarer' which was illustrated with four fine line drawings by Heath Robinson.

The first art editor of the Strand Magazine was W H J Boot, who held the post for twenty years from 1891 to 1910. He had become acquainted with Heath Robinson in 1908, when he published a series of comic drawings under the title 'Why I am Not a Criminal' that featured such characters as 'the kind-eyed winkle-pilferer of Paddington Green'. He was followed by his son J Sydney Boot of whom Heath Robinson said:

> ... I was always pleased to feel that he had a kindly interest in me and my work. It seemed that he extended his kindness to all he dealt with and little enough to himself; I, and many another artist too, lost a friend when he died.[30]

Sydney Boot was perceptive enough to see in Heath Robinson the ideal illustrator for the *Strand Magazine's* children's stories and during 1915 and 1916 Heath Robinson and H R Millar shared them equally. Unfortunately, from 1917 onwards children's stories were no longer a regular feature of the magazine and Heath Robinson illustrated only two more, one in 1917 and one in 1918. Whilst he continued to contribute both comic drawings and illustrations to the magazine over the years, a wonderful series of fairy story illustrations came to an end.

In all, he provided illustrations to a total of fourteen children's stories in the *Strand*. They were executed with great care and attention to detail. In subject they present an ideal combination of fantasy and humour, whilst in execution they are a blend of all the best elements in the last four books that he had illustrated. The compositions show great originality, freeing themselves entirely from the constraints of the page format and spreading at will across one or two pages, leaving the text to find space around them. The high standard set in the first of the stories was maintained throughout and taken as a whole they represent one of his finest achievements in the field of fairy tale illustration, possibly even surpassing the drawings for *Bill the Minder*. It seems that the combination of a good, unfamiliar story with a limited requirement to make two, three or four drawings at a time inspired his best work.

The drawings to 'How the Sea Became Salt', a Norwegian fairy story, are typical. The first of them, which occupies three-quarters of the first page of the story, shows a poor farmer meeting 'an old man who had a long white beard' who was to change his life. They are observed by a small goblin that is sitting on a rock, while in the background is an enchanter's castle. The second drawing, which extends diagonally across two pages, shows the farmer negotiating with the imps who inhabit the enchanter's castle for a magic coffee grinder. This drawing in particular, with its procession of 30 tiny figures tumbling across the double page opening, is a masterly invention that must have fascinated young readers of the story. A third drawing shows the farmer's rich brother, who has bought the coffee grinder, being submerged in the flow of milk, soup and herring that he has wished for and now cannot stop.

Many of the stories that H R Millar illustrated for the *Strand* were reprinted in books such as *The Silver Fairy Book* or *Queen Mab's Fairy Realm*, but no such happy fate awaited Heath Robinson's work. Instead, most of his pictures were used to illustrate stories in *Playbox Annual* for the years 1917 to 1922, many of them illustrating stories other than the ones for which they were intended. They were badly reprinted, some of them in pale colours and in many cases the carefully designed relationship between drawing, text and overall page size has been completely lost. Sadly, when Hamlyn reprinted the drawings in *The Heath Robinson Illustrated Story Book* in 1979 they used the *Playbox Annuals* as their source and the book by no means does justice to the originals. It also omits some of the best of the drawings from the *Strand*, such as the illustrations to the Japanese story 'The Ogres of Ojejama' or the illustration of the 'Sea Goblins' from the story of the same name. In the latter case the other two pictures that Heath Robinson made for the story are used to illustrate the much inferior tale of 'The Greedy Boy and the Princess'. No doubt sea goblins and ogres were thought to be too frightening for the young readers of *Playbox Annual*.

30. *My Line of Life*, op. cit., p. 110.

Opposite: Seated man with pipe, 17th century dress (probably a 'Sketch Club' sketch) [107].

A move to Cranleigh

In the spring of 1918 Heath Robinson and his family moved from Pinner to Cranleigh, a small town in the heart of the Surrey countryside. The move was made, he said, to enable the whole family to banish the frightfulness of the war in all its forms from their minds and to lead peaceful country lives.[31] It was there, in 1919, that his youngest child, Tom, was born. The three older boys went to Cranleigh School, which was founded in 1863 and was one of the better minor public schools, while his daughter Joan attended St Catherine's School in nearby Bramley. They were all day pupils and so the pattern of family life was not disrupted by one or other member departing for boarding school. Heath Robinson was a shy and simple man, closest to his children while they were still young and so the ten years they spent at Cranleigh after the First World War were among their happiest.

With this move, Heath Robinson became more cut off from the general run of the London art and publishing world and therefore reliant on his agent A E Johnson to find commissions for him. Fortunately postal communications were reliable and rapid and it was mainly by this means that the two kept in touch. However, he was not completely isolated from the society of his fellow artists. When he first moved to Cranleigh, Lawson Wood was living there and Bertram Prance had a house in the nearby village of Rudgewick. Both Bert Thomas, who had been a neighbour in Pinner, and Alfred Leete had children at Cranleigh School and so frequently had occasion to visit, and H M Bateman would come over from his house in Reigate.

Another regular means of contact with other artists was through his two clubs, The London Sketch Club and The Savage. The London Sketch Club had been formed at the beginning of the century and provided a place where members could meet each Friday, partly to enjoy good food, drink and congenial company, but more importantly to fulfil the function suggested by the name of the club, the practice of rapid memory sketching of given subjects. Walter Churcher, writing in *The Studio* magazine in 1915 said that the club kitchen produced 'steak puddings and roast sirloin having no rivals save at 'The Cheese' and 'Simpsons''.[32] To judge from the list of members at that time, which included John Hassall, Cecil Aldin, Claude Shepperson, Harry Rountree, Edmund Dulac, H M Bateman, G E Studdy, Willy Pogàny and many other fine artists, the sketching must have been of an equally high standard. Heath Robinson had been elected a member in 1910, soon after he gave up his London studio and moved to Pinner, having been proposed by Frank Reynolds and seconded by his agent A E Johnson.

He became a member of his second club, The Savage, in 1924, having been proposed by Bert Thomas. This was an older club that had been founded at the suggestion of George Augustus Sala in 1857. Membership was limited to professionals in the categories of Literature, Art, Drama, Science and Music. A sixth category, Law, was added in 1956. The main activity of the club was to organise a series of Saturday Suppers that took place during the winter and spring months. For each supper one of the members took the chair and often there would be a guest of honour. Each occasion was marked by a souvenir menu card, usually drawn by one of the artist members, and many of the originals of these are stored in a large Tibetan wine cooler in the club. They include a number by Heath Robinson, the earliest of which dates from 1911, some thirteen years before he became a member. Another, from 1938, marked a dinner at which the eminent scientist, Sir James Jeans, was the guest of honour. He was so delighted with the menu card, which showed an early attempt to split the atom with 'Heath Robinson' machinery, that he asked the artist to let him have the original, promising that it would find an honoured place in his room. Similar cards were also produced for Sketch Club functions and Churcher reproduced one by Heath Robinson for a 'smoking conversazione' on 4 December, 1913 which

31. *My Line of Life*, op. cit.

32. *The Studio*, January 1915, vol. 63, pp. 243–55.

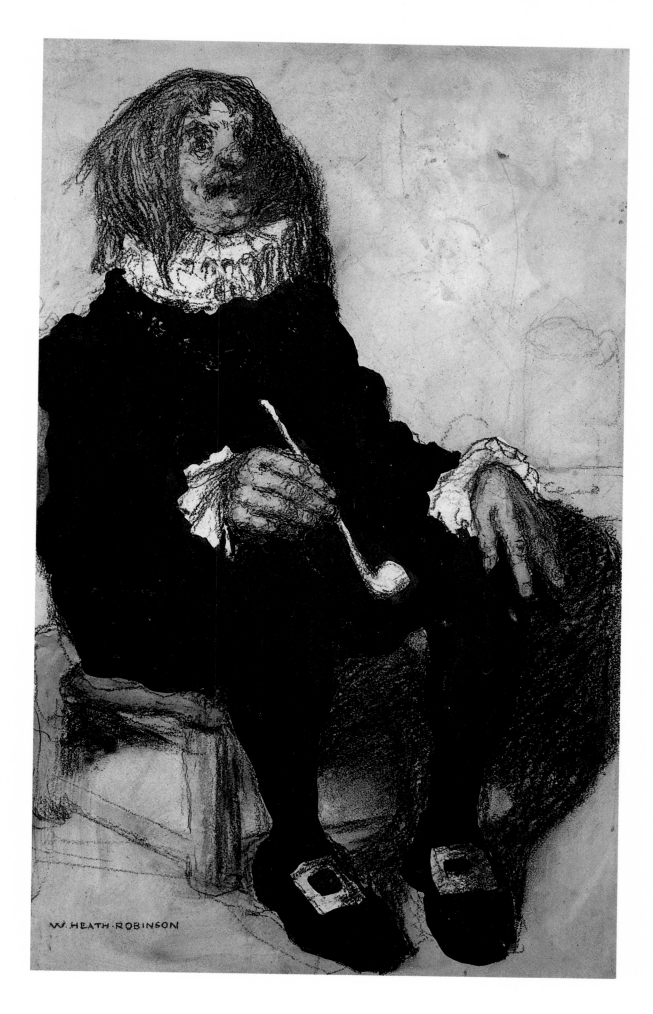

Left: A headpiece for *The Merry Wives of Windsor* from the Cape *Shakespeare* [55a].

Below: Falstaff deposited in the Thames, an illustration for *The Merry Wives of Windsor* from the Cape *Shakespeare* [55b].

Opposite: Landscape with tall tree and haystack, watercolour painted near Cranleigh [109].

shows an artist being tempted by Pan with a pipe in one hand and a foaming tankard in the other.

The Jonathan Cape *Shakespeare* drawings

One of the first commissions that A E Johnson secured for Heath Robinson soon after his move to Cranleigh was from the newly formed publishing house of Jonathan Cape. It was for over four hundred drawings to illustrate a new edition of the complete *Works of Shakespeare*. Work on the project had started by January 1921, when Cape took a number of the drawings to America in the hope of finding a publisher there with whom he could share the cost. By the end of 1921 the commission was not completed, although the four hundred drawings originally contracted for had been delivered and A E Johnson reported that Cape and his partner Wren Howard were delighted with them. In February 1922 a further consignment of drawings was delivered and at the beginning of March Heath Robinson received £200 on account for the work to date.

The precise format in which the edition was planned to be published is not clear, but there are a few pointers to aid speculation. A request from Cape for a drawing on every page was rejected because it would have required upwards of 3000 drawings. This implies either a set of eight to twelve volumes each containing several plays, or a set of about forty slim volumes with a single play or group of poems in each. What little evidence remains seems to favour several plays per volume. In a letter to Heath Robinson, Cape mentions that he would like a full-page illustration to face the opening of each play, a choice of words that implies more than one play to a volume. Another letter from Howard requests that the pictures that were to run down the sides of the pages should be drawn in pairs with the same dimensions so that they could be reduced on a single block. They were to be reduced to one and a half inches width, implying a page size larger than might be expected if each play was to be published in a separate volume.

The illustrations made during 1921 were wholly in line, but in March 1922 a letter from Howard mentioned proofs he had made of some coloured illustrations. In May A E Johnson noted that the last two coloured subjects had been sent to Cape. It therefore appears that by this time the project had become even more ambitious and costly. The illustrations were finally completed in June 1922, but either because of lack of funds, or because of the declining market for illustrated books the edition was never published. It was not until the publishing house moved office in 1991 that a number of the original illustrations were discovered. These included three watercolours and over 650 line drawings.

They are particularly interesting for the insight that they provide into the development of Heath Robinson's style and approach to illustration at this time. As he had demonstrated earlier, with books such as *Rabelais* and *Poe's Poems*, he was capable of adapting his style of drawing to the subject at hand. In the complete works of Shakespeare he was presented with subjects ranging from bawdy comedy to high drama, and from tender romance to brutal violence. He was also presented with a severe challenge by the scale and format of the project. His response is illustrated here with a small selection of the surviving drawings. He reaches back into the store of images used during the previous 25 years, but also develops completely new styles as the subjects demand.

The plays that involve Falstaff and his retinue of common characters offer an ideal opportunity to develop further the style of drawing developed for the

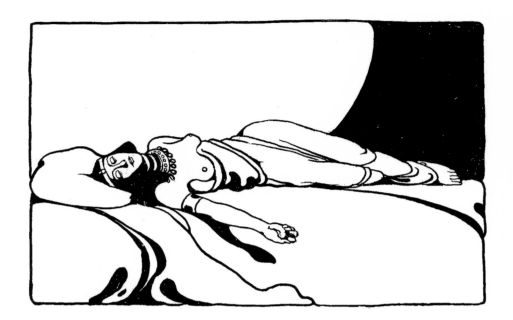

rustics in *A Midsummer Night's Dream* seven years earlier. The figure of Mouldy in *Henry IV Part II* follows directly from that group, while the potman calling back over his shoulder harks back to the *Arabian Nights* drawings of 1899. His mastery of both expressive gesture and facial expression is given full scope.

The second group of drawings, from the History plays, shows another side of Heath Robinson's art. In illustrating *Rabelais* he had ample opportunity to explore nightmarish visions and horror, but in his drawings for the History plays he shows his capacity to depict pure evil in the two assassins from *Richard III,* or the macabre in the head on a pike from *Henry VI.*

Perhaps the greatest revelation is the highly simplified, decorative, lyrical style of drawing that he seems to have developed for this project. Whether applied to landscape, as in the pair of images of trees to decorate *As You Like It*, or to figures as in *Cleopatra* or the assassination scene from *Julius Caesar*, it combines an almost abstract sense of pattern with a powerful dramatic impact that is ideally suited to both subject and format. Whether the shift in style resulted from a conscious decision to make his work look more modern, from a need to produce drawings more quickly, or was merely a response to the subject matter we cannot know. It was probably a combination of all three. Looking for sources of inspiration, one turns to the work of Edward Gordon Craig and William Nicholson, but they rarely captured the sense of fluid movement that Heath Robinson achieves in the best of the drawings for the Cape *Shakespeare*.

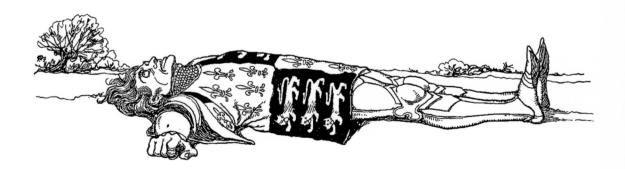

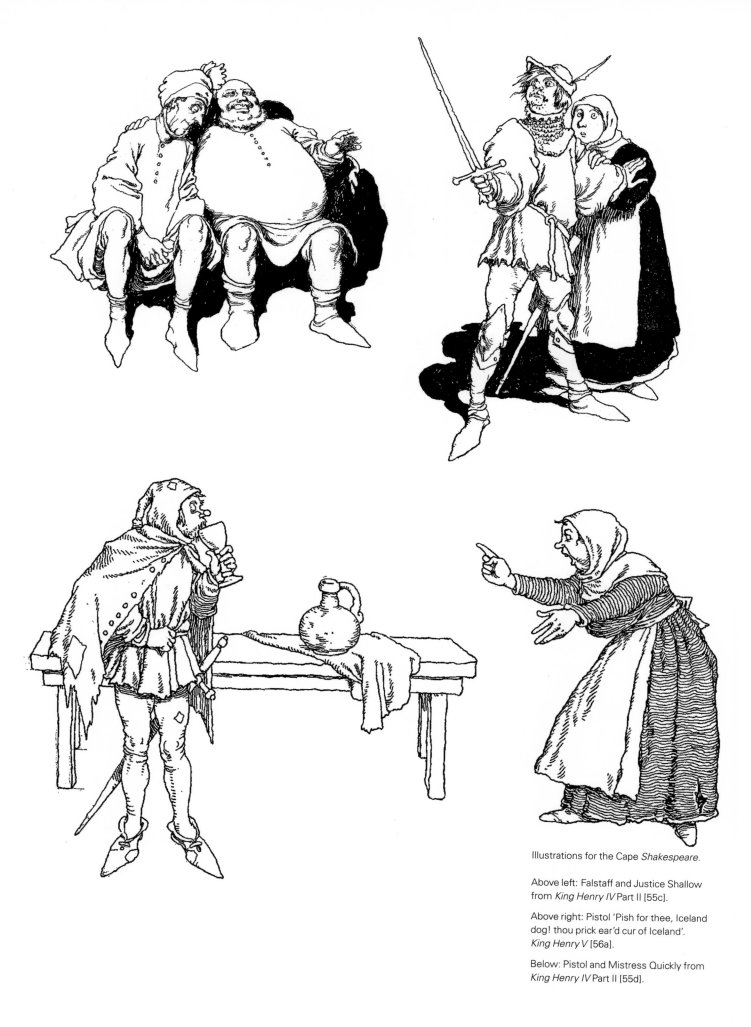

Illustrations for the Cape *Shakespeare*.

Above left: Falstaff and Justice Shallow from *King Henry IV* Part II [55c].

Above right: Pistol 'Pish for thee, Iceland dog! thou prick ear'd cur of Iceland'. *King Henry V* [56a].

Below: Pistol and Mistress Quickly from *King Henry IV* Part II [55d].

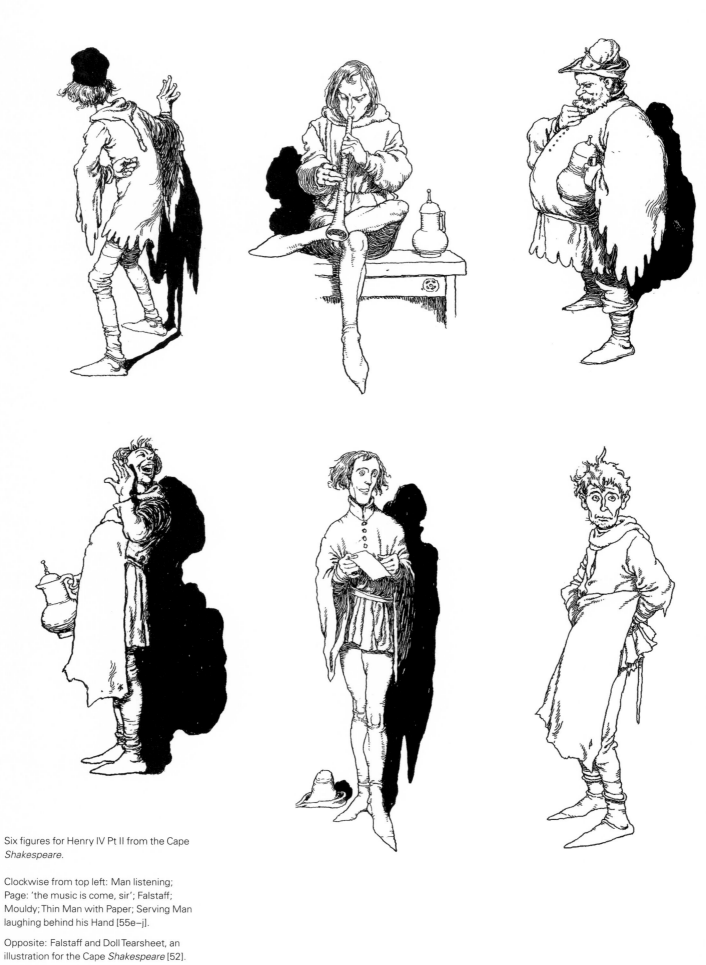

Six figures for Henry IV Pt II from the Cape
Shakespeare.

Clockwise from top left: Man listening;
Page: 'the music is come, sir'; Falstaff;
Mouldy; Thin Man with Paper; Serving Man
laughing behind his Hand [55e–j].

Opposite: Falstaff and Doll Tearsheet, an
illustration for the Cape *Shakespeare* [52].

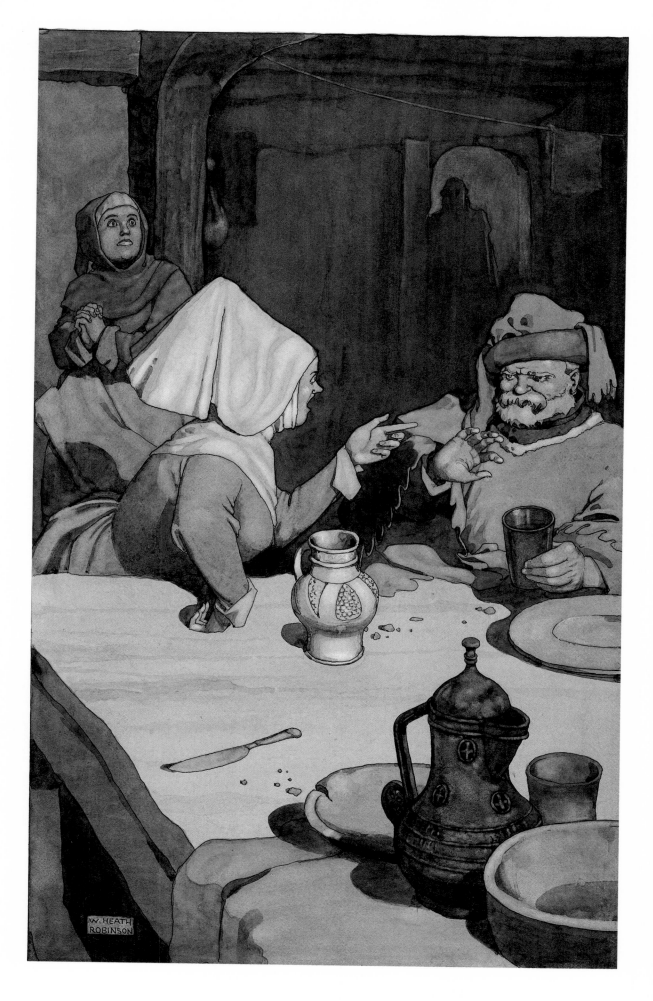

A group of drawings for the History Plays from the Cape *Shakespeare*.

Clockwise from top left: *King John*, Ruffian's Head; *King John*, Old Man's Head; *Henry VI Part III*, Head on a pike; *Richard III*, The Assassins; *Henry V*, Glowering Man [56c–g].

Opposite; Prospero and Miranda, an illustration for the Cape *Shakespeare* [51].

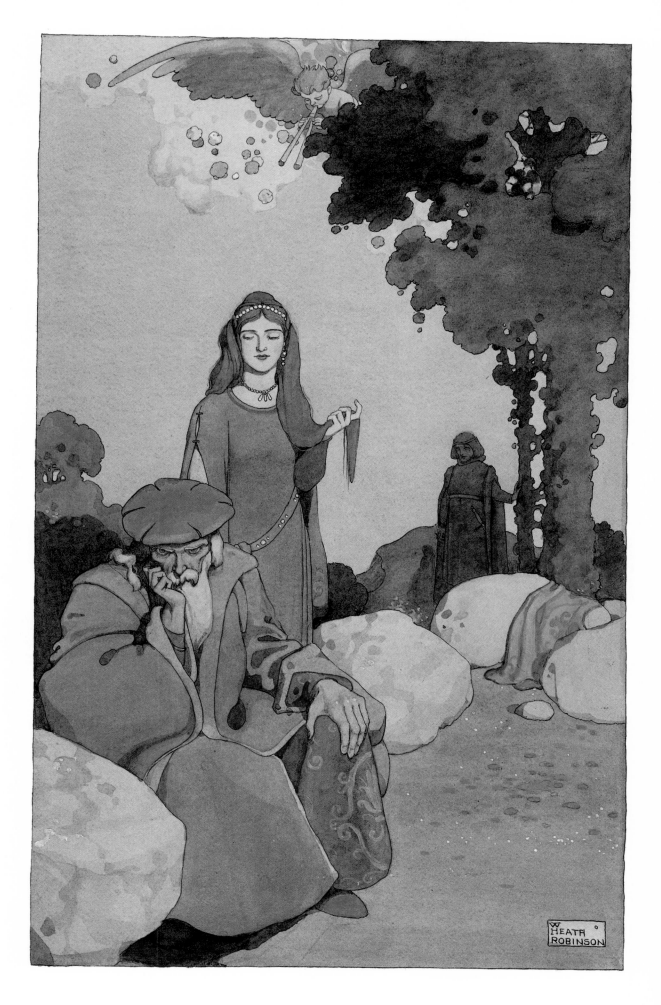

JUL· 429

JUL· 467·

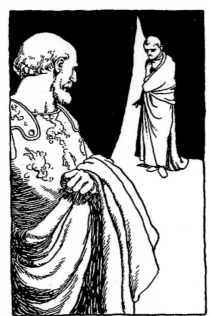

JUL· 457·

JUL·
423

Above and opposite: A sheet of illustrations
for *Julius Caesar* and *Macbeth* from the
Cape *Shakespeare* [53].

MAC. 469. 505

MAC. 530.

JUL. 403
431

MAC.
473. 511. 529.

MAC. 471. 503

JUL. 415.

MAC
493
517

MAC. 475. 507 519

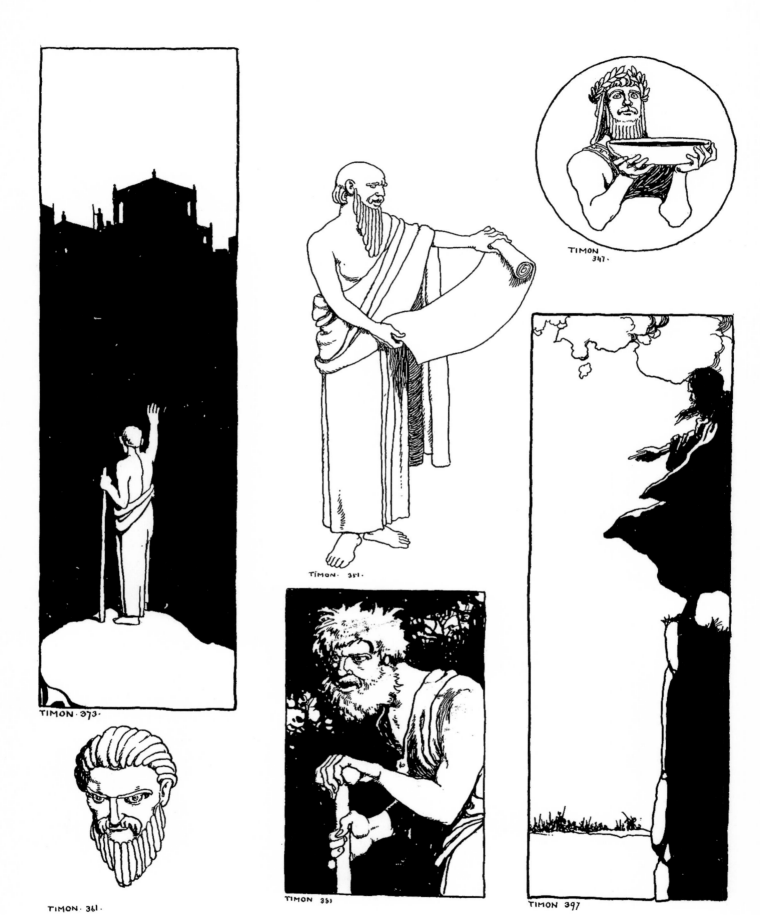

TIMON · 347 ·

TIMON · 373 ·

TIMON · 351 ·

TIMON · 361 ·

TIMON 381 ·

TIMON 397

Above and opposite: A sheet of illlustrations for *Timon of Athens* from the Cape *Shakespeare* [54].

TIMON· 399·

TIMON·
377·

JUL· 453

JUL· 445

Post war blues – *Old Time Stories, Peter Quip* and *Topsy Turvey Tales*

At the same time that Heath Robinson was illustrating *Peacock Pie* he was also, through his agent, discussing ideas for another book with Constable. His first suggestion was a new edition of Aesop's fables and there is no doubt that he would have proved an ideal illustrator for this. In his illustrations to various stories over the years, ranging from *The Giant Crab* to the drawings of birds and a lion in the *Strand Magazine* he had shown his ability to draw animal subjects. However, Constable & Co. were not confident of the commercial prospects for such a book and so Heath Robinson made two other suggestions. A E Johnson wrote in February 1916:

> … Mr Robinson suggests Perrault's Tales, which have not been overdone, so far as he is aware, as a gift book. He would propose to draw the illustrations, as regards costume, etc., more or less in the style of Perrault's period, which he thinks would provide him with very good opportunities for some charming drawings. Failing Perrault, he would like to illustrate a series of folk tales to which he has access. These are in the vein of the famous Grimm collection, being derived from Austria and Bohemia in much the same way as the Grimm stories were derived from Germany. The collection was published some 25 to 30 years ago and is little known.[33]

This latter collection was Vernaleken's *In the Land of Marvels* that had been translated by Edwin Johnson and published by Sonnenschein & Co. in 1884. Heath Robinson was introduced to the book when he was asked to illustrate 'The Hat Full of Soldiers', a story from Vernaleken's collection that appeared in the *Strand Magazine* in January 1916, just a month before A E Johnson's letter to Constable. However, it was the suggestion of *Perrault's Tales* that appealed to Constable, and sadly it was not until 1934 that Heath Robinson had the opportunity to illustrate the Bohemian tales.

Heath Robinson had been asked to work within a price of one hundred pounds by Constable. For that sum he offered six coloured illustrations and from forty to fifty line drawings, of which a considerable proportion would be full page. He said he could probably complete the book by the end of June, which would have been in time for the Christmas market in 1916. However, first

Left: 'She was an ugly little fright', an illustration for 'Princess Rosette' in *Old Time Stories*, London: Constable & Co., 1921 [62].

Opposite: *Trees in Summer and Winter,* two page decorations for *As You Like It* from the Cape *Shakespeare* [58].

33. Letter from A E Johnson to Messrs Constable & Co. Ltd dated 15 February 1916, publisher's archive.

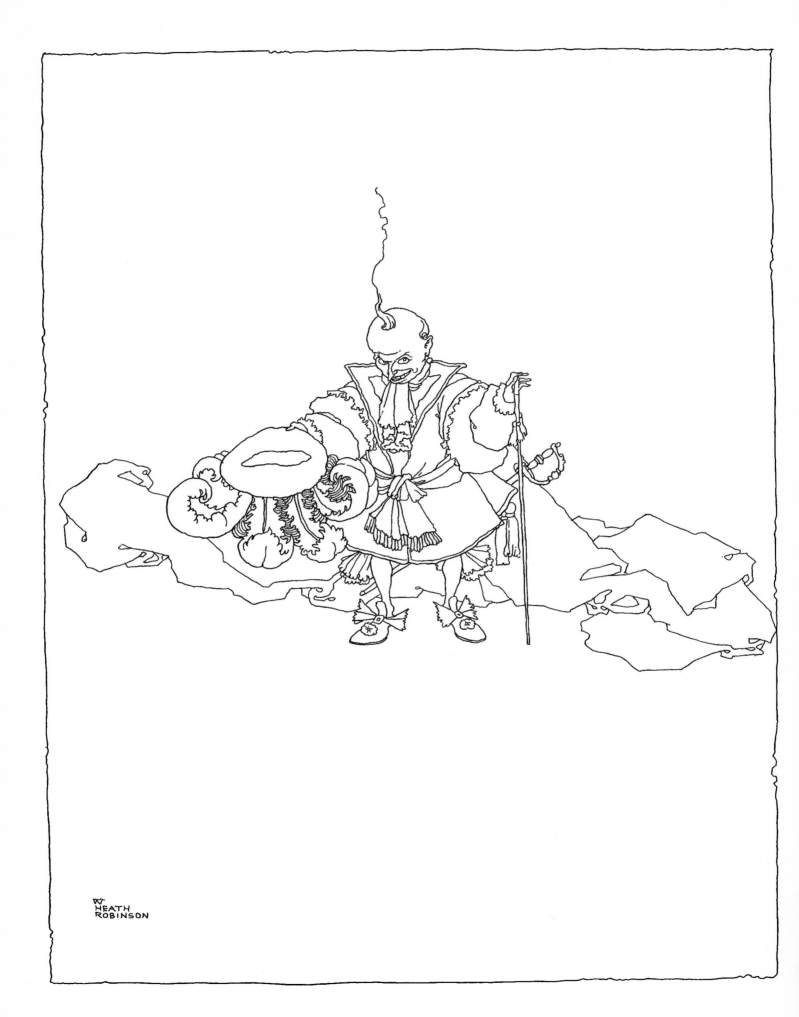

Constable had to find a suitable text. They considered using the edition that had been published by the Clarendon Press in 1888 and was edited by Andrew Lang, but for some reason this was rejected and it was decided to commission a new translation to be written by Heath Robinson's agent, A E Johnson. Then there was the question of how many tales to use, and whether to include the morals. It was decided that to add three more stories to Perrault's original eight, one by Mme de Beaumont and two by Mme d'Aulnoy, and consequently the book was titled *Old Time Stories*.

Opposite: Ricky of the Tuft, an illustration for *Old Time Stories*, London, Constable & Co., 1921 [59].

Below: The Wicked Nurse, an illustration for 'Princess Rosette' in *Old Time Stories*, London, Constable & Co., 1921 [61].

The lessons learnt in illustrating A *Midsummer Night's Dream* continued to be developed in the best of the drawings for this new book; but whereas the previous two books had drawn on the woodland scenes, here Heath Robinson explored the possibilities of the economical outlines and minimal backgrounds that he used for the scenes featuring the rustic characters in that book. Early in *Old Time Stories*, one comes to the startling picture of 'Ricky of the Tuft.' This is the first of five drawings in which the use of blank space is taken to the limit with brilliant effect. In each case the illustration consists of one or two figures drawn in decorative line and set in a frame with no background or foreground. These pictures rely on the tension between figures or between a figure and the frame for their success. In one of the illustrations, Cinderella seems to be running through the frame, breaking it on either side, whilst in the picture of Cinderella's stepmother and father, Heath Robinson has used the same composition as the coloured plate 'The Respectable Gentleman' in *Bill the Minder* but executed in a much simpler style.

The drawing of Bluebeard on his own is a masterpiece of draughtsmanship. The solitary figure is set against a silhouette landscape. The cruel face is surmounted by a massive turban that is decorated with two black feathers signifying death. He is clad in a lace ruff, a tasselled scarf and a brocade jacket whose

rich decoration contrasts with the simplicity of the overall design. The figure is so offset to the right of the drawing that he breaks the frame with his shoulder and turban, giving an impression of power.

The reviewer in *The Studio* magazine wrote of the book when it was first published:

> ... not only are these drawings remarkable for the beauty of their line, but in many of them this beauty is enhanced by the artist's appreciation of the value of blank space – an aesthetic factor to which the Japanese attach so much importance.[34]

However, not all of the drawings were in the styles described above. One of the late additions to the book is 'Beauty and the Beast' and in illustrating it Heath Robinson was unable to settle on a suitable style. The first drawing might have come from *The Water Babies,* the second is in his simple 'rustics' style, the third could have been made for the 1899 *Andersen's Fairy Tales* and in the fourth one sees the beast for the first time and finds he is borrowed from brother Charles's *Big Book of Fairy Tales.* The final drawing, with its 'fried egg' clouds is unlike anything else that he ever drew and is best forgotten. This lack of stylistic unity in the drawings for 'Beauty and the Beast' is a weakness of the volume as a whole. In spite of the presence of a number of fine drawings the book must be

Right Bluebeard, an illustration for *Old Time Stories*, London, Constable & Co., 1921 [60].

34. *The Studio*, November 1921, vol. 82, p. 242.

accounted a relative failure. The six coloured plates do little to redeem the situation, being little more than line drawings with thin washes of colour and poorly reproduced.

The book was finally published in 1921 and Constable made an attempt to recreate the luxury of the pre-war gift books. The binding for the small first issue was in deep red cloth with a circular white onlay blocked in gilt, rather like those used on *Hans Andersen* and *Peacock Pie.* The coloured plates were on beige card mounts and although the quality of the paper and the black and white printing were not as good as in the earlier books, the volume had a feel of quality. However, when subsequent issues appeared the white onlay had gone, the beige card mounts had been replaced by sugar paper in a dirty shade of green and evidence of cost cutting could not be disguised.

At this time, Heath Robinson was also engaged on a children's book that he had been commissioned to write and illustrate for the publishers S W Partridge & Co. In the summer of 1921 he had made a set of eight full-page line drawings for the book, *Peter Quip in Search of a Friend,* and these had been sent to Partridge together with a synopsis of the plot. Blocks were made from the drawings by the printers Thomas Forman & Sons and two sets of proofs of the illustrations, printed on Whatman boards, were sent to Heath Robinson in October 1921 for colouring. The printers then made a set of five-colour blocks from the coloured proofs. Partridge also asked Heath Robinson to colour the originals, but this he declined to do, saying that it would involve a very great deal more work to no advantage.

The book was planned to have thirty-two pages of text, which, with the eight full-page illustrations, would have given one picture to every five pages. Partridge thought this insufficient, but anxious to avoid extra expense, suggested that portions of the eight full-page drawings should be printed in line throughout the book to increase the proportion of

Above: *Peter Quip* in *Search of a Friend,* London: S W Partridge & Co., 1922.

pictures. Heath Robinson agreed to this provided that he chose which portions were to be used. In the event he found only 11 small portions of the original drawings suitable for the purpose, which he supplemented with eight additional line drawings. Partridge also said that the synopsis of the plot would soon be placed in the hands of a good writer to elaborate it, so although the book when published was wholly attributed to Heath Robinson, it was in fact ghost-written.

Proofs of the coloured plates were sent to Heath Robinson in March 1922 and *Peter Quip* was published in September of that year. It was an attractive volume in its bright pictorial boards and the coloured plates were beautifully printed on the same matt paper as the rest of the book. The story, like *Bill the Minder,* chronicles a journey made by a group of travellers, who in this case include a number of animals. It describes the adventures that befall the hero Peter as he searches for a friend and each adventure increases the size of his party. In both the plot and pictures Heath Robinson avoided the dangers he foresaw of producing a volume 'for the kind Uncle or Aunt who is going to make a purchase' and has produced a book that can be both understood and loved by young children. The simple nursery format and the clear, brightly coloured illustrations make no concessions to the adult world in the way that he feared *Bill the Minder* had done.

Early in 1922 a lady by the name of Elsie Smeaton Munro approached the publisher John Lane with a set of twelve children's stories that she had written, called *Topsy Turvy Tales.* She was acquainted with Heath Robinson and gave the

publisher to understand that she could get him to illustrate her stories. Under these circumstances Lane agreed to publish them, and in June Miss Munro's brother approached Heath Robinson's agent, A E Johnson to make formal arrangements for the illustrations. Unusually, Lane also insisted on possession of the original drawings. Writing on this point to Heath Robinson, who at the time was on holiday in Bognor, A E Johnson said:

> In the ordinary way I should drop negotiations forthwith, but, as a matter of fact, I do not see that the original drawings for this particular book will be of very much value to you. It is not as though they would be illustrations to a Classic like Hans Andersen, and it is unlikely that private buyers will be greatly interested in them.[35]

The book was published the following year and was to be the last book illustrated by Heath Robinson for a decade. At least four of the pen and ink drawings for the book are now in the Metropolitan Museum of Art in New York.

The unusual qualities of the text were well summarized by a reviewer for *The Bookman* who wrote in December 1923:

> … children will take these tales just as they are and enjoy them because they are funny and ridiculous things happen just as little people like them to happen. But older folk will realize their cleverness and perhaps writhe when they see their own caricatures. The author takes our time worn phrases and plots and conceits weaving them brilliantly into her twelve highly original stories … To say that the illustrations are by Heath Robinson is enough bush for the good wine in this book.[36]

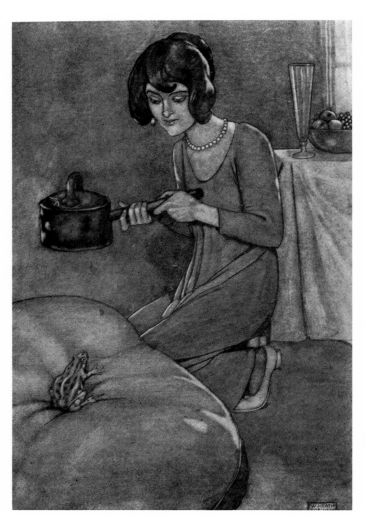

Above: 'He looked a fine figure of a frog', an illustration for *Topsy-Turvy Tales*, London: John Lane, 1923.

The coloured drawings are extremely attractive, and in their subdued tones and skilful use of dappled lighting are reminiscent of the work of Heath Robinson's older brother, Charles. The line drawings include a number of silhouettes and in many of the other drawings figures are depicted in the style of the cartoons that were now occupying so much of his time. Like *Old Time Stories,* this book lacks a coherent style, but a thickening of line and a simpler treatment of subject can be discerned throughout. The vivacity and tension that was apparent in the fantasy illustrations from *Bill the Minder* through to the children's stories in the *Strand Magazine* had gone and were never to return. It is hard to tell whether this was because of a change in his outlook and interests or, more likely, the changed economic climate that he had to work in after the First World War, causing him to divert his energies into humorous drawing and advertising.

By 1922 the demand for fine illustrated books that had been so buoyant ten years earlier had all but disappeared. In particular, there was no longer a large market for the kind of gift book in which the illustrations were its *raison d'être,* and the text, (usually out of copyright), an excuse for publishing a large number of beautiful pictures in black and white or colour. This resulted in some hardship for Heath Robinson's brother Charles who, in common with many illustrators at that time, had found that by 1919 his main source of income had virtually disappeared. However, Heath Robinson was more fortunate for his reputation was more widely based than that of his brother and whilst the war had brought a decline in the amount of work he found as an illustrator, it had also provided him with the opportunity to enhance his standing as a humorous artist.

35. Letter from A E Johnson to W Heath Robinson, 21 August 1922, Heath Robinson Trust collection.

36. *The Bookman Christmas Number,* December 1923.

Early broadcasts

It was Heath Robinson's increasing celebrity as a humorist that led him into the world of broadcasting. He had been a regular contributor to *The Bystander* since 1905, when one of his earliest cartoons had appeared in its pages, and in April 1923 an unusual competition run by that magazine introduced him to radio broadcasting. The competition was called, 'Drawings by Wireless'. Heath Robinson, speaking from the studio at London's radio station 2 LO, described to listeners a drawing he had made of the difficulties of erecting an aerial. Those wishing to participate in the competition were then invited to make a sketch in the style of Mr Heath Robinson and to send it to *The Bystander*. The winning entry would be the one that came closest to the original drawing that had been described. A prize of ten guineas was offered and the best drawings were published in a subsequent issue of the magazine. The winning entry looks more like the artist's published work than the simple sketch that he had prepared for the broadcast!

For a similar broadcast on 30 December 1925, listeners were asked to have a sheet of paper ready with numbered squares ruled on it. Heath Robinson was then able to give a sequence of instructions over the radio from which the listeners could construct a picture. Until it neared completion they had no idea what it was they were drawing, but if they had followed the instructions correctly the result was a picture of Noah's Ark with the dove perched on top of it. Cash prizes were offered to listeners for the three best sketches drawn to Heath Robinson's instructions. 15,000 entries were received and the first prize was awarded to a Mr E L Taylor, 'The Dog's Kennel', Woodham Lane, Addlestone, Surrey, whose drawing was published in *The Radio Times* on 22 January, 1926. Later broadcasts included an invitation to be a guest on the popular BBC programme 'In Town Tonight', in April 1934. He was interviewed with K M Gleason, the inventor of an electric fly-catcher. In 1938 he made an early television appearance during which he drew and demonstrated many of his devices, finishing up with a demonstration of his new pea-splitting machine.

Heath Robinson's original drawing (left) for his 'Drawings by Wireless' broadcast in April 1923 together with the winning entry from Mr Henry Bankes, who won 10 guineas.

Opposite: The front page of *The Daily Mail* for 1 October 1921 featuring Heath Robinson's idea of the Mackintosh's Toffee factory.

Advertising 2 – 'how it's made'

In 1921 John Mackintosh & Sons of Halifax asked Heath Robinson to provide the first in a series of cartoons by famous artists showing how and where they imagine Toffee de Luxe is made. Heath Robinson called his drawing 'A half hour in Toffee Town' and with a series of six small line-drawings in a single frame showed the various stages in the toffee-making process. These included boiling, cooling, shaping, covering with chocolate, counting and testing, all conducted by solemn little men operating typical Heath Robinson machinery. Mackintosh's were delighted with the drawing. H Mackintosh, the Managing Director wrote to Heath Robinson:

> Since your drawing was placed before us by our Agents, Messrs T B Browne, Limited we have had many a good laugh over same. Knowing the real factory, we can appreciate your caricature all the more.[37]

Mackintosh quickly came back for a second drawing to advertise a reduction in price from 9d to 8d. Heath Robinson submitted a rough sketch, to which his agent reported the response as:

> ... although excellent for future possible use, [is] not quite what they anticipated for 'the great reduction'. They expected something in your mechanical style...[38]

Already he was becoming typecast. He responded with an alternative rough sketch of a price reduction machine complete with dials, bells and trumpets.

The 'Toffee Town' drawing was not only a success with Mackintosh, but also prompted enquiries from other companies seeking similar drawings showing various stages of their manufacturing process. Discussing the price to be asked for a further drawing in November 1922, A E Johnson wrote to Heath Robinson:

> We have already broached the subject of a better price, and I think possibly something may be arranged. One cannot press the point too hard, however, for it was to a great extent the first Mackintosh advertisement which brought you this later advertising business, and it's a bit hard on the firm which has the enterprise to give an artist a new opening (especially one by which the artist profits) to penalise them for the success of their own judgement.[39]

Initially, no increase in price was negotiated, but this particular commission was the cause of some ill feeling between artist and client. Heath Robinson was asked to make a rough sketch that the advertising agent could take to Halifax at very short notice. He met the deadline, and the drawing was passed with a large number of amendments. The finished drawing was also required at unusually short notice and again Heath Robinson met the deadline, disrupting his programme of work in the process. He was therefore not amused when a fortnight after the 'final' deadline the drawing was returned with a request for a number of changes. Matters were made worse by the fact that he was not at all sympathetic with these changes, considering at least one of them to be 'a definite mistake'. However he effected them, and A E Johnson wrote the advertising agents a strongly-worded letter, informing them that an additional fee of five guineas would be charged for the alterations. He continued:

> As regards the various alterations, Mr Robinson instructs me to say that the fact that he has given effect to your clients' various amendments is not to be taken as evidence that he agrees with them... the plausibility underlying his most extravagant inventions, which is the secret of the artist's humour, is thereby undermined. But, as Mr Heath Robinson feels it to be clear that your clients have a better notion of what a Heath Robinson drawing should look like than he has himself, he has decided to give effect to all their proposals. He does not wish them to be disappointed.[40]

The drawing eventually appeared in the *Daily Mail* on 23 December 1922.

37. Letter from H Mackintosh to W Heath Robinson, September 1921, William Heath Robinson Trust Collection.

38. Letter from A E Johnson to W Heath Robinson, 19 November 1921, ibid.

39. Letter from A E Johnson to W Heath Robinson, 7 November 1922, ibid.

40. Letter from A E Johnson to Messrs, T B Browne (Agents for Mackintosh) 7 December 1922, ibid.

SECRET HISTORY OF THE
RUSSO-JAPANESE WAR
Read Lady Susan Townley
TO-MORROW's
Weekly Dispatch

LONDON. MANCHESTER. PARIS. NO. 7,98.

Daily Mail
OVER 1,350,000 NET SALE.

SATURDAY, OCTOBER 1, 1921. ONE PENNY

Famous artists' ideas of how Mackintosh's Toffee de Luxe is made.
Nº 1. W. Heath Robinson.

(This is the first of a series of humorous cartoons by famous artists, who have been asked to "imagine" how and where Toffee de Luxe is made.)

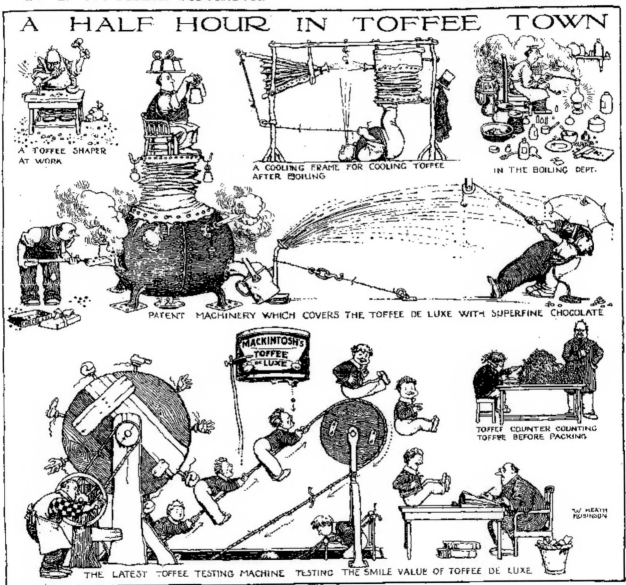

A HALF HOUR IN TOFFEE TOWN

A TOFFEE SHAPER AT WORK

A COOLING FRAME FOR COOLING TOFFEE AFTER BOILING

IN THE BOILING DEPT.

PATENT MACHINERY WHICH COVERS THE TOFFEE DE LUXE WITH SUPERFINE CHOCOLATE

MACKINTOSH'S TOFFEE DE LUXE

TOFFEE COUNTER COUNTING TOFFEE BEFORE PACKING

THE LATEST TOFFEE TESTING MACHINE TESTING THE SMILE VALUE OF TOFFEE DE LUXE

W. HEATH ROBINSON

The wonderful and fantastic inventiveness of W. HEATH ROBINSON gives to his art a distinctive humour that needs no word of embellishment. But delightfully funny as his idea of Mackintosh's Toffee Factory is even to the uninitiated,—its humour is increased a hundredfold to those who know the real thing. We wish that every reader of this paper could visit Toffee Town—then they could contrast Mr. Robinson's quaint conception with the actual.

You would see his "Toffee Shaper" in the form of scores of machines cutting the Toffee into the familiar squares at the rate of thousands of pieces per minute.

You would see the "Cooling Frame"—(not so acrobatic, but more effective!)—as row on row of burnished steel slabs, on which lie acres of Toffee, cooled from beneath by spring water and from above by cold air.

You would see the "Boiling Department" where the pans each hold five cwt. of Toffee.

You would see Chocolate de Luxe travelling on an endless band—a veritable army of "chocolate soldiers," line on line, dozens abreast.

A "Toffee Counter" does not exist, for 7,000,000 pieces are made in Toffee Town in a single day, and therefore it would take 250 days (counting steadily at the rate of one piece per second for 8 hours per day) to "tot up" one day's output. So we just weigh the Toffee! And although we have no "smile testing machine" in Toffee Town, we can guarantee that there are miles of smiles packed into every tin.

MACKINTOSH'S TOFFEE DE LUXE
—the Quality Sweetmeat.

Made by JOHN MACKINTOSH & SONS, Ltd., at Toffee Town, HALIFAX—the largest Toffee Manufactory in the World.

Sold by Confectioners in every Town and Village in the Kingdom at 9d. per ¼-lb. Also obtainable in every country in the World.

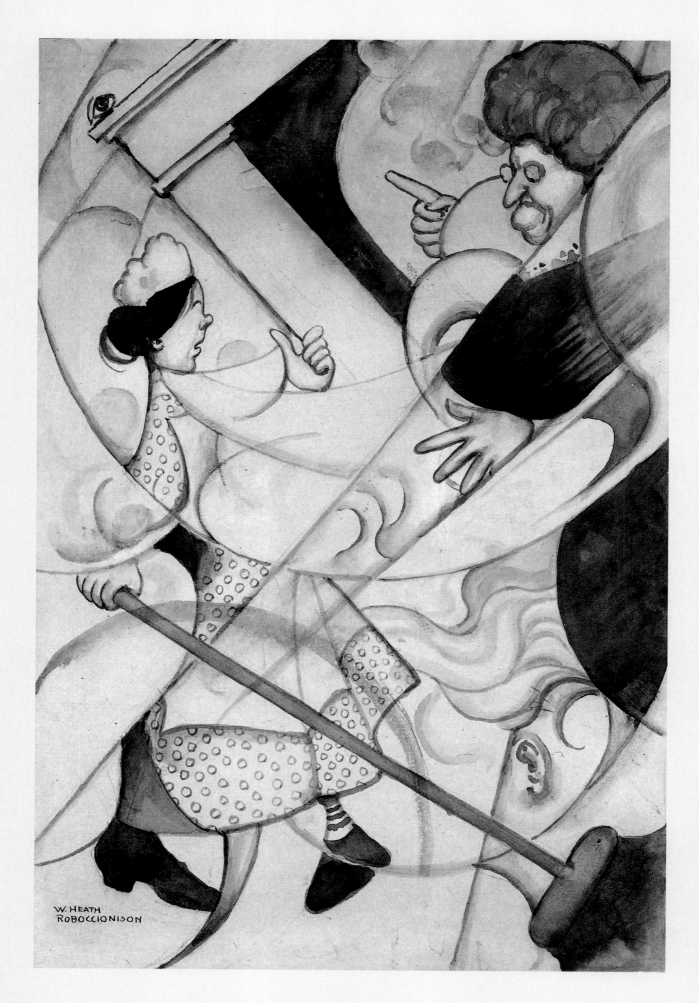

Heath Robinson and the Avant-Garde
[*An interjection by Peter Higginson*]

With his *Fireside Futurism*, dated around 1919, Heath Robinson gives us a fascinating insight into his relationship with Modernist *avant-garde* art, and demonstrates further the breadth of his interest in the world and culture around him. We will see another example of this in his guest talk at a Foyles literary lunch in 19... Signed 'W. Heath Roboccionison', it reveals not only his awareness of Umberto Boccioni's Futurist style, but also, via parody in the conversation between the 'brainy maid' and her mistress, the language of Futurist theory. The Italian Futurist movement, which began in 1908 under the leadership of the poet Filippo Marinetti, championed the speed and dynamism of modern progress, the machine and war; notoriously claiming the superiority of the motor car over classical statuary, as well as calling for the destruction of traditional art and museums. The first Futurist exhibition in London was at the Sackville Gallery in 1912, where thirty-five paintings were on show. This was followed in 1914 with a further exhibition of some seventy-five works at the Dore Gallery in Bond Street. The two main Futurist manifestos were published in each of the catalogues.

Included in the 1912 exhibition was Boccioni's *The Noise of the Street Enters the House*, 1911, which shows a women standing on her balcony giving herself up to the noise and speed of the building of the new city. Such a juxtaposition of domesticity and modernity would have appealed to Heath Robinson's humorous interest in the humble, ingenuous human being's confrontation with technology. As with his approach to machinery in his 'gadget' works, Heath Robinson follows the utopian logic of the Futurist movement to its absurd conclusion when it is forced into contact with mundaneness of ordinary life. The maid's explanation for the condition of her mistress's home is given in artsy gobbledygook, which is countered by the banality of the latter's summary dismissal of the servant, and in turn of artistic pretentiousness.

Similarly, in a work of around the same date, *An Awkward Point Arises on the Introduction of Cubism in the Schools* (*The Bystander*, August 6, 1919), Heath Robinson satirises the style of Cubism. As with Boccioni, he takes the Cubist proposal for a new reality to the point of nonsense, concluding that if the modern consciousness is to be a fragmented one, you are inevitably going to get hurt on the sharp edges.

Throughout his life, Heath Robinson had humorously debunked the posturing seriousness of the artist, both in his autobiography, *My Line of Life* and in works for such journals as *The Bystander* and *The Sketch*. In 1919, following years of war, the folly of the grand artistic gesture would have seemed particularly acute. Such blind utopianism – which in the case of Marinetti and his followers would eventually lead to their wholesale support of Mussolini's Fascism – was something that was also to tax the conscience of many European artists of the *avant garde* itself. Heath Robinson would have been more than aware of the Futurists' celebration of the machine. In 1918, during his visit to the trenches in northern France to draw the US troops at the front, he had seen for himself the horrors of the first mechanised war. Boccioni himself was among many artists who were to perish. This was the tragic result of a dehumanised technology – something that Heath Robinson was so careful to prevent in his own, particular machine aesthetic.

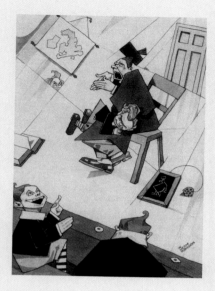

Above: An awkward point – Arises in the introduction of Cubism in the Schools (*The Bystander*, 6 Aug 1919, p. 387.)

Opposite: Futurism by the Fireside – Mistress (to Maid) 'Now, Jane, how often have I told you not to place your eye upon the mantelpiece.' Brainy maid. 'You are mistaken mum, that is not my eye but merely the dynamic conception of its lyrical form interpreted by infinite manifestation of its relations between absolute movement and relative movement or, in a word, between ambience and object, until it forms a...' Mistress 'Then you may take a month's notice'. (Date and place of publication unknown) [89].

Good Housekeeping and *Nash's Magazine*

A remunerative respite from the constant need to be funny came from time to time over the next fifteen years with commissions to provide serious illustrations for short stories and articles in *Nash's Pall Mall Magazine* and its sister publication *Good Housekeeping*. Both of these monthly magazines were published by the National Magazine Company. This had been founded in 1910 by the American newspaper magnate William Randolph Hearst to publish a short-lived new Sunday newspaper *The London Budget*. The company acquired *Nash's Magazine* in 1911, which it continued to publish with considerable success, and in 1914 they bought *Pall Mall Magazine* from Iliffe & Co. The onset of war and consequent shortage of paper caused the two titles to be merged in a single magazine. In 1922 the company started to publish *Good Housekeeping,* a title that was already a success in America for Hearst's International Magazine Company. To facilitate the use of American material, it was printed in a larger format than was usual for British magazines, and the following year *Nash's Pall Mall Magazine* was enlarged to the same format. From November 1925 both magazines were printed on a new Cotterell rotary press with two sets of cylinders allowing illustrations to be printed in black and white with one colour.

The editor of the *London Budget* had been J Y McPeake, and when that paper failed, he stayed on as a director of the National Magazine Company and in 1919 was made Managing Director. His son Alan started his career in publishing that year with *The Westminster Gazette* and in 1923 became art editor of both *Nash's Pall Mall Magazine* and *Good Housekeeping*. Alan had been to school with neighbours of Charles Robinson, and was a regular visitor to his house for Saturday evening entertainment around the piano. Thus there were ties of friendship between the Robinsons and the National Magazine Company, which perhaps explains why they were the only publishers to commission serious illustrations from Heath Robinson during the 1920s and 1930s.

His first illustration for the National Magazine Company was a pen and wash drawing to a story by Clemence Dane called 'Spinsters Rest' that appeared in *Nash's Pall Mall Magazine* in September 1925. The starting point for the story was an extract from one of Grimm's fairy tales, and the double page illustration of an old woman sitting in front of a large fireplace with the ethereal figures of her dreams parading in front of her derives much from Heath Robinson's fantasy illustrations of ten years earlier. Very similar in concept was

his illustration for a Richmal Crompton story, 'Miss Francis Goes to Stay with Friends' that was published in *Good Housekeeping* some eight years later.

Typical of Heath Robinson's work in black and white plus one colour for magazines is the illustration to 'Dickens is not Dead' by John van Durten. Van Durten was better known as a playwright and stage director, and subsequently emigrated from England to the US, becoming a US citizen in 1944. The illustration is a fine example of a comic-realist style that was being developed by Heath Robinson, L G Illingworth and one or two other artists almost exclusively for publication in magazines such as *Nash's Pall Mall Magazine* and *Strand Magazine*.

An attempt in 1927 to relaunch *Pall Mall* as a separate magazine was unsuccessful and the two titles had to be re-amalgamated in May 1929, the company having suffered heavy losses. At this time, and for the rest of its life, it was only the substantial profits from *Good Housekeeping* that enabled *Nash's Pall Mall Magazine* to continue in print. That it did so, and continued to attract top quality writers and artists was largely due to the benefit that Hearst got by syndicating material from *Nash's* in his US publications. He was also able to recycle US material in his UK magazines.

Amongst the most attractive designs that Heath Robinson made for the magazines were the Christmas covers. Between 1924 and 1929 he made four for *Nash's* and two for *Good Housekeeping*. They were richly coloured with liberal use of red and gold, and all feature his goblins. The design of 'The Fairies' Pedlar' for *Nash's* in 1929 is perhaps the best of them.

During the period between the wars, magazine illustration was a disciplined and demanding occupation. Generally an editor would pass an author's text to the art editor about three months before it was due to be published. Of this period the artist was allowed about three weeks to complete his work, the

remainder of the time being taken up in making blocks, preparing the work for the printer, printing and distribution, in many cases world wide. Usually the art editor would choose the subjects to be illustrated, having regard to the relationship between pictures and text, and ensuring that the reader was attracted without giving away too much of the plot.

The art editor also decided how much of the double page spread was available for illustration and whether colour was to be used. The artist was then required to make roughs for approval by the art editor and to be used in planning the overall layout of the pages. Once they were approved he could then go on to prepare the finished drawings. In his book *Magazine Illustration* published in 1939, George Leech RI, for many years art editor of *Strand Magazine,* identified three main principles of magazine illustration. These were that the pictures should illustrate the author's text, that they should decorate the page and that they should reproduce well. He also wrote:

> One or two of the well known illustrators are sufficiently versatile to tackle almost any kind of story, but the majority are only really good when dealing with the type that appeals specially to them.[41]

In his work for *Nash's Pall Mall Magazine* and *Good Housekeeping* Heath Robinson rarely failed to achieve all three of Leech's principles and without doubt proved himself capable of illustrating a very wide range of stories and articles.

Advertising 3 – Connolly's

In 1920 Heath Robinson embarked on the second major advertising collaboration of his career, with Connolly Brothers (Curriers) Ltd who were the largest producers in Europe of motor hides at a time when not only were the seats of cars made of leather, but also the folding hoods. They also supplied leather for furniture, bags and cases, harness and saddlery and for 'railway use'. Heath Robinson was commissioned to produce a twelve-page booklet illustrating various stages in the production of Connolly motor hides for the Motor Show that year. The booklet was called *Nothing Like Leather* and contained six full pages of

41. *Magazine Illustration: The Art Editor's Point of View* by George W Leech RI, London: Sir Isaac Pitman & Sons Ltd, 1939.

illustrations showing the Connolly process. There were also smaller drawings of 'the gent who first realised the waterproof nature of cowhide' and 'an early method of skinning a cow'. The title-page had a delightful vignette in line titled 'for endurance' and the cover was decorated with four silhouettes illustrating the virtues of leather.

The following year Connolly's commissioned a similar booklet called *Curried Careers* from Fougasse, but this proved to be less popular. They therefore returned to Heath Robinson in 1922. The design of this booklet was largely left to the artist, with the stipulation that it should concentrate on the motor industry side of their trade. A E Johnson wrote to Heath Robinson at the end of August asking him to prepare designs for a 24 page booklet. A dummy booklet with rough sketches was delivered to A E Johnson, so that he could decide with Connolly's the size and format required. Johnson also reluctantly advised the artist, who at the time had a very full schedule of work, that:

> … it will be absolutely essential for you to come up to town for half a day in order to be taken over Connolly's works again. This is most exasperating, as you are so very busy, and it seems to be totally unnecessary. But, as you know, many of these firms have an idea that nothing can be satisfactorily accomplished until you have been over the works, and the case is particularly acute with Connolly's, because the old man of the firm (a white haired old thing whom you probably met) has got the notion *firmly* in his head, and is clinging to it with the pertinacity of the aged. I did my best to avoid the point, but I can see very clearly that if you do not pay a second visit to the works, the old man in the first place will be convinced that any and every sketch you do is not up to the standard of the first book and not nearly so good as it would have been had you again toured the works: and secondly he will develop the idea that Mr Robinson is not giving to the job as much attention as he ought to. In these circumstances, there seems nothing for it but to manage another visit to the works... Apart from its being policy to gratify the whim of old Connolly somehow, I think it will save time in the long run to fall in with his wishes. Otherwise he will be making absurd criticisms of every sketch you do, and you will lose more time over alterations, etc than you would gain by not going.[42]

Heath Robinson duly visited the works. At the end of September A E Johnson wrote with Connolly's comments on the rough sketches, most of which had been passed. The company's main concern was over the drawings at the head of the foreign language pages at the end of the booklet, which might 'offend national susceptibilities'. They also wondered whether a more arresting picture could be produced for the front cover. Heath Robinson made the adjustments requested and resubmitted the dummy. Johnson wrote to say that Connolly's were very pleased with the revised sketches, and asking for the finished drawings 'by first thing on Monday at the latest, and if by any chance you were to get through them before the end of the week, so much the better'. As usual, Heath Robinson delivered on time. Proofs of the booklet were sent on the 24 October and the final product, which was called *Light on Leather* was available for distribution at the Motor Show at the beginning of November. Once again the booklet was a success, and whilst not quite an annual institution, by 1939 the tally of Heath Robinson booklets for Connolly's was twelve, including two collected editions. He also contributed in 1924 to *Tough Testimonials*, a Connolly booklet that included work by ten artists.

It is difficult to select highlights from the series, which is itself a testimonial to the sustained inventiveness and sheer brilliance of its creator. However, there are two booklets that particularly appeal. *Nothing Takes the Place of Leather* in 1925 pictures a world without leather in which a miserable and uncomfortable populace perform various tasks with inferior substitutes. Footballers in carpet slippers or with stockinged or rag-swathed feet kick a padded bundle tied with string for a ball. Businessmen hurry to work with their documents carried in various pots, pans or jugs, and a bagless bagman tries to

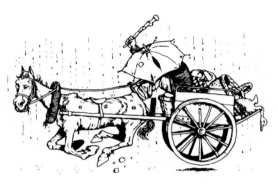

'For endurance', a drawing for *Nothing Like Leather*, Connolly Bros. Ltd, 1920.

42. Letter from A E Johnson to W Heath Robinson, 21 September 1922. William Heath Robinson Trust Collection.

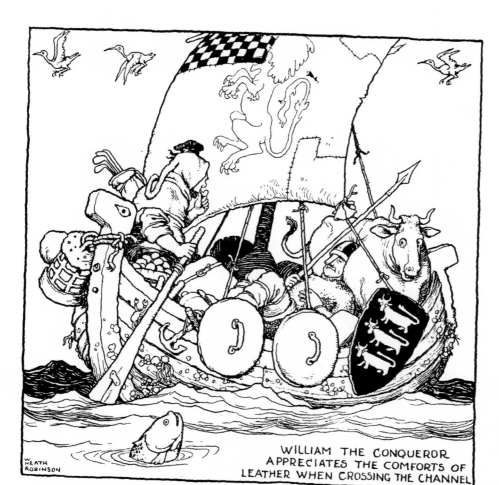

WILLIAM THE CONQUEROR APPRECIATES THE COMFORTS OF LEATHER WHEN CROSSING THE CHANNEL

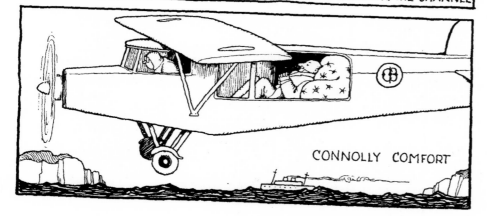

CONNOLLY COMFORT

carry his samples in his arms. Motorists drive in the rain protected variously by an upturned bath, a carpet and a table. In the home a watch is fixed to the wrist with a piece of string, a razor is stropped on the cat's tail and a father attempts to chastise his son with another length of string.

Eight years later the Connolly booklet had doubled in size, and depicted *Connolly Chronicles*, in which parallels were drawn between historical events and present day uses for leather. Mr and Mrs Noah find the most comfortable seats on the Ark – on the backs of the bull and the cow – while their modern counterparts enjoy leather upholstery. William the Conqueror 'appreciates the comfort of leather when crossing the channel' while his modern counterpart does the same in an aeroplane. Several similar parallels are illustrated in a series of finely drawn full page and smaller pictures.

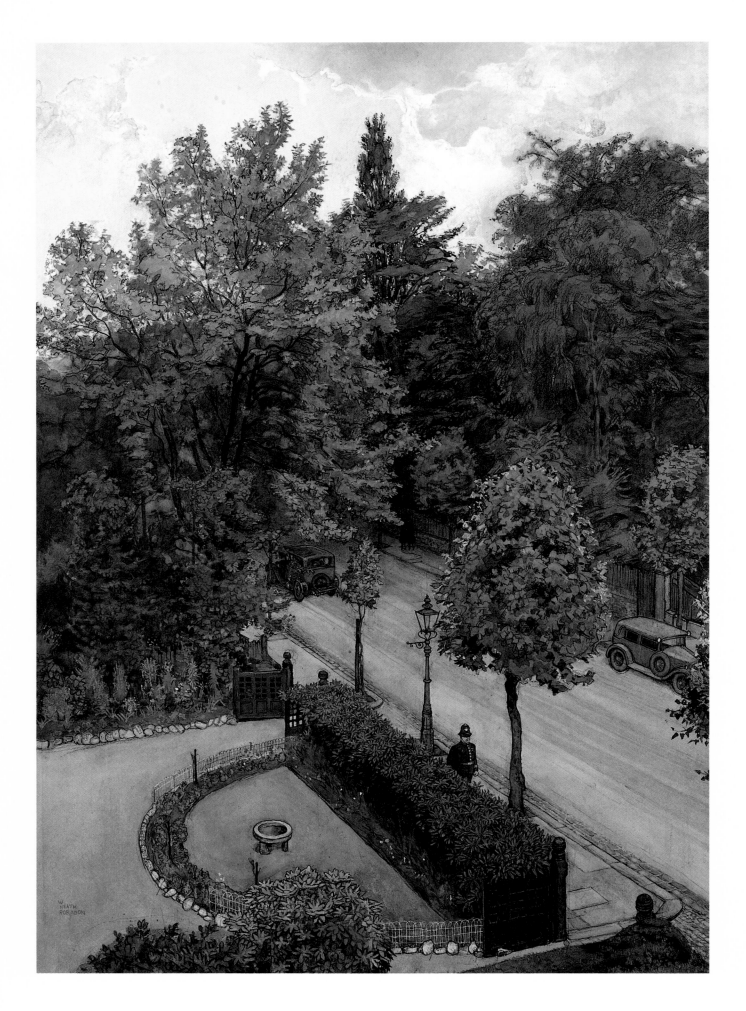

Move to Highgate

It was in 1929, ten years after arriving in Cranleigh that Heath Robinson moved again, this time back to the area of North London that he had left twenty years earlier. His daughter Joan had left home to train as a nurse, whilst his eldest son Oliver was working for *Good Housekeeping* whose offices were in Queen Victoria Street in the City of London. The other children were nearing the end of their schooling, and would in all probability find jobs in London also, and so the family home was established in Highgate, first at Shepherd's Hill and then from 1934 at 25 Southwood Avenue, the house in which Heath Robinson was to spend the remaining years of his life. It was hard to leave the country life and the friends they had made in Cranleigh, but there were compensations. His brother Charles was still living in Crouch Hall Road, Crouch End, which was within walking distance, as were the Holloway Road and Highgate Hill, scenes of many childhood adventures, and Hampstead Heath where he had first tried to earn his living as a landscape painter.

Professor Branestawm

Around the end of 1932 Heath Robinson received his first request for nine years to return to book illustration, although in this case the drawings were to have much more in common with his contemporary cartoon work than with his earlier book illustrations. The request came from John Lane and was for a coloured frontispiece and a number of line drawings to illustrate a book called *The Incredible Adventures of Professor Branestawm* written by Norman Hunter. This was a children's story telling, as the title suggests, of the adventures of the archetypal absent-minded inventor. The professor himself provides an ideal subject for Heath Robinson, with his bald head on which he kept five pairs of spectacles, whilst the professor's inventions give the artist endless scope to devise the eccentric mechanical devices for which he was already well known. This was the first time that Heath Robinson had illustrated a book in his cartoon style and it works very well. The illustration showing the professor's entry into North Pagwell library on a home made penny-farthing is a masterpiece, with books, furniture and librarian all flying in different directions and the great wheel of the bicycle at the centre of the drawing forming the axis about which everything else is moving.

The book was published for Christmas 1933. It seems not to have sold very well, only gaining popularity after the Second World War when a paperback edition was published by Penguin Books, and now the first edition is quite scarce. Since the first Penguin edition was issued in 1946, it has been reprinted about twenty times and in 1965 a new hard-covered edition was published by The Bodley Head. This too has been reprinted many times, so the book now seems to be more popular than it ever was. Unfortunately though, neither the paperback nor the more recent hard-covered editions reproduce the original coloured frontispiece. Indeed, the publishers seem to have forgotten that it ever existed and in recent years have gone to the trouble of colouring one of the line drawings to serve as a wrapper design, ignoring Heath Robinson's wonderful depiction of the professor flying high above the countryside in his home-made aeroplane, which would have served their purposes far better.

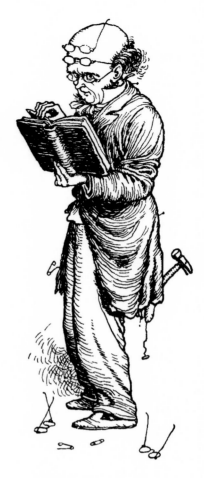

Above: The Professor, an illustration for The *Incredible Adventures of Professor Branestawm*, London: John Lane, 1933.

Opposite: Shepherd's Hill, Highgate, a watercolour painted circa 1933 [110].

Right: The Knickerbocker Bar on the
Empress of Britain.

Opposite top: Design for the Knickerbocker
Cocktail Bar on the Empress of Britain [101].

Opposite bottom: Design for the Children's
Room on the Empress of Britain [102].

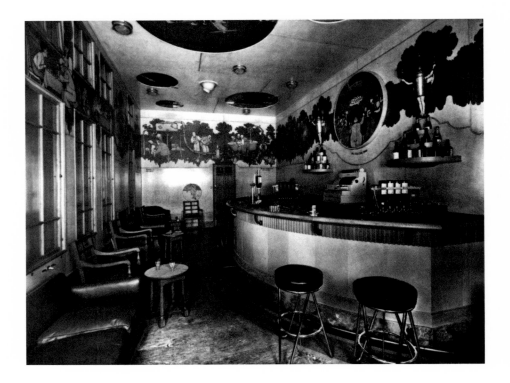

Designs for the Empress of Britain

By the late 1920s Heath Robinson's fame as 'The Gadget King' was growing and in 1930, along with the general run of advertising and magazine work, came an unusual commission. He was engaged by the Canadian Pacific Railway Company to decorate the children's room and cocktail bar of their newest and largest transatlantic liner, the *Empress of Britain*, which was being built in Scotland. The commission pleased him greatly and he said that he was honoured to be associated with the many other famous artists involved in the decoration of the ship. Among them were such well known names as Frank Brangwyn, Edmund Dulac and Maurice Greiffenhagen. His designs were painted on large wooden panels at his studio in Highgate, where his son Alan was allowed to help with some of the work. The panels were transported to the shipyards of John Brown on the Clyde to be installed and Heath Robinson then spent four days on board to put the finishing touches to his work.

Writing about this project, the editor of *The Studio* said in 1931:

> In constructing the latest and biggest addition to their fleet the CPR have succeeded in presenting to the world an exhibition of the concerted efforts of British talent and British manufacture. Seldom, in recent times, can one point to a more successful example of what Britain stands for in fine quality of material linked with superb craftsmanship and engineering.[43]

The main designs for the cocktail bar showed the story of cocktails, and they were supplemented by a number of circular *trompe l'oeil* panels in the ceiling. These show faces looking down, a parachutist dropping in, or a ramshackle aeroplane passing overhead, which must have made drinkers who had had one cocktail too many wonder quite where they were! The decorations were the basis of an article in the *Strand Magazine* in December 1931 by Anthony Armstrong called 'The Story of Cocktails' and this was reprinted by Canadian Pacific as an advertising brochure. Some time later the same set of illustrations were used in *Cocktail Mixing*, a small, twelve-page booklet with a number of cocktail recipes in it.

The ship was used as a troop carrier during the Second World War and was sunk by a German submarine. All that remains of his work are two trial panels, two watercolour designs and some black and white photographs.

43. *The Studio*, July 1931, vol. 102, p. 21.

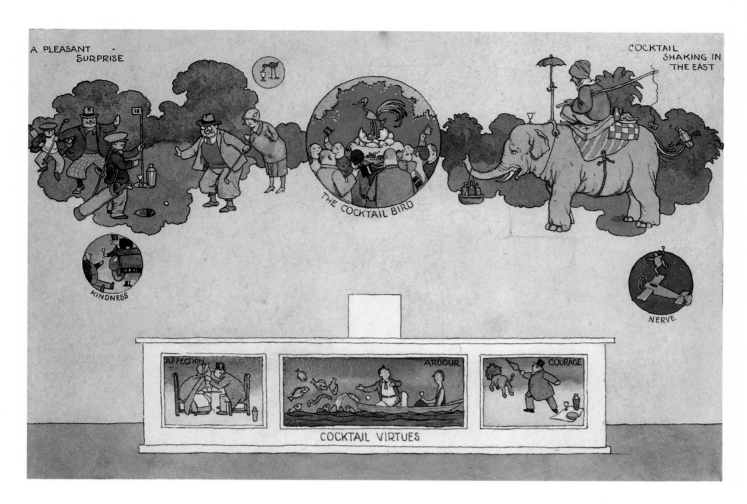

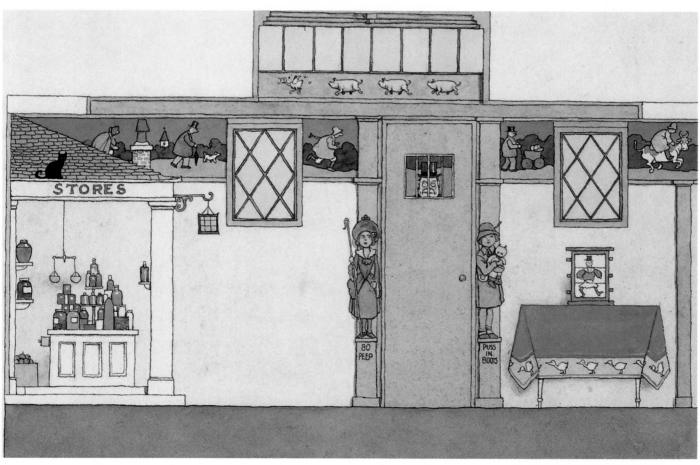

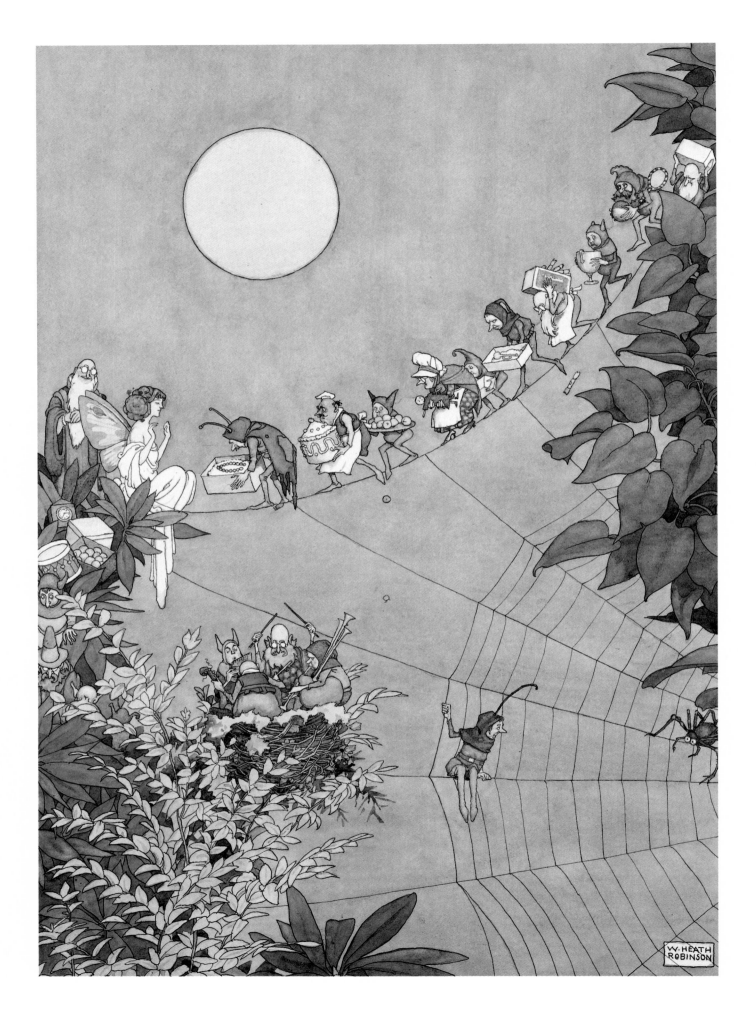

Heath Robinson's goblins

Undoubtedly, by 1933, Heath Robinson was best known for his cartoons, but people also knew him as the creator of a strange family of fairy folk and goblins. These characters appeared first as part of Titania's retinue in *A Midsummer Night's Dream,* and soon re-appeared in one of the illustrations for 'The Rusty Pot and the Wooden Balls' in the *Strand Magazine* in 1916. The same year Heath Robinson designed the cover for Walter Carroll's piano music, *Forest Fantasies,* in which one of the goblins features playing the bagpipes as he leads a fairy procession through a wood. Then in 1919 *The Graphic* Christmas number published a full-page coloured illustration to eight lines of verse entitled 'The Little Folk' which showed a procession of Heath Robinson goblins playing musical instruments and coming over a hill top. A similar picture was published the following year, this time to ten lines of verse entitled 'The Old 'Visiters'', showing another procession of the goblin folk marching through snow to bring food to a poor girl in her cottage. There were similar pictures in subsequent Christmas Numbers and at Christmas 1924 the goblins were to be found helping out in the kitchen on the cover of *Good Housekeeping*. They featured on another *Good Housekeeping* cover at Christmas 1928 and on the cover of *Nash's Pall Mall Magazine* for Christmas 1929 where they appeared as the customers of the fairy's peddler.

Similar pictures were contributed to a publication called *Holly Leaves,* which was the title given to the Christmas number of *The Illustrated Sporting and Dramatic News*. In 1923 a picture called 'The Waits' featured goblin carol singers, while in December 1925 the most enchanting of all these goblin pictures, 'The Fairy's Birthday', delighted readers of the magazine. Unlike the other pictures in the series, this one is set on a sunny summer's morning. The fairy of the title sits looking very regal on a branch of a leafy bush, her chancellor standing behind her overseeing the ceremony. A cobweb is stretched from her bush to another nearby and along its main thread comes a procession of goblins bearing various gifts. These include cakes, oranges, a doll, a trumpet, a bat and ball and a silver cup. Below her are other gifts that she has already received. One of the goblins keeps watch on the spider who is looking menacing at the centre of his web, while in a bird's nest below her a goblin orchestra play on bagpipes, a cello, pan pipes and a drum. The whole is a masterpiece in both conception and execution. The scene is lit by a huge orange sun whose shape is echoed in the curve of the cobweb and the procession it supports. The various bushes are real varieties painted with loving accuracy but at the same time contribute to the harmony of the overall design. The colouring has a delicacy and luminous transparency equal to Charles Rennie Mackintosh's late watercolours. The fairies and goblins are not the malevolent sprites of Rackham's illustrations, but have a homely and somewhat bumbling appearance. They may be short-sighted, overweight and suffer from pains in their joints or shortness of breath. They have a rustic quality and may well have been based on the characters that Heath Robinson met in and around Cranleigh.

As has already been mentioned, in 1916 Heath Robinson illustrated 'The Rusty Pot and the Wooden Balls' in the *Strand Magazine*. This story was taken from Vernaleken's collection of Bohemian folk-tales, *In the Land of Marvels*. Although Constable had rejected this title in favour of *Perrault's Fairy Tales* when choosing a successor to *Peacock Pie*, he did not give up the idea of illustrating the book. In June 1922 he gave A E Johnson three pen drawings illustrating the stories 'The Wild Cat of the forest', 'The Fairest Bride' and 'The Three Wondrous Fishes', all from *In the Land of Marvels*. Presumably, he wanted Johnson to show them to various publishers in the hope of getting a contract to illustrate a new edition, but he had no success. It was not until 1933 that he was finally able to start work on the book for Hutchinson. It was published in 1934 under the title *Heath Robinson's Book of Goblins* and contained seven coloured plates, over 50 line drawings and 93 vignettes depicting the eponymous goblins.

The change of title was obviously an attempt by the publisher to cash in both on Heath Robinson's reputation as a humorist and on the popularity of his already well-known goblin pictures. The vignettes are far and away the best things in the book. It was unfortunate that Constable did not give the artist the opportunity to illustrate the book fifteen years earlier, for the 1916 *Strand Magazine* pictures show what might have been whilst the 1933 book only shows how much Heath Robinson's vigour and power as an illustrator of fantasy had declined. The larger drawings in the book are stiff and lacking in drama compared with the earlier work. The coloured plates, although possessing a certain charm, seem clumsy compared with the delicate and rhythmic compositions of *Hans Andersen* or *A Midsummer Night's Dream*.

The book has never been republished, but in 1978 Hutchinson brought out a delightful little volume called *Goblins* in which a number of the goblin vignettes were enlarged and coloured and each given an accompanying verse written by Spike Milligan. The final product was one of which the artist would surely have approved, had he ever seen it.

Old King Cole
Was a merry old soul,
And a merry old soul was he;

He called for his pipe,
And he called for his bowl,
And he called for his fiddlers three.

'Old King Cole', a design for nursery china commissioned by Soane and Smith in 1927.

Nursery china

In 1927 Heath Robinson was asked to design a range of nursery china for Soane and Smith, a Knightsbridge store. The service was produced by W R Midwinter of Burslem, Staffordshire. There were sixteen designs based on popular nursery rhymes which were reproduced on the china in full colour. The distinctive feature of the pieces was the inclusion of a frieze of children's faces that ran round the inside rim of cups and bowls and round the outer edge of plates and porringers. As one might expect the designs were highly original, a number of them featuring the now popular Heath Robinson goblins. Jack Spratt and his wife bend over their meal watched through their parlour window by a group of hungry children. Tom, Tom the Piper's Son is vigorously chased round one side of a mug. Turning it round one sees on the other side his mother thrashing him with a besom, while between the two images is a vignette of a steaming leg of bacon! In the background of this design the tower of Pinner church can be seen amongst the trees. In the design for 'Old King Cole' it is the children that delight, especially the little girl dancing behind the fiddlers, so serious – and of course the dog.

The designs were applied to a wide variety of shapes including cups, saucers, plates, cereal bowls, teapots, jam pots, sugar bowls, mugs, porringers, egg cups and even a tureen. The service was so popular that it was later sold through a variety of outlets, although the later designs were simplified with the frieze of children's faces replaced by a simple band of dark blue or pale green.

The 'how to...' books

Between 1926 and 1929 Heath Robinson had produced some of his best humorous illustrations to accompany articles by Frank Swinnerton in *Good Housekeeping*. However, during the 1930s Swinnerton moved on to more serious forms of writing. Although Heath Robinson continued to do similar work with a variety of authors, it was not until 1935 that he found a new partner for this light-hearted form of illustration. It is fitting that this new partnership should have been inaugurated between the covers of the *Strand Magazine*, which had commissioned work from him in a variety of styles since 1908. In 1935, the *Strand* was still maintaining its high standards of illustration and the November issue, featuring such artists as Arthur Wragg, Will Owen and L G Illingworth, also included an article entitled 'At Home with Heath Robinson'. This had a text by Kenneth R G Browne and ten pen and wash illustrations by Heath Robinson. The illustrations, which showed novel uses for unwanted items, were drawn under the working title 'Rejuvenated Junk'.

K R G Browne, a fellow 'Savage', was an ideal collaborator for Heath Robinson. He was the son of Gordon Browne who is still well known as an illustrator of books and magazines, and was the grandson of Hablot Knight Browne, who under his pen name of 'Phiz' gained lasting fame as the illustrator of many Victorian novelists, including Charles Dickens, Charles Lever and Harrison Ainsworth. The article in the *Strand Magazine* marked the start of a partnership that was only brought to an untimely end by the death of Browne in 1940. Heath Robinson wrote of the books and articles that they produced together:

> This collaboration seems to have solved a difficulty that I have often found with my lighter drawings. They rarely lend themselves to illustration in the ordinary sense of the term. It is the equal partnership in our mutual productions which is so satisfactory, at least to me. Instead of the finished story being handed to the artist to illustrate, we start level. Before we begin our different parts, we discuss the matter between us. In this way each is able to help the other. A consistency between the artist's and the writer's work is secured which cannot easily be obtained in any other way. My partner in these undertakings has a delightful sense of humour. It is great fun devising with him these little plots to make our readers laugh at themselves and one another.[44]

During 1932 and 1933 Heath Robinson had drawn a series of cartoons for *The Sketch* entitled 'Flat Life', which depicted various gadgets designed to make the most of the limited space available in the contemporary flat. It was this series of drawings that provided Browne and Heath Robinson with the inspiration for their first full-length book together. It was called *How to Live in a Flat*, and as well as greatly extending the original ideas showing many ingenious ways of overcoming the problems caused by lack of space in flats and bungalows, also provided much fun at the expense of the more extreme designs in thirties furniture and architecture. There is an extended section that explores the

Examples of nursery china made by W R Midwinter between 1928 and 1935.

44. *My Line of Life*, op. cit. p181.

possibilities of tubular steel furniture, including a chair with a tap on the side providing a continuous supply of beer through the tubular frame from a barrel in the basement below. Geometric carpet designs, many of which

> … appear to have been designed by colour-blind surrealists under the influence of some potent drug …

were made more practical in the 'Heath Robinson Games Rug' which can be used for chess, draughts and halma. Architectural designs were also gently satirised with curved windows and balconies much in evidence throughout.

The book was published by Hutchinson for Christmas 1936 and was well received. Over the next three years Browne and Heath Robinson successfully repeated the formula in a further three titles. Heath Robinson received much teasing from his family about the choice of subject for the second book, *How to be a Perfect Husband*, but looking back over his cartoons one finds that romance and courtship had been amongst his most frequently chosen subjects, from the early 'Cupid' cartoons to such pictures as 'The Coquette' and 'Stolen Kisses' which were reproduced in *Absurdities* in 1934. It is a popular misconception that Heath Robinson's work appeared regularly in the pages of *Punch*. In fact, apart from one cartoon in the Summer number for 1923, his only contributions were seven previews of his drawings for the *How to …* books.

The next book in the series received a valuable preview when the *Strand Magazine* published an article called 'A Highly Complicated Science' in August 1938. The science referred to was that of gardening and the article by K R G Browne was accompanied by nine of Heath Robinson's drawings all of which were subsequently used in *How to Make a Garden Grow*. The captions to the drawings were changed for the book, many being shortened. For example, 'The curvilinear re-entrant snuff-spray prevents spraying the people next door' was changed to 'The Re-Entrant Snuff-Spray'.

Again, much of the subject matter for this book and the next, *How to be a Motorist* 1939, was drawn from Heath Robinson's earlier cartoons. Amongst his earliest work for *The Sketch* was a series of drawings on the practicalities of gardening. This included a picture of 'root pruning' showing the gardener tunnelling down to the roots of a plant to prune them. Although the earlier drawing is much more elaborate, the idea is the same as is presented on page 27 of *How to Make a Garden Grow*. Similarly the theme of motoring recurs frequently in the earlier cartoons, with the three sets of motoring cartoons in *Out and Away* 1919–20 and *The Home Made Car* series, which first appeared in the *Strand Magazine* in 1921, being amongst the best of them.

But there is an important difference between the full-page cartoon for a newspaper or magazine, and the humorous book. The cartoon must be capable of making the reader laugh whatever his mood as he turns the page and so must achieve an instant impact with a strong idea and sound execution. The reader of a humorous book, on the other hand, will have picked it up in the expectation of being amused, and so here the author or artist's problem is one of how to sustain the humour in an extended form, rather than to create a sudden effect with a single idea. In the *How to ...* books Heath Robinson found the opportunity to present the reader with a set of variations on a theme, allowing him to look at his subject from every angle and to explore each idea that presented itself. Thus the books allow us to see a different aspect of his humorous art; to see its depth, rather than just selected high points.

On the 5 April 1940 Kenneth Browne died at the age of 45, but fortunately this did not mean that the series of *How to ...* books had come to an end. The onset of the Second World War provided new and topical subject matter, and Heath Robinson found a writer amongst his neighbours in Highgate. This was Cecil Hunt, who at 38 had already published a number of humorous books, as well as standard works on journalism and short story writing, books of literary

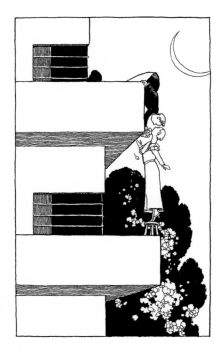

reminiscences and a variety of books on other subjects. He had been fiction editor of the *Daily Mail* and the *Evening News*, literary editor of the *Daily Mail* and was also a regular broadcaster. In 1940 he was perhaps best known for his series of 'Howler' books, the most recent of which had been *Hand-Picked Howlers* published in 1937 with illustrations by Edmund Blampied. Three titles resulted from the new partnership, *How to Make the Best of Things*, *How to Build a New World* and *How to Run a Communal Home*.

The 1934 Ideal Home Exhibition

To Heath Robinson 1934 was a memorable year. It saw the creation at the 'Ideal Home Exhibition' at Olympia of his ideal home, 'The Gadgets'. The house stood on a site 50ft by 30ft and was nearly 20ft high. It was peopled with more than thirty life-like moving figures, all busy about their daily tasks. Father, mother, baby, nurse – each was modelled by the engineering firm of Veranco Ltd, under the supervision of their creator, to a scale of half life-size. Each too was said to be fitted for clothes of a fashionable kind, although to whose idea of fashion is not quite clear. The visitor could see the family in action from the time they were woken in the morning until they retired at night. Father and mother dropping through the bedroom floor to the dining room beneath on the end of counter-balanced ropes would by so doing turn on the radiogramophone, give the cat its milk and uncover the breakfast sausages.

A correspondent writing in *Decoration* magazine described the scene thus:

> Events in the lives of the inhabitants, from the ringing of the unwelcome morning alarm clock, are shewn with a delicious humour certain to delight observers and lead them to send their friends, cousins and aunts to the Exhibition.
>
> The quaint methods of carrying out the tasks of everyday life so typical of this artist are all presented. Weird devices for the last minute preparations of breakfast

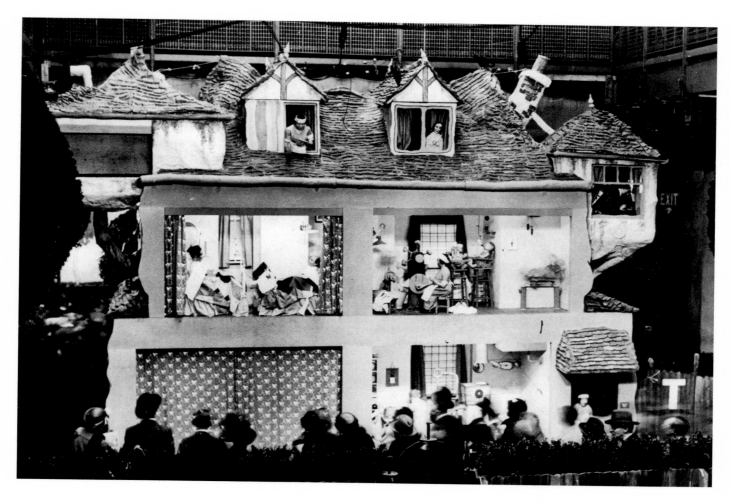

synchronising with the descent through the ceiling of the husband and wife and the simultaneous automatic starting of the wireless set and the pouring out of the cat's milk as they take their seats at the table are only equalled by the unheard of methods employed elsewhere.

The custard-making machine in the kitchen, apparently using an unlimited number of eggs and worked by the foot of the cook whilst she industriously peels potatoes, is only excelled by the daring devices employed in the nursery. The house-wife will see demonstrated an entirely original method of bathing the baby.

The extraordinary surprises in the house itself find their parallel in the garden. Heath Robinson methods of killing weeds and grubs and of mowing will be shewn, and clothes washing and drying are dealt with in ways that no one but Mr Heath Robinson could have devised.[45]

One can only speculate on what might remain of this fabulous creation – a few newspaper reports certainly, and a set of postcards depicting 'The Gadgets' that was sold at the exhibition. It also seems likely that somewhere in a film archive there might be some newsreel footage showing Heath Robinson's creation in action. He was now indeed the Gadget King!

The Gadgets', Heath Robinson's *Ideal Home* at the Ideal Home Exhibition, 1934.

45. *Decoration*, April 1934, pp. 77–9

Earning a living – humorous drawings for magazines

Opposite: How a sermon may be cut short by the mere falling of an autumn leaf. *Hutchinson's Magazine*, November 1924, p. 399 [90].

Once the flow of commissions for book illustration had dried up after WWI, Heath Robinson had to fall back on advertising work and humorous drawings for magazines to earn his living. During the 1920s he was contributing a weekly cartoon to *The Bystander* magazine and he was also a regular contributor to *The Royal Magazine, Hutchinson's Magazine* and *The Humorist*. He contributed more occasionally to the *Strand Magazine, Passing Show. London Opinion, Pearson's Magazine, Gaiety, Nash's Pall Mall Magazine, The Graphic, John Bull* and *Printer's Pie*. His work also appeared in the American magazines *The Sportsman* and *Puck*. That he was working under some pressure is evident. On 2 August 1922, the day that he started his summer holiday in Bognor Regis, his agent wrote to him setting the following programme of work:

1. 2 pages 'Violent Verse for Patient People': line drawings: for *Royal Magazine*, August 14 latest.

2. 2 pages '1922 Review' 2 colour line drawings (red and blue): *Royal Magazine*, August 21.

3. 4 drawings 'Anti-Christmas Bolshevik Plots': 2 colour line blocks (red and black): *Strand Magazine*, September 4.

4. 1 drawing, subject to be selected: 2 colour half-tone (red and black): *Nash's Magazine*, September 6.

5. 4 drawings ' Yuletide Industries': black and white halftone: *London Magazine*: September 10.

6. 3 or 4 'Brightening Christmas': black and white halftone: *Pearson's Magazine*, September 15.

Would you please drop me a line by return to say whether you think you can manage the above programme. But for the two items for Royal Magazine it seems to me you can keep your holiday clear, though, of course, you will have a tremendous rush the moment you get back. with every day for the next fortnight booked up.[45]

This was in addition to his weekly drawings for *The Bystander* and a full page coloured advertisement for Sandy MacDonald's Scotch Whisky, which he completed during the first week of his holiday. He agreed that he could meet the programme set out, asking only that the cartoon for *The Bystander* might sometimes be in line, rather than the more usual pen and wash. However, for the weekly drawing for special numbers of *The Bystander* magazine at such times as Easter, Summer or Christmas, he was allowed a second colour. He seemed to take extra care with these drawings, as is evidenced by 'The Intellectual Summer Holiday' and 'How to train yourself …'

For *Hutchinson's Magazine* in 1924 he anticipated chaos theory with an ingenious series of eight pictures under the generic heading of 'Consequences'. They had such titles as 'How the thoughtlessness of a butterfly seriously affected the bishop's corn' or 'How a sermon may be cut short by the falling of a leaf'. They illustrate in a single picture how the first mentioned event leads, through a tortuous chain of consequences to the final outcome. They are a good example of the primary subject matter for Heath Robinson's humorous work, which was not gadgets and devices, but the human condition, the workings of fate and the weakness and self-importance of man. This latter aspect is clearly illustrated in his drawing 'Testing artificial teeth in a modern tooth works. At first sight this appears to be just another 'gadget' drawing, albeit a particularly magnificent one, but like many of his drawings it has a deeper significance. The massive size of the machine compared with the objects to be tested and the large number of technicians and managers diligently pursuing their appointed tasks all serve to satirise the pomposity and self-importance of the 'experts'. The effect is only heightened by the quality of the painting and the fine industrial landscape that provides the backdrop to the proceedings.

While the majority of Heath Robinson's humorous drawings are entirely fresh and original, it is sometimes possible to find the inspiration for his work in

45. Letter from A E Johnson to W Heath Robinson, 2 August 1922, Heath Robinson Trust Collection.

Above: The intellectual summer holiday.
The Bystander Summer Number, 10 June
1925, p.841 [91].

Opposite: How to train yourself to avoid
being caught in any part of the field.
The Bystander, 30 June 1926, p.849 [92].

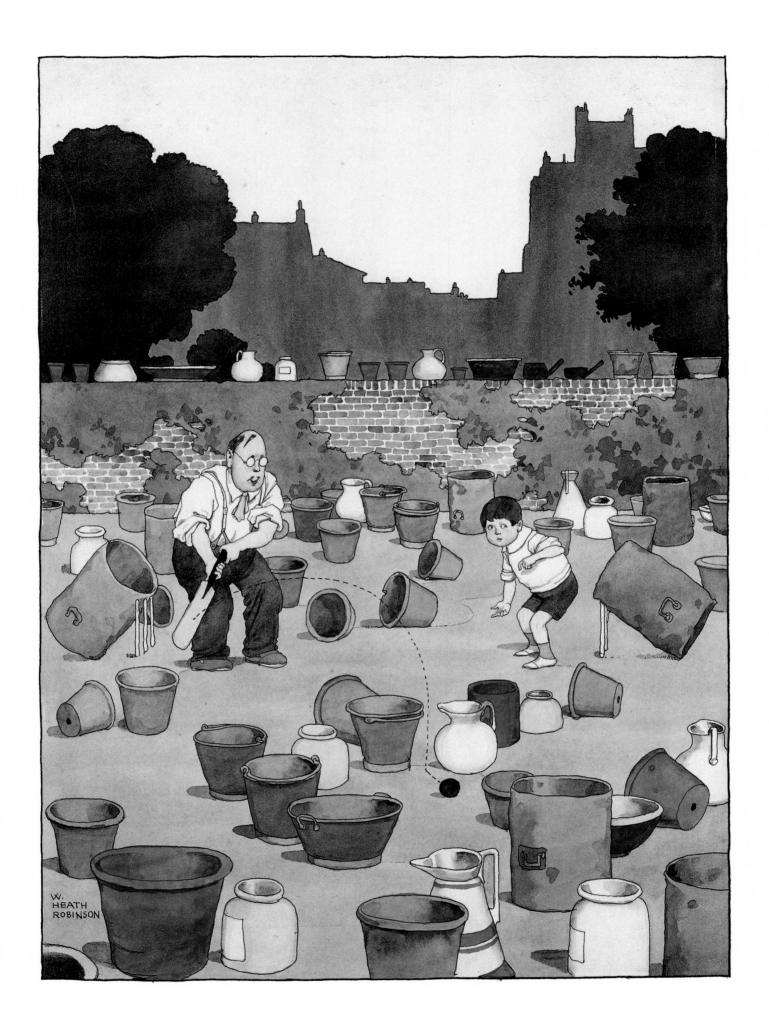

111

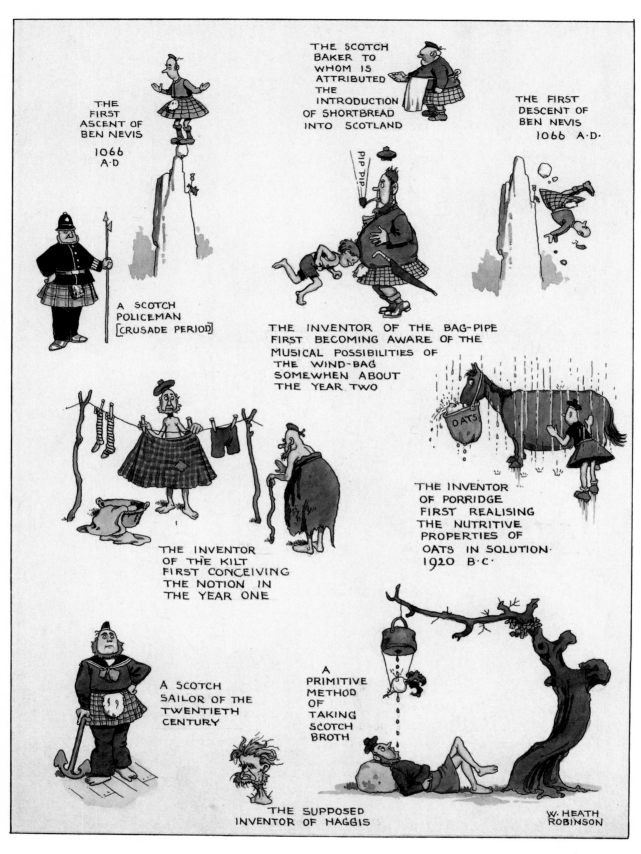

Above: Extracts from a short outline of
Scotch history, first published circa May
1920 [88].

Opposite: A Christmas Scandal, *Holly
Leaves*, Christmas 1943 [97].

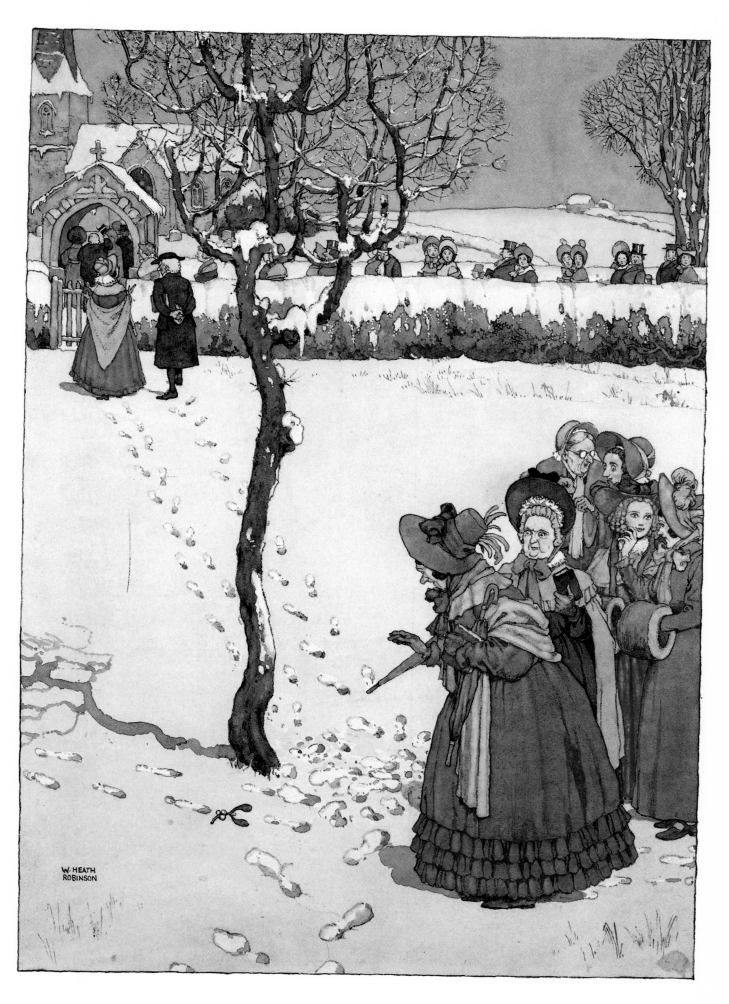

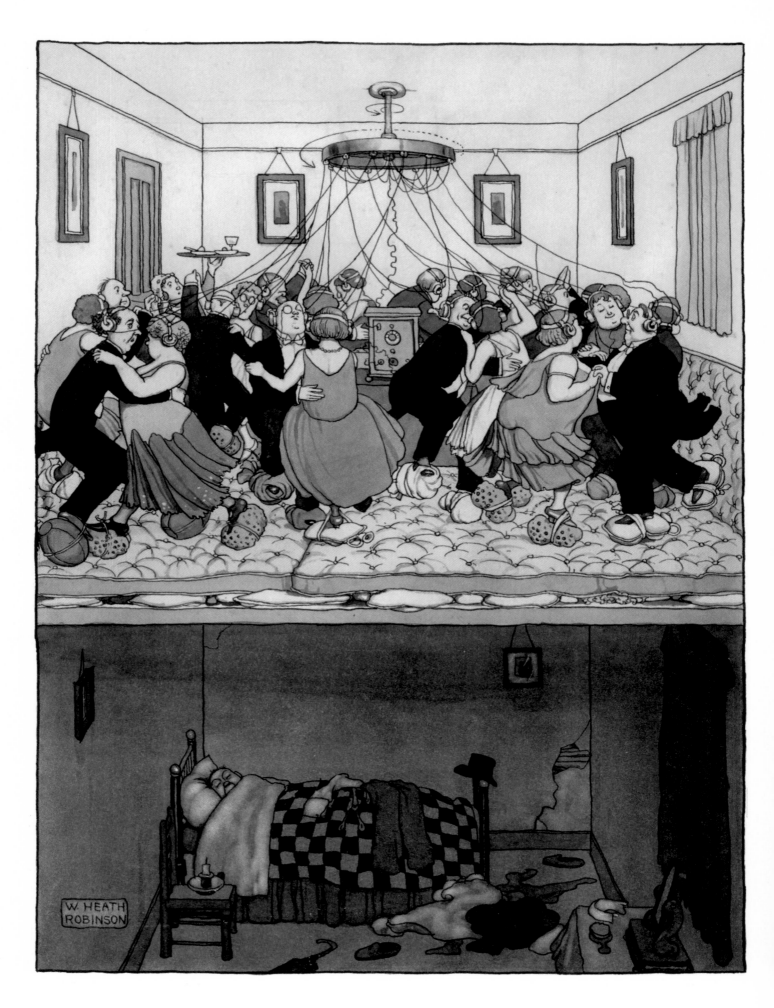

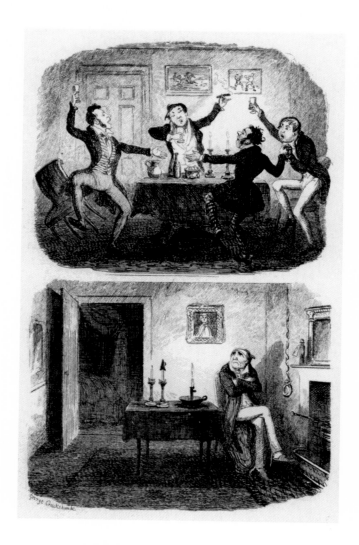

the classic 19th century humorous tradition. The origin of his delightful 'Savoy Orpheans' drawing lies in George Cruikshank's *Comic Almanac* for 1837. This includes a plate titled 'Over-head and Under-foot' showing four young blades carousing in an upstairs room, jumping and stamping around. In the room below their neighbour, looking extremely miserable, sits waiting for the noise to stop, so that he can retire to his bed, which is seen through an open door. Heath Robinson has taken this composition, with the two rooms, one above the other, seen in cross-section, and has used to show how considerate of their neighbours people can be. In the upper room a party of over 20 people are dancing vigorously to the BBC's broadcast of the Savoy Orphean Dance Music, but they have taken precautions to ensure that their neighbour in the room below is not disturbed. There are mattresses on the floor, the dancers' feet are muffled in various ways, and the music is heard through individual earphones. While the neighbour in Cruikshank's picture is having a miserable time, Heath Robinson's neighbour is sleeping soundly.

Another link between the 19th century comic tradition and Heath Robinson's work can be found in the volume of *Punch* for 1850. At page 109 is a drawing titled *The Advantage of Lodging Under a Mechanical Genius*. It shows a man being woken by having his bedclothes pulled off him. This is done by a cord that passes over a pulley and is attached to a heavy weight. The falling of the weight has been triggered by the clock on the wall reaching a specified time, and the weight has fallen with sufficient force to break through the floor, waking the man in the room below. This is, in simplified form, the archetypal Heath Robinson gadget, invented by an unidentified *Punch* artist about 60 years earlier. It is also another example of the 'two room' composition.

Left: Over-head and Under-foot, an illustration by George Cruikshank for his *Comic Almanack*, 1842.

Right: The Advantage of Lodging Under a Mechanical Genius, *Punch*, 1850, p. 109.

Opposite: How to take advantage of the Savoy Orpheans dance music broadcast by the BBC without disturbing your neighbour in the flat below, *Sunday Graphic*, 9 December 1928, page 14 [93].

Left: Our friend Charlie Greenfield, an illustration for *My Line of Life*, London: Blackie & Son, 1938 [75].

Centre: Half-title, to Chapter 1, an illustration for *My Line of Life*, London: Blackie & Son, 1938 [68].

Bottom: To snare young birds in Highgate woods, an illustration for *My Line of Life*, London: Blackie & Son, 1938 [70].

Opposite: Testing artificial teeth in a modern tooth works, *The Looker On*, 13 April 1929, p.7 [94].

Autobiography – *My Line of Life*

Another of Cecil Hunt's earlier titles had been *Author-Biography* and perhaps Heath Robinson had read this before starting to write his own autobiography in 1937. This was commissioned by Blackie & Son, the Glasgow publisher, and like most autobiographies by people who are not professional writers, must have seemed something of a gamble to them, even with the prospect of Heath Robinson's drawings, both new and old, to brighten the book and provide added interest. They need not have worried, for the book that Heath Robinson wrote was a true reflection of the man and a rare example of the best kind of autobiography. He wrote with honesty, naturalness of style, modesty and an obvious affection for his fellow men. Kenneth Browne wrote to him after reading the book:

> … I think you have made an extremely good job of it. One would think you had been a professional writer all your days, in fact.[47]

The reviewer in *John O'London's Weekly* summed up the qualities of the book when he said:

> He writes seriously – which is not to say dully – and quietly about his heritage and his upbringing, and his business, his taste and his good fortune. He is human, not humorous, straightforward and not whimsical; and since his life has hardly been one of action, this is a book which depends more on its humanity than any other quality.[48]

Reading contemporary reviews one finds that the book was universally well received and recommended, a reception that seems to have been reserved for a relatively small proportion of books published at that time. It is amusing to note in many of the reviews an air of surprise, firstly that Heath Robinson was a real person and secondly that he was, in his everyday life, a normal and sane family man. One feels that some reviewers were disappointed not to receive a piece of knotted string and a set of plans for a page-turning machine with their copy of the book.

Its publication made Heath Robinson something of a literary celebrity, at least for a short period. He was invited to lecture at the *Sunday Times* National Book Fair where he demonstrated, among other things, how to split peas with an axe! He was also one of the guests at a Foyles literary lunch, along with James Agate, Pamela Frankau, A G MacDonnell and others. Billed to speak at the lunch on 'Art', he said that he had always encouraged modern art and would show the Vorticist patent match extinguisher, which might also be Cubist or Surrealist. He then went to an easel and drew this curious contraption incorporating rubber tubing, a container for compressed air, and a bulb fixed to a post on the floor, by means of which the artist could blow out his match when he had lit his pipe, even when he had a palette in one hand and a brush in the other. Apparently this performance was watched with a silence that no speaker could have commanded.

47. Letter from Kenneth Brown to W Heath Robinson, William Heath Robinson Trust collection.

48. *John O' London's Weekly*, 2 December 1938.

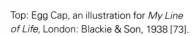

Top: Egg Cap, an illustration for *My Line of Life*, London: Blackie & Son, 1938 [73].

Centre: We get all we came out to see (half title to chapter 14), an illustration for *My Line of Life*, London: Blackie & Son, 1938 [80].

Bottom: The Rebuke, an illustration for *My Line of Life*, London: Blackie & Son, 1938 [74].

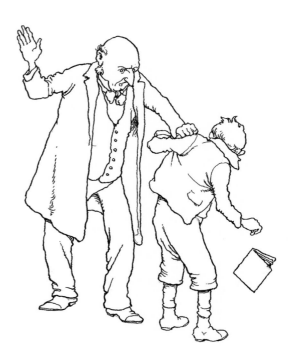

World War II

The Second World War saddened Heath Robinson, filling him with a sense of weariness and futility and he referred to it as 'this disastrous war'. His expression in the drawing 'The War Artist Arrives' clearly shows how he felt. As in the previous conflict, his humorous drawings were much in demand, and he was given a page in *The Sketch* each week. The drawings he made during this period include one of the few instance of recognisable living people appearing in his humorous pictures. In 1940 he made a series of drawings called 'The Ubiquitous Winston' which chronicled the exploits of a Churchill super-hero as he attempted to win the war single-handed. He also invented the 'sixth column', a band of civilians whose aim was to frustrate the evil plans of the fifth column. They appeared in a series of five drawings in June and July 1940 that are amongst the best from this period. The first of them shows the sixth column preventing an attempt to starve us out by poisoning the pigeons in Trafalgar Square. The most spectacular of them shows the dislodging of a machine gun nest in the dome of St Paul's cathedral.

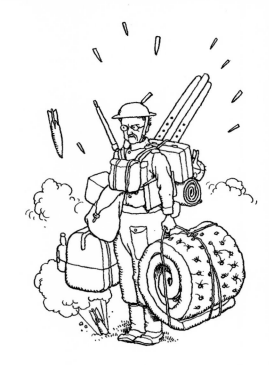

Other cartoons revived the theme of inventions to help win the war or to reduce the damage on the home front caused by the Blitz. Comparing these drawings with the First World War cartoons one notices a change of emphasis. During the First World War it was the enemy soldiers and their behaviour that provided the majority of the subjects for his cartoons. This time most of the jokes feature British soldiers or even civilians coping on the home front, and one feels that the Nazi enemy was too terrible to be the subject of such a gentle humorist.

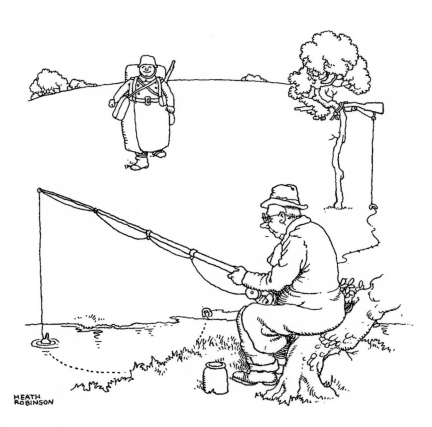

Top: The War Artist Arrives, half-title vignette for *Heath Robinson at War*, London: Methuen, 1942 [81].

Bottom: Guerrilla tactics, a drawing for *Heath Robinson at War*, London: Methuen, 1942 [83].

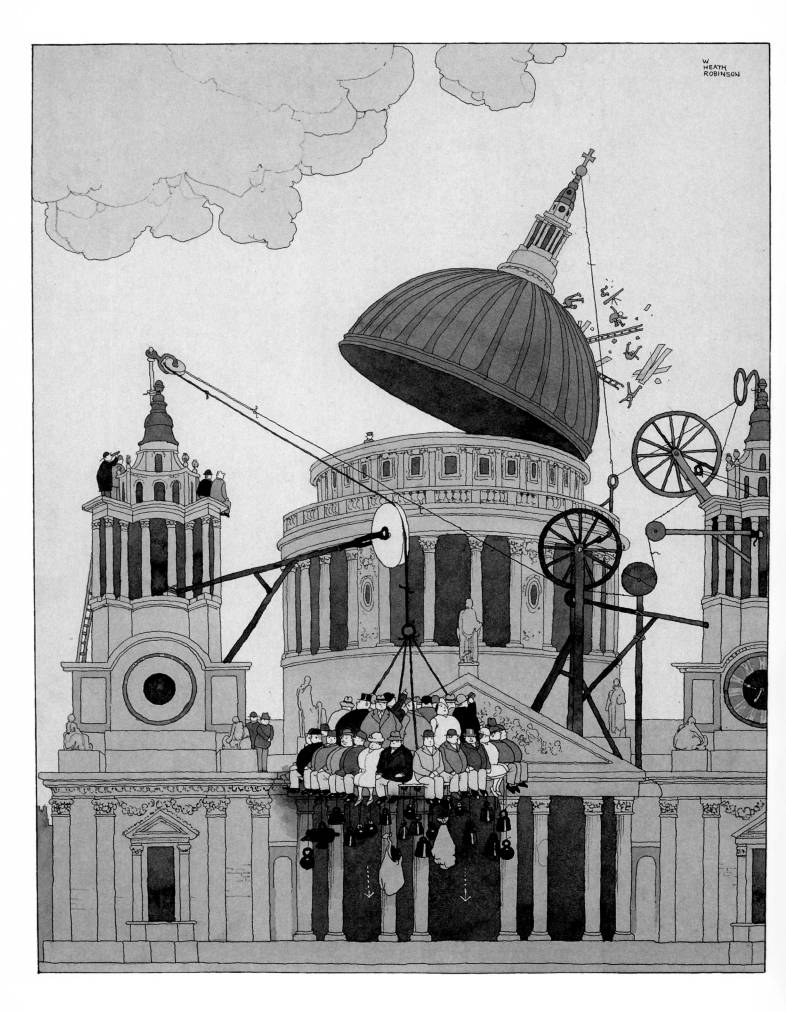

A number of the drawings were collected in a slim volume called *Heath Robinson at War* for which he made a number of additional line drawings and which was published by Methuen in 1942. In the introduction to that volume Heath Robinson said that:

> To meet the difficulties of this peculiar situation, and after consultation with many heads of departments, I have decided to form a front of my own to be called the Heath Robinson Front to distinguish it from all the other Fronts on the earth, in the sea and in the air. It is proposed that this new front shall not function in any departmental manner. It will combine in one stupendous effort the activities of the already established fronts, to whose success it will contribute materially.
>
> I feel that I cannot provide better propaganda for this new movement than will be found in this little brochure. It will, I hope, sufficiently explain the attitude to the war we intend to maintain. It will demonstrate the uniqueness of our approach to the difficulties confronting us. At the same time it will introduce many new and unheard of instruments of warfare. These may or may not be adopted by the War Office.

Above: The wrong way to come down in a parachute a drawing for *Heath Robinson at War*, London: Methuen, 1942 [82].

Below: Equitable distribution of loot, a drawing for *Heath Robinson at War*, London: Methuen, 1942 [84].

Opposite: Stout members of the sixth column dislodge an enemy machine gun post on the dome of St Paul's, *The Sketch*, 10 July 1940, p. 35 [95].

Above: The Bather [111].

Opposite top: Eastern market scene [104].

Opposite bottom: Trees in a park [105].

49. *The Studio*, July 1920, vol. 79, pp. 191–2.

Painting and drawing for pleasure.

Throughout his adult life Heath Robinson would spend much of the limited spare time he had either drawing or painting in watercolours. He might draw family members (including the cat, Saturday Morning), indulge his love of land-scape or seascape painting, join his friends at the London Sketch Club making a 'two hour sketch' of 'the good old days' or pursue his experiments into light, colour, movement and abstraction. His children remembered him on holiday at the seaside, dressed in suit, collar and tie, setting up his easel on the beach or in a country lane to paint the scene before him. When painting for pleasure he was able to adopt a much freer style, executing sensitive, impressionistic watercolour sketches. The combination of his facility with the medium and his distinctive vision means that although these pictures are completely different from his commercial work, they are immediately recognisable as his.

The most distinctive of them are those such as 'The Bather' in which moulding and graduated transitions from light to shade are eschewed in favour of adjacent areas of homogeneous tone indicating both form and movement. A similar treatment can be seen in the trees in the background of the watercolour illustration for 'The Tempest' (page 73) and in a number of other watercolour sketches that were probably studies for the Cape *Shakespeare*. It is not clear what inspired these experiments, but they bear some relation to the work of artists such as George Sheringham and Reginald Higgins who were both members of the Decorative Art Group. According to a note in *The Studio* in 1920, this group, by 'practically banishing from their schemes 'that third dimension, the illusion of which is created by the use of shadows'' sought to recognise 'the supreme importance of colour and line in decoration'.[49] At their best these paintings transcend the purely decorative, conveying a sense of movement and freedom through their instinctive balancing of line and tone. However he seems never to have had the opportunity to explore fully the potential of this style and in his later years reverted to a much more conventional way of working.

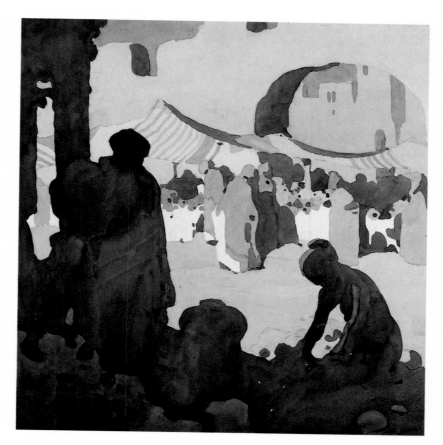

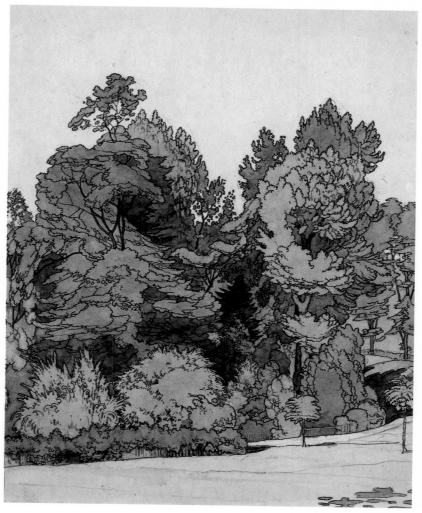

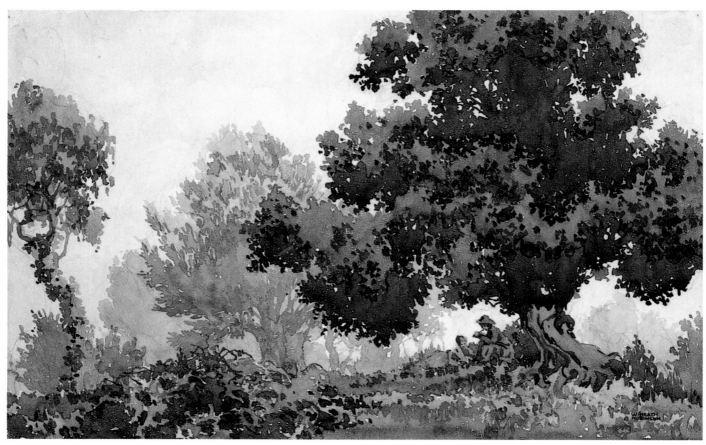

124

His last book

A final echo of Heath Robinson's earlier fantasy illustrations can be found in *Once Upon a Time,* a book of fairy stories written by Dr Liliane M C Clopet and published in 1944. The book contains four stories that gave him a chance to return to many of his favourite subjects. The first story has a young man blown across the sea, as was Vammerdopper in *Uncle Lubin,* and also features a cat. In his later years Heath Robinson's own cat, Saturday Morning, was his constant companion and, as surviving sketch books show, a constant subject for his pencil. The other three stories all feature animals and the reader is treated to a delightful Heath Robinson menagerie including a very robust family of pigs, horses, geese, bears and even ladybirds. He made many more drawings for the book than could be included under the strictures of wartime economy. Although these pictures have none of the dramatic tension of the earlier fantasy work, they exhibit a warmth and lively good humour that cannot fail to please. Dr Clopet was delighted with the illustrations, and wrote to Heath Robinson praising ... 'the fun and the sweetness and of course, the sheer beauty of the drawings.'

Dr Clopet asked Heath Robinson to illustrate another of her books, but by this time he was not a well man, and wrote in August 1944:

> I have to go into hospital for an operation, after which I shall need time to recuperate, so you see that I shall not be able to undertake anything for some little time. Moreover, I have many arrears of work to make up before I undertake anything new.[50]

He had a preliminary operation and was pronounced fit for a major operation, but on the 13 September 1944, before it could take place, he died from heart failure.

Conclusion

In the years from 1896–1944 Heath Robinson's success across the many areas in which he worked was greater than that of any other popular artist of the 20th century. He reached the highest level of achievement as an illustrator in both black and white and colour, as a humorous artist, in advertising and as a watercolorist. Moreover his name became a household word and entered the English language. His immediate appeal and general popularity during his lifetime resulted mainly from his humorous work and in this field he was both brilliant and unique. He was an unusually prolific artist with a seemingly inexhaustible stock of good ideas. Like artists such as Hogarth and Rowlandson before him, the secret of his appeal lay in his great abilities as a serious artist. The many lovers of his work had an opportunity to appreciate those abilities in January 1945 at a Memorial Exhibition at the Fine Art Society in New Bond Street, which was opened by David Low. Over a hundred pictures were on show and, although his humorous work predominated, there were also book illustrations and watercolours, including the beautiful frontispiece to *Bill the Minder. A* reporter for *The Times,* after commenting on his 'brand of pleasing lunacy' went on to remark:

> What may be unexpected in this exhibition is the fineness of Heath Robinson's craftsmanship – the clear and firm fluency of his pen line, the quality of his watercolour washes. Those who have known his work only in reproduction will be surprised at its technical excellence.[51]

In the years that have followed, there have been few opportunities for admirers of his work to make that judgement for themselves. There was an excellent centenary exhibition at the Medici Galleries in 1972, and a travelling exhibition visited a number of provincial galleries in 1977. Chris Beetles Ltd had major selling exhibitions in 1983 and 1992 and the Heath Robinson Trust

Opposite top: Spanish figure and tree [106].

Opposite bottom: Landscape with two figures under a tree [108].

50. *The Life and Art of W Heath Robinson* by G Langston Day, Herbert Joseph, London 1947.

51. *The Times* January 1945.

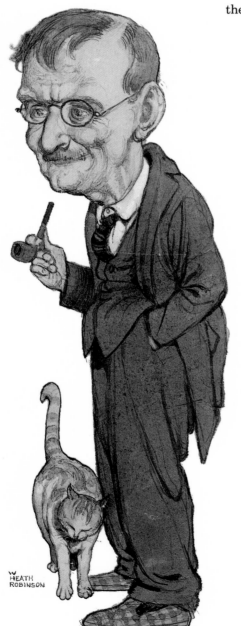

marked the 50th anniversary of Heath Robinson's death with an exhibition at Christie's, King Street, in 1994.

Like L S Lowry and Stanley Spencer, Heath Robinson is a national institution, a maker of images that captured the essence of British life. His work needs to be permanently accessible. As the cartoonist Fougasse (Kenneth Bird) said, 'Of the greatness of Heath Robinson there is no question', but how is that greatness recognised in our national collections? Not at all. The British Museum has four of his pictures and the Victoria and Albert Museum has five, none of which has been put on display. In both cases, the pictures were acquired by bequest rather than as a matter of deliberate policy. It was only in recent years that the National Portrait Gallery acquired its first portrait of Heath Robinson, also by bequest, and this has not yet been exhibited.

We must therefore be grateful to the artist's daughter, Joan Brinsmead, who had the foresight to collect much of her father's best work, and to her husband, Denis Brinsmead, who protected the collection by forming the William Heath Robinson Trust. The Trust is now working to establish a permanent museum in which this important collection can be displayed. Once established, the museum will not only show Heath Robinson's work, but will be a focus for the study of the history of book illustration.

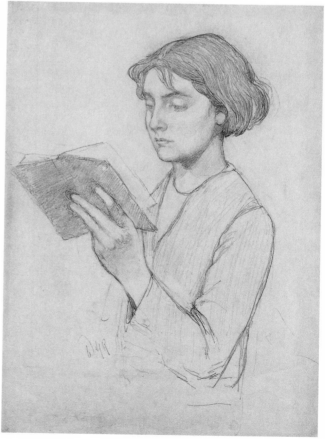

Family portraits

Clockwise from top left: Christine, early
1930s [114]; Madeleine and Saturday
Morning, early 1930s [112]; Madeleine,
early 1930s [113]; Portrait of Joan, circa
1920 [115].

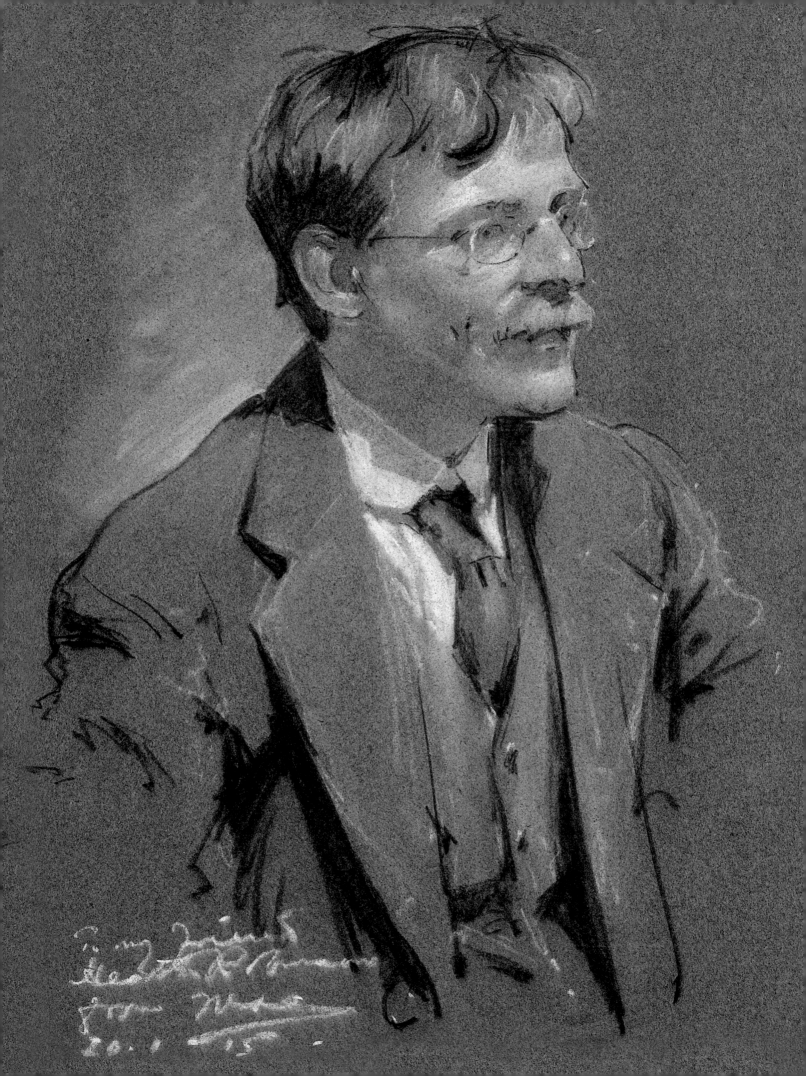

To my friend
Heath Robinson
from Max
20.1.'15

Catalogue

All pictures are from the William Heath Robinson Trust collection unless otherwise stated

Don Quixote, London: Bliss, Sands & Co., 1897

1. 'They All Gazed at Him, and Admired at the Sight', pen and ink, 302 × 188mm

Andersen's Fairy Tales, London: J M Dent & Sons Ltd, 1899

2. 'She took off her red shoes, her most cherished possessions, and threw them in the river', an illustration for *'Fairy Tales from Hans Christian Andersen'*, pen and ink, 275 × 170mm (private collection)

The Adventures of Uncle Lubin, London: Grant Richards, 1902

3. The Half-title, pen and ink drawing, 285 × 233mm

4. The First Adventure – Introduction. Three pen and ink drawings, coloured for exhibition after publication, each 283 × 232 mm, 282 × 238mm, 286 × 240mm

5. The Second Adventure – The Air-Ship. 'The Aeronaut', pen and ink, coloured for exhibition after publication, 303 × 248mm

6. The Fourth Adventure – The Candle and the Iceberg, three pen and ink drawings, coloured for exhibition after publication, each 303 × 236mm, 29 × 229mm, 302 × 231mm

7. The Sixth Adventure – The Mer-man and his Family, 'The Mer-man and the Humming Top', two pen and ink drawings, coloured for exhibition after publication, each, 279 × 239mm, 288 × 232mm

8. The Sixth Adventure – The Mer-man and his Family. '… quietly swallowed the poor old mer-man right up', pen and ink, 297 × 240mm

9. The Eighth Adventure – The Shower, three pen and ink drawings, 297 × 240mm, 297 × 240mm, 297 × 240mm, 297 × 240mm

10. The Eleventh Adventure – The Rajah, 'The Plague', pen and ink, coloured for exhibition after publication, 297 × 240mm

Rama and the Monkeys by Geraldine Hodgson, London: J M Dent & Sons Ltd, 1903

11. 'Rama lifted the Bow', pen and ink, 265 × 160mm (private collection)

The Works of Rabelais, London: Grant Richards, 1904

12. 'May you fall into sulphur, fire and bottomlesse pits', pen and ink, 580 × 405mm (private collection)

13. 'Ring, Draw, Reach, Fill and Mixe', pen and ink, 480 × 340mm (private collection)

14. Studies of heads for *Rabelais*, published in *Strand Magazine*, July 1908, pen, ink and pencil, 425 × 520mm

15. Tailpiece, Book 1, Chapter 4, pen and ink, 245 × 313mm

16. Tailpieces, Book 1, Chapters 18 and 20, pen and ink, 313 × 245mm

17. Headpieces, Bk IV Prologue and Chapter 1, and Tailpieces Chapters 11 and 16, pen and ink, 295 × 180mm

18. Headpieces Bk IV, Chapters 28, 30; Tailpieces Bk IV, Chapters 19, 20, 23, 25, 35, 37, pen and ink, 323 × 285mm

Twelfth Night by William Shakespeare, London: Hodder & Stoughton, 1908

19. Duke. 'So full of shapes is fancy', watercolour and body colour, 538 × 365mm

20. Olivia. 'Well, come again tomorrow; fare thee well', watercolour and body colour, 585 × 464mm

A Song of the English by Rudyard Kipling, London: Hodder & Stoughton, 1909

21. 'The coast-wise lights of England give you welcome back again!' pen and ink, watercolour and body colour, 375 × 510mm

22. 'There's never an ebb goes seaward now, but drops our dead on the sand', pen and ink, watercolour and body colour, 463 × 583mm

Bill the Minder by W Heath Robinson, London: Constable & Co., 1912

23. Frontispiece, pen and ink, watercolour and body colour, 555 × 410mm (private collection)

24. 'He Climbed the Rick', pen and ink, 150 × 289mm

25. Headpiece to 'The Ancient Mariner', pen and ink, 230 × 290mm

26. Headpiece to 'The Triplets', pen and ink, 282 × 292mm

27. Headpiece to 'The Real Soldier', pen and ink, 289 × 232mm

28. 'Moping about the Common', pen and ink, 232 × 289mm

29. 'Kept Him out of Mischief', pen and ink, 232 × 289mm

30. Tailpiece to 'The Camp Followers', pen and ink, 150 × 289mm

31. Headpiece to 'The Siege of Troy', pen and ink, 289 × 232mm

Andersen's Fairy Tales, London: Constable & Co., 1913

32. 'Suddenly a large raven hopped upon the snow in front of her', pen and ink, 420 × 291mm

33. The Little Robber Girl, pen and ink, coloured for exhibition after publication, 405 × 290mm

34. Karen, pen and ink, 395 × 290mm

A Midsummer Night's Dream, London: Constable & Co., 1914

35. Theseus. 'Now, fair Hippolyta, our nuptial hour draws on apace' pen and ink, 440 × 327mm

36. Lysander '…and she, sweet lady, dotes, Devoutly dotes, dotes in idolatry, Upon this spotted and inconstant man', pen and ink, 397 × 298mm

37. Half Title to Act II. Pen and ink, 537 × 311mm

38. Titania, 'Playing on pipes of corn, and versing love to amorous Phillida', pen and ink, 436×330mm

39. Demetrius, 'Thou runaway, thou coward, art thou fled', pen and ink, 426×310mm

40. Puck, 'So, goodnight unto you all', pen and ink, 403×288mm

The Water-babies by Charles Kingsley, London: Constable & Co., 1915

41. 'There are Land Babies – then why not Water-Babies?', pen, ink, watercolour and bodycolour, 286×218mm

42. 'There would be a New Water-Baby in St. Brandan's Isle', pen, ink, watercolour and bodycolour, 375×290mm

43. 'On they went', pen and ink, 416×296mm

44. 'Trudging along with a bundle on her back', pen and ink, 411×296mm

45. 'When all the world is young, lad', pen and ink, 396×297mm

46. 'Thou Little Child', pen and ink, 240×325mm

47. 'The first thing which Tom saw was the black cedars', pen and ink, 396×277mm

Peacock Pie by Walter de la Mare, London: Constable & Co., 1916

48. Cake and sack, pen and ink, 291×231mm

Unpublished Illustration

49. The Moon's First Voyage, pen and watercolour, 283×412mm (private collection)

Strand Magazine

50. 'First go a little farther …', pen and ink, an illustration for 'How the Sea Became Salt', Apr 1915. vol. 49, pp. 467–71, pen and ink, 415×267mm (lent by Luke Gertler)

Unpublished Illustrations commissioned by Jonathan Cape in 1921 for an edition

of *Shakespeare's Works* (Lent by Random House)

51. Prospero and Miranda – Watercolour and bodycolour, 490 x 300mm

52. Falstaff and Doll Tearsheet. – Watercolour and bodycolour 490×300mm

53. A sheet of illustrations for *Julius Caesar* and *Macbeth*, pen and ink 375×545mm

54. A sheet of illustrations for *Timon of Athens*, pen and ink 375×545mm

55. A group of drawings for *Henry IV Part II* and *The Merry Wives of Windsor*, pen and ink
a) A Headpiece for the Merry Wives of Windsor (MWW 119), 74×396mm
b) Falstaff deposited in the Thames (MWW1 57), 318×123mm
c) Falstaff and Justice Shallow (H IV Pt II 295), 124×151mm
d) Pistol and Mistress Quickly (H IV Pt II 307), 184×251mm
e) Man Listening, (H IV Pt II 271), 188×80mm
f) Page: 'the music is come Sir' (H IV Pt II A2 Sc2), 174×112
g) Falstaff (H IV Pt II 259) ,205×104mm
h) Mouldy (H IV Pt II A3 Sc2) 298×80mm
i) Thin man with paper (H IV Pt II 293), 188×74mm
j) Serving man laughing behind his hand (H IV Pt II 251), 173×135mm

56. A group of drawings for the History Plays, pen and ink
a) Pistol: 'Pish for thee, Iceland dog! thou prick – ear'd cur of Iceland.' (H V), 155×112mm
b) Richard III corpse (R III 729), 95×266mm
c) Ruffian's Head (King John P41), 116×119mm
d) Old man's head (King John P47), 136×88mm
e) Head on a pike (H VI Pt III 547), 212×56mm
f) The Assassins (R III 659), 155×143mm
g) Glowering man (H V P323), 222×97mm

57. An illustration for *Anthony and Cleopatra*, pen and ink 301×305mm

58. Trees in Summer and Winter: Two page decorations for *As You Like It*, pen and ink 354×254mm

Old Time Stories told by Master Charles Perrault, translated from the French by A E Johnson, London: Constable & Co. Ltd, 1921

59. Ricky of the Tuft, pen and ink, 366×270mm

60. Bluebeard, pen and ink, 353×270mm

61. The Wicked Nurse, pen and ink, 281×225mm

62. 'She was an ugly little fright', pen and ink, 227×283mm

Connolly Advertising.

63. 'William the Conqueror appreciates the comfort of leather when crossing the Channel', a drawing for *Connolly Chronicles*, 1933, pen and ink, 506×405mm (private collection)

How to Live in a Flat by W Heath Robinson and K R G Browne, Hutchinson & Co, London, 1936

64. Romantic possibilities in modern flats, pen and ink, 380×272mm

65. The one-piece chromium steel dining room suite, pen and ink, 298×270mm

66. Modern carpet designs may provide endless entertainment for your guests, pen and ink, 380×272mm

67. Roof hiking in a modern flat, pen and ink, 226×270mm

My Line of Life by W Heath Robinson. London: Blackie & Son Ltd, 1938

68. Half title to Chapter 1, pen and ink, 114×87mm

69. My Grandfather Robinson engraving, pen and ink, 214 ×170mm

70. To snare young birds in Highgate woods, pen and ink, 107×120mm

71. The Hoop Club, pen and ink, 145×230mm

72. The Schoolmaster, pen and ink, 120×77mm

73. Egg Cap, pen and ink, 80 × 194mm

74. The Rebuke, pen and ink, 130 × 98mm

75. Our Friend Charlie Greenfield, pen and ink, 83 × 173mm

76. To Hampstead (half-title to Chapter 8), pen and ink, 140 × 177mm

77. My little daemon, pen and ink, 94 × 170mm

78. Haunted by a strange little genius, pen and ink, 150 × 140mm

79. My good genius introduced me to new friends, pen and ink, 132 × 127mm

80. We get all we came out to see, (half-title to Chapter 14), pen and ink, 98 × 157mm

Heath Robinson at War. London: Methuen, 1942

81. Half title vignette – The War Artist arrives, pen and ink, 272 × 190mm

82. The wrong way to come down in a parachute, pen and ink, 380 × 273mm

83. Guerrilla tactics, pen and ink, 272 × 190mm

84. Equitable distribution of loot, pen and ink, 380 × 275mm

Humorous Illustrations for Magazines

85. Daring abduction of a society beauty at Westgate-on-Sea (rough sketch for an early version of the drawing published in *The Sketch*, 24 July, 1912), pen, ink and watercolour, 457 × 325mm

86. The First Aero Wedding (*Flying Magazine*, 30 May 1917), pen, ink and watercolour, 435 × 290mm

87. German breaches of the Hague Convention – Huns using siphons of laughing gas to overcome our troops before an attack in close formation, (*The Sketch*, vol. 91, p. 139 Aug 1915 and *Some Frightful War Pictures*, plate XXIII), pen, pencil and wash, 419 × 285mm

88. Extracts from a short outline of Scotch history (first published circa May 1920), pen,

ink, watercolour and bodycolour, 395 × 298mm

89. Futurism by the Fireside – Mistress (to Maid) 'Now, Jane, how often have I told you not to place your eye upon the mantelpiece.' Brainy maid. 'You are mistaken mum, that is not my eye but merely the dynamic conception of its lyrical form interpreted by infinite manifestation of its relations between absolute movement and relative movement or, in a word, between ambience and object, until it forms a …' Mistress 'Then you may take a month's notice (no publication traced) Pen and monochrome watercolour, 450 × 287mm

90. How a sermon may be cut short by the mere falling of an autumn leaf (*Hutchinson's Magazine*, November 1924, p.399), pen and monochrome watercolour, 438 × 314mm

91. The intellectual summer holiday (*The Bystander*, Summer no. 10 June 1925, p.841), pen, ink and watercolour, 404 × 295mm

92. How to train yourself to avoid being caught at any part of the field (*The Bystander*, 30 June 1926, p.849), pen, ink and watercolour, 385 × 270mm

93. How to take advantage of the Savoy Orpheans dance music broadcast by the BBC without disturbing your neighbour in the flat below (*Sunday Graphic*, 9 December 1928, p.14), pen, ink and watercolour, 255 × 370mm (private collection)

94. Testing artificial teeth in a modern tooth works (*The Looker On*, 13 April 1929, p.7), pen and monochrome watercolour, 471 × 354mm

95. Stout members of the sixth column dislodge an enemy machine gun post on the dome of St Paul's (*The Sketch*, 10 July 1940, p.35), pen and monochrome watercolour, 403 × 310mm

Holly Leaves

96. The Fairy's Birthday (December 1925, p. 21), pen, ink and watercolour, 480 × 337mm

97. A Christmas Scandal (Christmas 1943), pen, ink and watercolour, 479 × 345mm

Nash's Pall Magazine

98. Cover design for Christmas Number 1929, pen, ink watercolour and bodycolour, 597 × 446mm

99. Illustration for 'Dickens is not Dead' by John van Durten, September 1934, pen, ink, watercolour and bodycolour, 464 × 543mm

Good Housekeeping

100. Illustration on two panels for 'Miss Francis Goes to Stay with Friends' by Richmal Crompton, November 1933, pen and wash, each panel 535 × 377mm

Decorations for the 'Empress of Britain' liner

101. Design for the Empress of Britain – The 'Knickerbocker' Cocktail Bar, watercolour, 270 × 375mm

102. Design for the Empress of Britain – The Children's Room, watercolour, 267 × 375mm

103. Trial panel for the mural in the 'Knickerbocker' Bar on the Empress of Britain, oil paint on a veneered wooden panel, 315 × 230mm

Watercolours and drawings

104. Eastern market scene, watercolour on thin board, 382 × 370mm

105. Trees in a park, pen and watercolour on paper, 290 × 225mm

106. Spanish figure and tree, watercolour on textured paper, 354 × 255mm

107. Seated man with pipe, 17th century dress, charcoal and water colour on board, 510 × 316mm (probably a 'Sketch Club' sketch)

108. Landscape with two figures under a tree, watercolour on paper, 402 × 570mm

109. Landscape with tall tree and haystack, painted near Cranleigh. Watercolour on textured paper, 355 × 255mm

110. Shepherd's Hill, Highgate, pen and watercolour, 761 × 537mm

111. The Bather. Watercolour on paper, 297×468mm

Family Portraits

112. Madeleine and Saturday Morning, early 1930s, watercolour. [Madeleine Robinson (1908–91) was a neice of William and a daughter of Tom; Saturday Morning was the cat of Will's family] (private collection), 240×175mm

113. Madeleine, early 1930s, pencil drawing (private collection), 355×255mm

114. Christine, early 1930s, drawing. [Christine Robinson (1903–91), niece of Will, sister of Madeleine], 355×255mm (private collection)

115. Portrait of Joan, pencil [Joan Brinsmead, Heath Robinson's daughter], 210×266mm

116. Portrait of William Heath Robinson by C D Ward, black and white chalk on grey paper, 355×279mm, inscription: 'To my friend/Heath Robinson/from Ward/20.1.15'

117. Self-caricature with Saturday Morning, pencil and watercolour 366×255mm (private collection),

Appendices

Books wholly illustrated by William Heath Robinson

Danish Fairy Tales and Legends by Hans Christian Andersen, Bliss, Sands & Co., London, 1897 (16 line drawings)

The Life and Exploits of the Ingenious Gentleman Don Quixote de la Mancha translated from the original Spanish of Miguel de Cervantes Saavedra by Charles Jarvis Esq. Bliss, Sands & Co., London, 1897 (16 line drawings)

The Pilgrim's Progress from This World to That Which is to Come Delivered Under the Similitude of a Dream by John Bunyan, edited by George Offor. Bliss, Sands & Co., London 1897 (16 line drawings)

The Giant Crab and Other Tales from Old India by W H D Rouse. David Nutt, London, 1897 (52 line drawings)

The Queen's Story Book being historical stories collected out of English Romantic Literature in illustration of the reigns of English monarchs from the Conquest to Queen Victoria Edited with an introduction by Laurence Gomme. Archibald Constable & Co., Westminster, 1898 (20 line drawings)

A Soul on Fire by Florence Marryat. Sands & Co., London, 1898 (Pictorial binding.)

The Talking Thrush. Stories of Birds and Beasts. Collected by W Crooke and retold by W H D Rouse. J M Dent & Co., London, 1899 (82 line drawings)

The Poems of Edgar Allen Poe with an introduction by H Noel Williams. George Bell and Sons, London, 1900 (105 line drawings)

The Adventures of Don Quixote of La Mancha by Miguel de Cervantes. J M Dent & Co., London, 1902 (45 line drawings)

Mediaeval Stories by Professor H. Shuck, translated from the Swedish by W F Harvey, M A Sands & Co., London, 1902 (28 line drawings)

Tales from Shakespeare by Charles and Mary Lamb. Sands & Co., London, nd (1902) (16 line drawings)

The Adventures of Uncle Lubin written and illustrated by W Heath Robinson. Grant Richards, London, 1902 (Coloured frontis and 154 line drawings)

The Surprising Travels and Adventures of Baron Munchausen by R E Raspe. Grant Richards, London, 1902 (4 coloured plates and 1 line drawing)

The Child's Arabian Nights written and illustrated by W Heath Robinson. Grant Richards, London, 1903 (12 coloured plates and 25 line drawings)

Rama and the Monkeys adapted for children from the Ramayana by Geraldine Hodgson. J M Dent & Co., London, 1903 (Coloured frontis and 6 line drawings)

The Merry Multifleet and the Mounting Multicorps created by Richard Johnson and put into writing by Thomas O'Cluny. J M Dent & Co., London, 1904 (16 line drawings)

The Works of Mr Francis Rabelais, Doctor in Physic Containing Five Books of the Lives, Heroick Deeds & Sayings of Gargantua and His Sonne Pantagruel. Grant Richards, London, 1904. Two volumes (254 line drawings)

Stories from Chaucer Told to the Children by Janet Harvey Kelman. T C & E C Jack, London, nd (1905) (8 coloured plates)

The Memoirs of Barry Lyndon and Men's Wives by W M Thackeray. The Caxton Publishing Company, London, nd (1906) (3 coloured plates and 3 line drawings)

Stories from the Iliad or the Siege of Troy Told to the Children by Jeanie Lang. T C & E C Jack, London, nd (1906) (8 coloured plates)

Stories from the Odyssey Told to the Children by Jeanie Lang. T C & E C Jack, London, nd (1906) (8 coloured plates)

The Monarchs of Merry England (William I to Richard III) by Roland Carse. Alf Cooke, Leeds and London, nd (1907) (20 coloured plates and 73 line drawings)

More Monarchs of Merry England (Henry VII to Edward VII) by Roland Carse. T Fisher Unwin, London, nd, 1908 (20 coloured plates and 73 line drawings)

The Secret Woman by Eden Phillpotts. Collins Clear Type Press, London, nd (1907) (Coloured frontis)

The Book of Witches by O M Hueffer. Eveleigh Nash, London, 1908 (Coloured frontis)

Twelfth Night or What You Will by William Shakespeare. Hodder & Stoughton, London, nd (1908) (40 mounted coloured plates and 6 line drawings)

A Song of the English by Rudyard Kipling. Hodder & Stoughton, London, nd (1909) (30 mounted coloured plates and 59 line drawings)

The Collected Verse of Rudyard Kipling Doubleday, Page & Co., New York, 1910 (9 mounted coloured plates and 14 line drawings)

The Dead King a poem by Rudyard Kipling. Hodder & Stoughton, London, 1910 (22 line drawings)

Bill the Minder written and illustrated by W Heath Robinson. Constable & Co. Ltd, London, 1912 (16 mounted coloured plates and 125 line drawings)

Hans Andersen's Fairy Tales Constable & Co. Ltd, London, 1913 (16 mounted coloured plates and 95 line drawings)

Shakespeare's Comedy of a Midsummer Night's Dream Constable & Co. Ltd, London, 1914 (12 mounted coloured plates and 63 line drawings)

The Water-Babies A Fairy Tale for a Land-Baby by Charles Kingsley. Constable & Co. Ltd, London, 1915 (8 coloured plates and 104 line drawings)

Peacock Pie A book of rhymes by Walter de la Mare. Constable & Co. Ltd, London, nd (1916) (Coloured frontis and 96 line drawings)

Old Time Stories told by Master Charles Perrault. Translated from the French by A E Johnson. Constable & Co. Ltd , London, 1921 (6 mounted coloured plates and 50 line drawings)

Peter Quip In Search of a Friend written and illustrated by W Heath Robinson. S W Partridge & Co. Ltd, London, nd (1922) (8 coloured plates and 19 line drawings)

Topsy Turvy Tales told by Elsie Smeaton Munro. John Lane The Bodley Head Ltd, London, 1923 (6 coloured plates and 36 line drawings)

Good Housekeeping Cookery Book by Florence B Jack. *Good Housekeeping,* London, 1925 (Dustwrapper design)

Rudyard Kipling by Anice Page Cooper. Doubleday, Page & Co, New York, 1926 (7 line drawings taken from *The Collected Verse of Rudyard Kipling*, 1910)

If I Were You by P G Wodehouse. Herbert Jenkins, London, 1931 (Dust wrapper design)

The Incredible Adventures of Professor Branestawm by Norman Hunter, John Lane The Bodley Head Ltd, London, 1933 (Coloured frontis and 74 line drawings)

Balbus a Latin reading book for junior forms by George Maxwell Lyne. E Arnold & Co., London, 1934 (10 line drawings).

Heath Robinson's Book of Goblins stories from Vernaleken's *In the Land of Marvels*. Hutchinson & Co. (Publishers) Ltd, London, nd (1934) (7 coloured plates and 146 line drawings)

How To Live In a Flat by Heath Robinson and K R G Browne. Hutchinson & Co. (Publishers), Ltd, London, nd (1936) (119 line drawings)

How to Be a Perfect Husband by W Heath Robinson and K R G Browne. Hutchinson & Co. (Publishers), Ltd, London, nd (1937) (117 line drawings)

How to Make a Garden Grow by Heath Robinson and K R G Browne. Hutchinson & Co. (Publishers), Ltd, London, nd (1938) (115 line drawings)

My Line of Life by W Heath Robinson. Blackie & Son Ltd, London, 1938 (16 half-tone plates and 112 line drawings)

Success With Stocks and Shares by John B Gledhill and Frank Preston. Sir Isaac Pitman and Sons Ltd, London, 1938 (4 line drawings)

Mein Rant by R F Patterson. Blackie & Son Ltd, London, 1940 (12 line drawings)

How To Make the Best of Things by W Heath Robinson and Cecil Hunt. Hutchinson & Co. (Publishers), Ltd, London, nd (1940) (124 line drawings)

How to Build a New World by W Heath Robinson and Cecil Hunt. Hutchinson & Co. (Publishers), Ltd, London, nd (1941) (133 line drawings)

How To Run a Communal Home by W Heath Robinson and Cecil Hunt. Hutchinson & Co. (Publishers), Ltd, London, nd (1943) (126 line drawings)

Once Upon a Time by Liliane M C Clopet. Frederick Muller Ltd, London, 1944 (43 line drawings)

The Adventures of Don Quixote de la Mancha by Miguel de Cervantes. J M Dent & Sons Ltd, London, 1953 in the 'Children's Illustrated Classics' series (8 coloured plates and 26 line drawings)

Goblins verses by Spike Milligan. Illustrations by W Heath Robinson. Hutchinson of London, 1978 (39 line drawings with added colour)

The Heath Robinson Illustrated Story Book The Hamlyn Publishing Group Ltd, 1979 under the Beaver Books imprint (33 line drawings from the *Strand Magazine*)

Books partly illustrated by William Heath Robinson

Numbers of illustrations given are those by W H R, re-used material indicated by ®

The Arabian Nights Entertainments anon. George Newnes by arrangement with A Constable & Co., London, 1899 (207 line drawings)

Fairy Tales From Hans Christian Andersen translated by Mrs E Lucas, J M Dent & Co., London, 1899 (35 line drawings)

Tales for Toby by Ascot R Hope. J M Dent & Co., London, 1900 (11 line drawings)

Fairy Tales from Hans Christian Andersen translated by Mrs E Lucas. J M Dent & Co., London, 1901 in the 'Temple Classics for Young People' series (5 line drawings ®)

Dent's Andersen in German edited by Walter Rippmann. J M Dent & Co., London, 1902 (12 line drawings ®)

The House Annual, 1902 Compiled by W A Morgan. Gale & Polden, London, 1902 (6 line drawings)

Boys' and Girls' Fairy Stories J M Dent & Co., London, 1903 (3 coloured plates and 3 line drawings)

Grant Richards's Children's Annual for 1903 Edited by T W H Crossland. Grant Richards, London, nd (1902) (2 coloured plates)

Grant Richards's Children's Annual for 1904 edited by T W H Crosland. Grant Richards, London, nd (1903) (4 coloured plates)

Grant Richards's Children's Annual for 1905 edited by T W H Crosland and W Collinge. Grant Richards, London, nd (1904) (2 coloured plates)

Kingdoms Curious by Myra Hamilton. Wm. Heinemann Ltd, London, 1905 (2 line drawings ®)

The Children's Christmas Treasury of Things New and Old J M Dent & Co., London, nd (1905) (3 coloured plates and 6 line drawings)

Fairy Tales from Hans Christian Andersen J M Dent & Co., London, 1906. In the Everyman series (11 line drawings®)

Arabian Nights Entertainments retold for Young Folks. Anon. Collins Clear Type Press, London & Glasgow, nd, (1907), in the Tales for the Children series (10 line drawings ® of which 2 have been coloured)

The Arabian Nights A. Constable & Co. Ltd, London, nd (1908) (80 line drawings ®)

Oxford Reading Book no. IV, Henry Frowde, London, n,d, July 1908 (1 coloured plate and 2 line drawings)

A Day With William Shakespeare by Maurice Clare. London: Hodder & Stoughton, nd, ca 1910 (1 coloured plate®)

Happy Hearts a picture book for boys and girls, edited by Harry Golding. Ward, Lock & Co. Ltd, London, 1911 (Cover design and frontis in colour)

Red Paint written by L E Filmore, edited by A E Johnson. Hodder & Stoughton, London, 1911 (9 line drawings)

The Golden Treasury of Songs and Lyrics compiled by F T Palgrave. Hodder & Stoughton, London, nd (1911) (1 coloured plate®)

The Odd volume edited by John G. Wilson. Simkin, Marshall, Hamilton, Kent & Co. Ltd, London, 1911 (1 coloured plate and 1 pencil drawing)

Happy Hearts a Picture Book for Boys and Girls edited by Harry Golding. Ward, Lock & Co. Ltd, London, 1912 (Cover design and 2 coloured plates)

Stories From The Arabian Nights including Sinbad the Sailor and the Story of Aladdin. Anon. Thomas Nelson & Sons, London, Edinburgh, Dublin & New York, nd, 1912 (1 coloured plate)

Aladdin or the Wonderful Lamp anon. Collins Clear-Type Press, London & Glasgow, nd, ca 1912 (10 line drawings ®)

The Works of Sir Walter Scott including The Waverly Novels and The Poems. Large Paper Edition – in Fifty volumes. Houghton, Mifflin Company, Boston and New York, 1913. Limited to 375 copies printed at the Riverside Press, Cambridge, Massachusetts (4 photogravure frontispieces)

Tales from Shakespeare by Charles and Mary Lamb. Hodder & Stoughton, London, nd (1914) (2 coloured plates ®)

Lucky-Bag Tales a Picture Book for Little Folks. London: Cassell & Company, Ltd nd, ca 1915 (1 drawing in blue and black®)

The Queen's Gift Book Hodder & Stoughton, London, nd (1916) (1 mounted colour plate and 3 line drawings)

Princess Marie-Jose's Children's Book. Cassell & Company, London, nd (1916) (1 coloured plate)

The Book of Limericks by Sir William Bull and 'Orion' of the *Daily Express* (William Warren). *Daily Express,* London, 1916 (1 rough sketch)

Playbox Annual for 1917 amalgamated Press, London, nd (1916) (6 line drawings ®)

Playbox Annual for 1918 amalgamated Press, London, nd (1917) (9 line drawings ®)

Playbox Annual for 1919 amalgamated Press, London, nd (1918) (6 line drawings®)

Bo Peep: A Picture Book Annual For Little Folks. Cassell and Company Ltd London, New York, Toronto and Melbourne, 1918 (1 line drawing ®)

A Merry Mixture a children's annual. Cassell & Co. nd (3 line drawings ®)

Playbox Annual for 1920 amalgamated Press, London, nd (1919) (5 line drawings®)

The Cream of Curiosity by R L Hine. G Routledge & Sons, London, 1920 (2 line drawings ®)

Playbox Annual for 1921 amalgamated Press, London, nd (1920) (6 line drawings ®)

Merry Moments Annual George Newnes, London, nd (1920) (2 line drawings ®)

Pelman Pie edited by Max Pemberton. Hodder & Stoughton for the Pelman Institute, London, nd (1920) (1 coloured lithograph)

Playbox Annual for 1922 amalgamated Press, London, nd (1921) (3 line drawings ®)

Toby's Annual G Heath Robinson and J Birch Ltd nd (1922) (4 line drawings ®)

Ward, Lock Story Books 1922–3. Eight titles with the same W H R endpapers

'Animals' Xtra and Louis Wain's Annual
Louis Wain Fund Committee, London, nd
(1925) (1 line drawing)

I Like to Remember by W Pett Ridge. London:
Hodder & Stoughton Limited, 1925 (1 half-
tone plate ®)

Everyland Annual for Boys and Girls. III. ed.
by W E Cule. The Carey Press, London, nd
(1926) (7 line drawings ®)

Scout Pie stories and Articles by Many
Eminent Writers Illustrated by Famous
Artists. Edited by Ernest Young. London:
C Arthur Pearson, Ltd, nd, (ca. 1927)
(1 half-tone drawing)

Arabian Nights the Children's Press,
Glasgow, nd (1932) (27 line drawings ® of
which 2 have been coloured)

The Children's Wonder Book edited by John
R Crossland and J M Parrish. Odham's Press
Ltd, London, 1933 (6 line drawings ®)

The Golden Wonder Book edited by J R
Crossland and J M Parrish, Odhams Press Ltd
London, nd (1934) (2 line drawings ®)

Professor Branestawm Stories by Norman
Hunter. E J Arnold and Son Ltd, Leeds,
Glasgow & Belfast, nd (1939) no. 27 in the
'Broadcast Echoes' Series (6 line drawings ®)

Some Frightful War Pictures Duckworth,
London, 1915

Hunlikely! Duckworth, London, 1916

The Saintly Hun Duckworth, London, nd
(1917)

Flypapers Duckworth, London, 1919

Get On With It! G Heath Robinson and
J Birch, London, nd (1920)

A Jamboree of Laughter from a Boy Scout's
Diary. A V N Jones, nd (1920)

The Home Made Car Duckworth, London,
nd (1921)

Motor Mania 'The Motor Owner', London,
nd 1921

Quaint and Selected Pictures G Heath
Robinson and J Birch, London, nd (1922)

Humours of Golf Methuen, London, 1923

Absurdities Hutchinson, nd (1934)

Railway Ribaldry Great Western Railway,
London, 1935

Let's Laugh Hutchinson, London, nd (1939)

Heath Robinson at War Methuen, London,
1942

Inventions Duckworth, 1973

Men That Might Have Been Ferret Fantasy
Ltd, 1974

The Gentle Art of Advertising compiled by
Quentin Robinson and introduced by Lord
Horder. Duckworth, 1979

*Great British Industries and Other Cartoons
from 'The Sketch' 1906–14* selected and
introduced by Geoffrey Beare. Duckworth,
1985 n.b. The book was published without
proofreading, and so there are a number of
errors in the text and captions. An errata slip
was issued

Meals on Wheels selected and introduced by
Peter Haining. Souvenir Press, 1989

In 1982 Duckworth also published a
compilation of drawings taken from their
earlier volumes, which they called 'The Best
of Heath Robinson', but it certainty was not!

Books and articles about William Heath Robinson

'The Delicacy of Humour' by M H Dixon. *The Ladies' Realm*, Dec 1907, vol. 23, pp. 231–8. An interesting early article on W H R's humour, with nine reproductions.

'A Maker of Absurdities', anon. *London Magazine*, Aug 1908, vol. 20, p. 626. A short article with a self-caricature accompanying a series of cartoons entitled 'How to Agricult'.

'Mr W Heath Robinson and His Work'. Anon. *Strand Magazine*, Jul 1908. vol. 36, 41–9. Photograph and 14 illustrations, most of which were not published elsewhere.

'Photographic Interviews no. V—A Famous 'Sketch' Artist: Mr W Heath Robinson'. *The Sketch*, 4 Jan 1911. vol. 72, 399–400. Seven photographs.

W Heath Robinson by A E Johnson. Adam and Charles Black London 1913 in the 'Brush, Pen and Pencil' series. Seven coloured plates, eight half-tone plates, 16 full page and 31 smaller line drawings. A number of these drawings are not published elsewhere.

'An Original Artist' by Lampeter Todd. *The Advertising World*, December 1915, pp. 523–7. An article covering both W H R's illustration and humorous work which makes the case for his talents to be employed by advertisers, with 13 line illustrations.

'The Line Drawings of W Heath Robinson' by A E Johnson. *The Studio*, May 1916. vol. 67, pp. 223–8. One double page, six full page and 13 smaller line drawings.

'Invention and Imagination. The Art of W Heath Robinson' anon. *To-day*, 27 May, 1916, vol. 1, p108. A perceptive and balanced article, with a photograph of the artist, to introduce the series of cartoons 'The Hun Virtuous'.

The Art of the Illustrator: W Heath Robinson and His Work by Percy V Bradshaw. The Press Art School, London, nd (1916). Sepia photograph with humorous line border and six plates tipped on to loose grey card mounts showing different stages of the same coloured illustration.

'In the Days of My Youth' by W Heath Robinson. *T P's and Cassell's Weekly*, 18 April 1925. vol. 3, pp. 956, 964 and 966. One small line drawing.

'The Art of Mr, Heath Robinson' by A L Baldry. *The Studio*, May 1925. vol. 89, pp. 242–9. Two full page coloured plates, two full page and one half page half-tone illustrations and one full page and two small drawings in line.

'Heath Robinson as Advertisement Designer' by Christopher Mann. *Commercial Art*, June 1927, vol. 2, pp. 256–9. A short assessment of WHR's advertising work with four well reproduced illustrations.

'Joking Apart' by Fenn Sherie *Pearson's Magazine*, Dec 1930. vol. 70, pp. 579–85. Includes one half page half-tone illustration and one small drawing in line and tone by WHR, both printed in red and blue. The article shows the serious side of six humorous artists.

'The Heath Robinson 'Ideal Home' at Olympia', anon. *Decoration*, Apr 1934, vol. 4, pp. 77–9. A brief description of 'The Gadgets' with one full page and four smaller line drawings.

My Line of Life by W Heath Robinson. Blackie & Son Ltd, London 1938. Facsimile Reprint by E P Publishing, Wakefield, 1974. For details see main Bibliography.

'The Gadget King' by G W Langston Day. *Everybody's Weekly*, 31 Mar 1945, pp. 8–9. Six half-tone illustrations in red and black, all from the Memorial Exhibition at the Fine Art Society.

The Life and Art of W Heath Robinson by G Langston Day. Herbert Joseph Limited, London, 1947. One double page and six full page coloured plates, three photographs, eight half-tone plates, eight full page and 17 smaller line drawings. Reprinted by E P Publishing, Wakefield, 1976.

'The Other Side of Heath Robinson' by Charles Hamblett. *Illustrated*, 13 Dec 1947. Three page article with four coloured illustrations and ten text illustrations.

The Penguin W Heath Robinson introduced by R Jordan. Penguin Books Ltd, Middlesex, 1966. (96pp). Pictorial card covers. 80 full page and five smaller illustrations.

'Artist and Inventor – the Wry Genius Behind the Word', anon. *Argosy*, Dec 1968, pp. 78–83. An explanation of the term 'Heath Robinson' with five line drawings.

'Magic in His Madness' by Leslie Garner. *The Sunday Times Magazine*, 4 Jun 1972. front cover and pp. 14–22. Composite cover design and nine illustrations including a fine example of one of W H R's serious watercolours reproduced in colour.

'Heath Robinson's Contraptions', anon. *Illustrated London News*, May 1972, vol. 260, pp. 35–7. Minimal text, but an excellent photograph of Heath Robinson in his studio and six humorous drawings

Heath Robinson, Artist and Comic Genius by John Lewis, with an introduction by Nicolas Bentley. Constable, London, 1973. Four coloured plates, 33 half tone illustrations and 119 drawings in line.

The Art of W Heath Robinson by Alan Horne, University of Toronto, 1977. A guide to an exhibition in the Thomas Fisher rare book library.

The Illustrations of W Heath Robinson by Geoffrey Beare. London: Werner, Shaw Ltd, 1983. The first book to focus on the artist's serious work. 50 illustrations in colour and b/w and a full bibliography.

'Journeys, Oracles and Herbs: Heath Robinson's Rabelais' by Simon Houfe. *Country Life*, 25 Oct 1984, vol. 176, pp. 1184–5. An interesting article with eight line illustrations.

The Inventive Comic Genius of Our Age: W Heath Robinson by Geoffrey Beare. Catalogue of an exhibition at Chris Beetles Ltd, London, 1987.

The Brothers Robinson by Geoffrey Beare. Catalogue of an exhibition at Chris Beetles Ltd, London, 1992. This catalogue attempted to examine the work of the three Robinson brothers in the context of the technical and commercial developments that shaped their careers

Heath Robinson Advertising by Geoffrey Beare. Bellew Publishing, London, 1992. A companion volume to *The Illustrations of W Heath Robinson*, with a commentary, bibliography and over 190 illustrations.

William Heath Robinson by James Hamilton. Pavillion, London, 1992. A well illustrated and readable biography, with interesting new material from the Grant Richards archive, but unreliable and difficult to use as a reference source.

'W Heath Robinson: The creative genius whose name became part of the English language' by David Leake. *This England*, Autumn 1994, vol. 27, no. 3, pp. 18–22. Two portraits, a photograph and ten illustrations.

'A Magical Mystery Tour of W Heath Robinson's Children's Books' by Geoffrey Beare. *Biblio*, April 1997, vol. 2, no. 4, pp. 18–25. Nine illustrations.

'Machine Dreams' by Max Vaduluk and Christopher Hitchens. *Vanity Fair*, July 1997, pp. 86–93. Five illustrations, three photographs, and five photographic reconstructions of Heath Robinson devices featuring celebrities such as Tim Curry, Rupert Everett and Sting.

'The Shakespearean Illustrations of William Heath Robinson' by Geoffrey Beare. *Folio*, Autumn 2001, pp. 4–10. One coloured and two black and white illustrations. Includes Heath Robinson's watercolour illustration for *King Lear* in the unpublished Cape Shakespeare.

Index